CU00919948

IF UNDELIVERED PLEASE RETURN TO:
THERESA McCULLOUGH Ltd
35 DOVER STREET
1st FLOOR
LONDON
W1S 4NQ

When Gold Blossoms

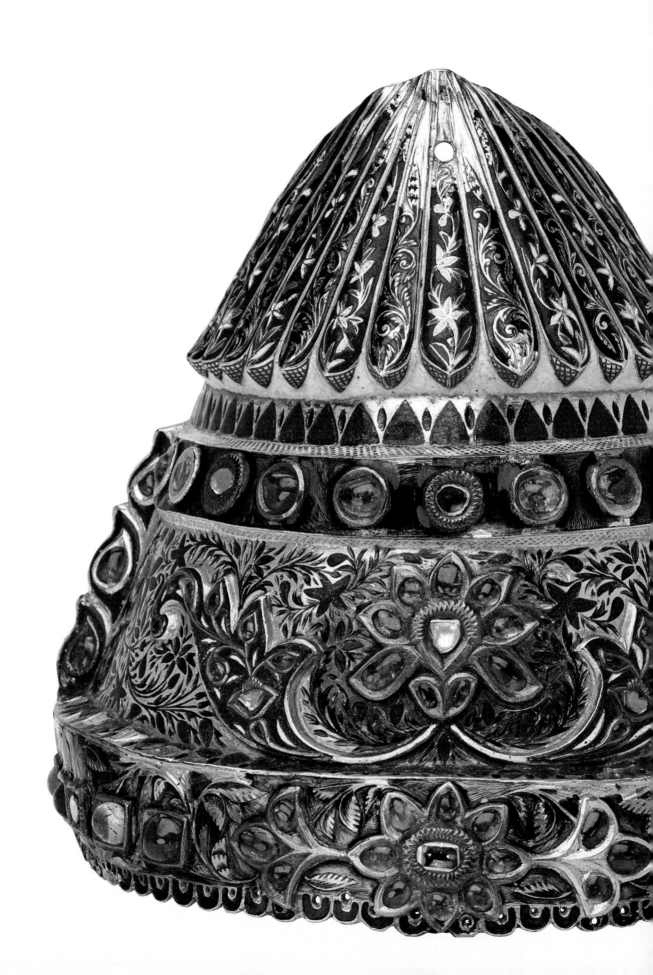

When Gold Blossoms

INDIAN JEWELRY FROM THE

SUSAN L. BENINGSON

COLLECTION

MOLLY EMMA AITKEN

ASIA SOCIETY & PHILIP WILSON PUBLISHERS

Copyright © 2004 Asia Society.
All rights reserved.

This publication was produced in conjunction with the exhibition *When Gold Blossoms: Indian Jewelry from Susan L. Beningson Collection* presented at the Asia Society Museum from September 14, 2004 through January 23, 2005.

Merrill Lynch is proud to be the Lead Corporate Sponsor of *When Gold Blossoms: Indian Jewelry from the Susan L. Beningson Collection.*

Photography credits:
All photographs by Benjamin Harris B.S.K., except figures where noted and catalogue number 12 by Robert Lorenzson and numbers 25, 26, 27, and 147 by Bruce White.

Designed by Katy Homans
Edited by Annie M. Van Assche, Deanna Lee, and Neil Liebman

First published in 2004 by
Philip Wilson Publishers, 109 Drysdale Street, The Timber Yard, London N1 6ND

Distributed in the United States and Canada by Palgrave Macmillan, 175 Fifth Avenue, NY 10010

Distributed in Europe and the rest of the world by I.B. Tauris, 6 Salem Road, London W2 4BU.

Note to the reader: Here for ease of reading, Hindi and Sanskrit words have been spelled without special symbols.

ISBN: 0-87848-097-8 (softcover)
ISBN: 0 85667 599 7 (hardcover)
Library of Congress Control Number: 2004104906

Printed and bound in Italy by
Editoriale Lloyd of Trieste

Cover: Gold Chettiar *tali.* Tamil Nadu; 19th century; 74 cm length. Susan L. Beningson Collection, cat. no. 110.

Title page: Gold crown for the image of a deity, enameled and set with rubies, emeralds, and diamonds. Central India; late 18th or early 19th century; base: 14 x 26 cm. Susan L. Beningson Collection, cat. no. 16.

Contents

VISHAKHA N. DESAI

6 President's Statement

MOLLY EMMA AITKEN

8 When Gold Blossoms:
Indian Experiences of Jewelry

44 Catalogue

139 Glossary

141 Bibliography

President's Statement

VISHAKHA N. DESAI

Visitors to the Indian Subcontinent cannot help but observe that the Indian penchant for adornment—whether on buildings, fabrics, or the body—is one of the most ubiquitous aspects of the culture. This phenomenon of adornment is amply illustrated in Indian art, especially when it comes to the representations of divine and socially significant figures. The role of ornamentation is of greater significance in Indian culture than in most others. The fact that it has been persistently so for thousands of years also suggests that it is not just about the decoration of the body but that it has important social and ritual significance.

When Gold Blossoms: Indian Jewelry from the Susan L. Beningson Collection not only celebrates the dazzling beauty and awe-inspiring technical perfection of Indian jewelry but also provides a historical and social framework. As suggested in the first part of the title, this exhibition focuses on gold more than on precious stones. This is due to the fact that the Beningson collection is particularly strong in South Indian jewelry, which shows a marked preference for gold over the use of precious and semiprecious stones, which are prominently featured in North Indian jewelry of the Mughal and Rajput cultures.

Perhaps because there have been a number of exhibitions of North Indian jewelry in recent years, it is the Persian-inspired forms of inlaid jewels with delicately enameled backs that have come to define Indian jewelry for Western audiences. *When Gold Blossoms* attempts to show a somewhat different type of jewelry, with strong geometric forms in solid gold, often filled with rubies but without a great variety of types of stones.

Susan Beningson and I agreed at the outset that the approach to this exhibition would be to place her collection in a broad social and cultural perspective. Thus, Susan became excited about finding historical photographs that would be relevant to her collection and the jewelry molds that could shed some light on the details of technique and about adding a spectacular piece of temple jewelry from South India.

The next task was to find a curator who would enthusiastically respond to this idea and provide innovative scholarship. I had no doubt that Molly Aitken was the right person for this task. As a scholar of Indian painting, Molly has distinguished herself as someone who combines a clear understanding of art-historical theory and cultural nuances embedded in works of art with a keen eye for the sheer beauty of objects. Her essay in this publication, with its far-ranging references to literature, religious symbolism, and the social implications of the jewelry, will become one of the major works in the field. Her commitment to the objects themselves is equally strong, as is evident in her analysis of the forms and techniques of individual pieces. Having worked with Molly as one of her dissertation advisers, I am proud to witness her blossoming into an innovative scholar of diverse aspects of Indian art.

Susan Beningson has been an ideal partner for this project. She is an unusual collector as she pursues collecting and scholarly interests with equal passion. Born into a family of serious collectors, she was faced with the question of not whether but what to collect. She began collecting Asian objects—Chinese textiles, Southeast Asian sculptures, and Indian jewelry—while she was in her mid-twenties. Although her initial passion was for Chinese studies and

she maintained her special connection with China through her work in the business environment, Susan broadened her interests to encompass all of Asia. She is now a doctoral candidate at Columbia University, pursuing a degree in the study of early Buddhist art on the Silk Road in China. We are most grateful to her and to the Beningson family for their long-standing support of the Asia Society Museum and for this project.

A number of people have been integrally involved with this project from its inception—Helen Abbott, Associate Director of the Museum, has been instrumental in the successful implementation of all aspects of the project. Amy McEwen ably managed registrarial issues. Deanna Lee worked both on the accompanying catalogue and on the exhibition. Joshua Harris coordinated the exhibition design and installation with the designer, Dan Kershaw. Katy Homans designed this book with her usual style and grace.

The following pages present almost the entirety of Susan L. Beningson's collection of temple gold and sacred jewelry, women's jewelry (with an emphasis on marriage ornaments), and jewelry-related objects from the Indian Subcontinent. Thirty-seven of these pieces have been exhibited and published previously as part of the Freer and Sackler Gallery's exhibition, *The Sensuous and the Sacred, Chola Bronzes from South India.* The rest of the collection is published here for the first time.

We are most grateful to our corporate sponsor, Merrill Lynch, and I would especially like to thank Toyoti Chopra there.

When Gold Blossoms will be part of a series of exhibitions focusing on traditional India in the fall of 2004. We hope they will provide a rich visual feast and a means to a deeper understanding of the vibrant cultural and artistic traditions of India.

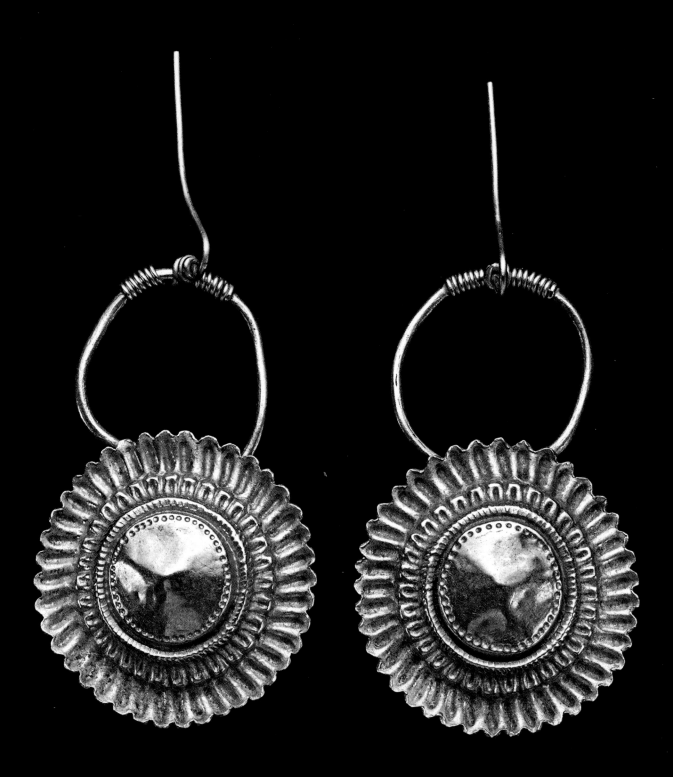

When Gold Blossoms presents the Susan L. Beningson collection of Indian jewelry. The focus of the collection is gold jewelry from the south of India, in particular, jewelry for deities and women. The collection began with a necklace that Beningson bought to wear (cat. no. 98) and a pair of earrings that she sought to match. It is a collection based not on academic principle but on the pleasures of seeing, touching, and wearing. *When Gold Blossoms* gives us the chance to share in the wearers' pleasures with careful, close viewing. It also looks at what we cannot see, namely, the

When Gold Blossoms: Indian Experiences of Jewelry

The Susan L. Beningson Collection

MOLLY EMMA AITKEN

past lives of these objects. Take, for instance, that first necklace bought for the collection, an abstraction of tiny berries with rubies good enough to eat. It is simple, even modern looking, and would not appear out of place on a New Yorker. There it would be, in essence, a new piece of jewelry, shorn of its meaning or the original sense of its design. Nothing intrinsic to its making

reveals whether it was a typical or eccentric piece, for whom it was made, what it meant to its wearers, or what it meant about its wearers. To address these questions, this publication and the exhibition of the Beningson collection at the Asia Society look at Indian experiences of jewelry: past and present, literary and literal, communal and individualistic, conventional and playful, and even defiant.

To understand what it means to wear jewelry in India, understand first what it means to go without jewelry. In premodern India, a defiant warrior who was brought to heel expressed his submission by removing his weapons and jewelry.[1] An ascetic renounces jewelry as part of a larger letting go of worldly ties.[2] And a new widow, if orthodox Hindu, breaks her glass bangles, gives up all or most of her jewelry, and adopts plain, white clothing.[3] The removal of jewelry in each of these cases expresses a death to society. The errant warrior has to "die" in the eyes of his king for the loyal warrior to be reborn; the ascetic "leaves the world";[4] and the widow was at one time encouraged to die, literally, by entering her husband's funeral pyre.

Ornament—by contrast—means life in India. It is auspicious, and it protects and brings growth and prosperity. It is inherent to beauty. It is a pleasure. But it is also a vital repository of social meanings. To adorn a person is to offer him or her protection, prosperity, respect, and social definition. The components of jewelry have added powers. Gold is thought to purify those it touches and gems to focus planetary influences that benefit those who wear them. Because of jewelry's potency, Indians have developed ornaments for every part of the body, from toe rings, anklets, and rings for the thighs to belts, nose rings, turban ornaments, braid covers, and even pendants for the parting of the hair. Over and above their powerful effects, ornaments flatter the body's forms and motions. They also demarcate a social skin.

Jewelry acts as an essential medium of social relationships, meanings, and exchanges in

Fig. 1.
Hammered gold florette earrings with repousse petals; modern earwires. South India; 5th–7th century. 6.7 x 2.8 cm. Susan L. Beningson Collection.

India. As such, jewelry is not inert but a motile part of life, shaping experiences and being shaped by them. From one community to another, even from one individual to another, the meanings of particular forms of jewelry, the rituals guiding their use, and the emotions surrounding their wearing vary immensely. Described in early poetry and medieval histories, nineteenth-century diaries, and contemporary websites, Indian experiences of jewelry go far beyond the search for beauty and the desire to display—or invest—wealth. Lived in, Indian jewelry is far more than it appears.

ORNAMENT IN INDIA

Traditionally, Indians have honored, protected, and blessed themselves with a world of ornamental design that began on the body and extended through virtually every manmade form in their lives. Jewelry, buildings, textiles, metalware, even the *mehndi* drawn on hands and feet, all employ similar motifs, framing devices, and uses of symmetry and alternation. Decorative segments are often framed by columns, and forms from nature dominate designs across media. Thus, lotus medallions feature on temples and mosques, vessels, and jewelry; mangoes on ornament shawls, *hookahs*, and nose rings; and peacocks adorn almost everything from thrones to scabbards and palaces to jewelry.

In India, a woman who is unadorned is not considered beautiful. A mother points to her daughter-in-law who has pawned all her jewelry and wears no ornaments: "Look at my daughter-in-law, isn't she ugly?"[5] At her best, a woman is expected to grace herself with sixteen adornments (*solah shringar*). It is a popular concept even today, but lists of the sixteen adornments vary enormously from source to source. The sixteenth-century historian Abu'l Fazl Allami's list included actions as well as objects, among them bathing, eating betel leaf (*pan*), anointing oneself with oil, braiding one's hair, wearing sandalwood unguent and collyrium, placing a sectarial mark on one's forehead, and decking oneself in necklaces, earrings, nose rings, a crown of jewels, and a belt hung with bells and flowers.[6]

There has always been a greater emphasis on women's adornment than men's, but men in India have historically been as (or almost as) lavishly dressed as women. Vatsyayana, the author of the circa fifth-century *Kama Sutra*, paid far more attention to men's than to women's adornment. He listed four types of ornaments for men: ornaments like earrings that required the flesh to be pierced (*avedhya*); ornaments like belts that were tied on with bands (*nibandhaniya*); ornaments like rings that could be slipped on (*prakshepya*); and ornaments worn around the neck (*aropya*).[7] Though images of women adorning themselves were popular in sculptures and paintings, visual sources, from second-century sculptures to nineteenth-century photographs, show that aristocratic men were as fully bejeweled as their wives and courtesans (fig. 2).

Fig. 2.
Portrait of a ruler; photograph; early 20th century. Susan L. Beningson Collection.

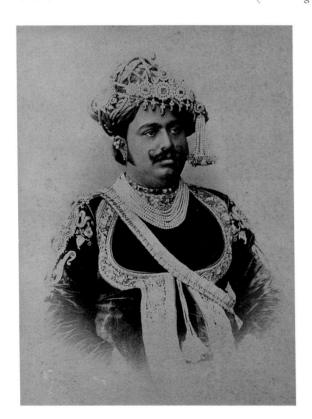

Ornament in India is meant to protect and bring good fortune. Designs that suggest life and growth are believed to promote prosperity and have traditionally been the most prevalent across media. Undulating lines and linked units wrap buildings, edge textiles, and circle bracelets and armbands; their unbroken continuities also suggest growth through repetition and, by extension, life and prosperity. They are inherently auspicious, as are birds, flowers, fruits, and seeds, which represent fecundity. Some of these motifs have persisted surprisingly unchanged.

One of India's earliest and still among its most popular motifs is the flowering vine, an undulating line sprouting leafy or flowering offshoots on alternating sides. In its post-seventeenth-century incarnation, the flowering vine owes a great deal to the Central Asian designs favored by Delhi's rulers, among whom it would have evoked images of paradise (fig. 3; cat. no. 126). Yet a similar vine appears as early as the second century B.C.E. on the Buddhist *stupa* of Bharhut, where it functions both decoratively and, in one place, didactically as a wish-granting vine that sprouts jewelry to denote good fortune. The applications of the flowering vine are as broad as its history is long for it is found on almost everything, from paintings to boxes, sword hilts, necklaces, and combs.

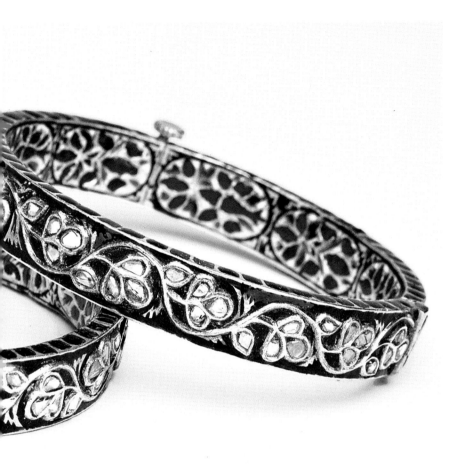

Fig. 3.
Detail of enameled gold bracelet, set with diamonds. Jaipur; 18th–19th century. Susan L. Beningson Collection; cat. no. 126.

METAPHOR AND TRANSFORMATION

What makes the continuity of design across media interesting in the Indian context is that it serves the tendency in Indian art and literature to use metaphor and simile—to associate everything with something else. In Indian literature, almost everything, from a woman's eye to a scene on the street, is transfigured by metaphor or simile. A river is a courtesan, for instance, and a candle weeps tears. Playing with the contiguity of forms on the body, poets turn pearls into beads of sweat exuded in passion and tears into diamonds. Architecture and painting translated this habit into plastic form. Treatises on painting instructed the painter to model human anatomy on natural forms—a woman's arm on a jungle creeper, for instance, or a man's torso on the head of a bull. Books on architecture described temples as living entities, their inner sanctums as fecund wombs (*garbha griha*).[8]

Ornament has traditionally been an essential component of these visual metaphors. A band of lotus petals on a building made it blossom, while flowers and fountains could turn a carpet—

and hence a room—into a celestial garden. Jewelry partakes in these transformations. Some pieces borrow from architectural forms, such as the barrel-roofed temple gateway (*gopura*), which associates jewelry with temples. Many pieces are modeled on natural forms: gold beads are molded into flower buds (cat. no. 96), rubies represent the petals in flowers (cat. nos. 48 and 64), and earrings are shaped as snakes (cat. no. 63). A common type of braid ornament takes the form of a many-headed rearing cobra (fig. 4; cat. no. 24), suggesting the snakelike quality of a woman's braid. Jewelry also sparks the metaphoric transformation of those who wear it. Pendants and earrings turn the face into a celestial event in these lines by the sixteenth-century poet Manjhan:

Fig. 4.
Gold cobra-head braid ornament (*nagar*) with silver back. Tamil Nadu; 18th or 19th century. Susan L. Beningson Collection; cat. no. 24.

Her pendants were encrusted with diamonds and gems. On one ear she had hung the sun, on the other, the sphere of Jupiter. With two luminous orbs on either side, her face rose like the moon between the stars.[9]

To live with Indian jewelry, then, is to live with an infinite potential for flights of metaphoric fancy and discoveries of hidden links among disparate things.

Shared ornamentation encouraged the association of one form with another—the king with the god, the god with the temple, the temple with a beautiful woman, and a beautiful woman with a season (or a river). Take the example of Indian religious architecture. The culture treated *stupas* and temples as living entities, to be honored and adorned like kings or gods with flowers and gold. Ornament—including jewelry forms—played up this metaphoric animation of stone. The walls of Hindu and Jain temples were understood to be infused with the energy of creation, a female power (*shakti*). One expression of *shakti* was the depiction of women on temple walls, particularly in North India. The touch of a maiden's foot was believed to make a tree burst into flower, and literature speaks of these women making the architecture bloom (fig. 5).[10]

A woman touching a tree is a recurring motif on temple walls, turning stone into fecund nature. The flowers and vines depicted on temple walls enhanced this image of the blooming temple, and sculptural representations of jewelry extended the metaphor into the very columns of the building. Temple columns were sometimes carved into flowering vases that symbolized female fertility[11] and were often ornamented like women. An eleventh-century column (in fig. 6), for instance, is encircled with braceletlike bands and adorned with chains draped and hung with bells that resemble a late-eleventh-century stone representation of a woman's girdle (fig. 7). In effect, these columns have become feminine and imbue the walls with the fertile powers of femininity.

Fig. 5.
Detail of a Celestial Woman on a
Pillar Bracket. Uttar Pradesh; mid
9th century. John Ford Collection,
Baltimore. Photograph courtesy of
John Ford.

Fig. 6.
Column from a temple in Osian,
Rajasthan; 11th century. Notice the
similarities among the bands around
the column, the bracelet worn by
the woman next to the column, and
those worn by the woman in Figure 7.
Notice also that the bell-hung chain
around the column is very like the
belts worn by women in sculptures
like in Figure 7. Photograph courtesy
of Vishakha N. Desai.

Fig. 7.
Celestial Entertainer. India, Karnataka;
later Chalukyas of Kalyani period,
late 11th–early 12th century. Schist
(metasiltstone); 101 cm height. Mr.
and Mrs. John D. Rockefeller 3rd
Collection of Asian Art, 1979.031.
Photograph courtesy of Lynton
Gardiner.

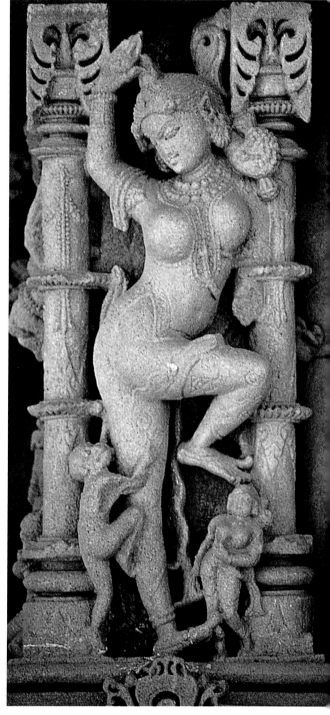

Jewelry, in turn, frames the body like a temple. Deities wear crowns imitating temple spires (*shikhara*) (fig. 8).[12] Premodern armbands are architectonic, and a common motif on jewelry from South India mimics the finials on temple gateways. Similarly, the a masklike amalgam of lion, deer, and Death's head (*kirtimukha*) is found both on jewelry (fig. 9; cat. no. 56) and on the steps and doorways of temples (fig. 10). Serving an apotropaic function, the *kirtimukha* simultaneously disgorges and consumes the curling, foaming energy of a building, signifying the godhead who creates and destroys.[13] A sea creature (*makara*) often shown flanking the *kirtimukha*, shares similar meanings (cat. nos. 95, 135, 141). These creatures emit a stream of repeating units, reminding us that repetition is the most basic feature of ornament and that the cosmic significance of repetition is infinity. On a mortal, these figures relate the human body to a set of walls, enclosing a space vulnerable to evil influences and requiring protection.

On a deity, architectural forms and figures like the *makara* and *kirtimukha* may frame the icon as a temple in its own right. The crown and armbands of the eleventh-century Vishnu from the Museum of Fine Arts, Boston (fig. 8), illustrate this kind of transformation. Decorated with a common architectural unit (*chandrasala*), based on the ends of the Indic barrel vault, the crown and armbands share a single, rigid, frontal plane that seems to plot a virtual door, turning Vishnu into a corporeal temple.

Fig. 9.
Gold earrings with horned, masklike faces (*kirtimukhas*). South India; 19th– early 20th century. Susan L. Beningson Collection; cat. no. 56.

This metaphoric link between the body and the temple is enhanced by the many pieces of jewelry that depict the gods, some of which functioned as miniature shrines. The Beningson collection includes a number of examples, among them earrings graced with figures of Lakshmi (cat. no. 54), rings displaying Rama's coronation (cat. nos. 36 and 37), and an armband decorated with a seated Vishnu (cat. no. 23). These pieces would have satisfied devotional needs. A seal ring repeatedly inscribed with the name "Rama" had salvific powers (cat. no. 38). A gold pendant containing figures of Shiva and Parvati in a golden arch would have functioned as a miniature shrine (cat. no. 31). In a lighter spirit, hair ornaments and combs carrying images of the seductive god Krishna, would have suggested that the wearer was a beauty in the eyes of her beloved diety (cat. nos. 43, 150, 153). Such pieces were often placed in the kinds of frames that surround

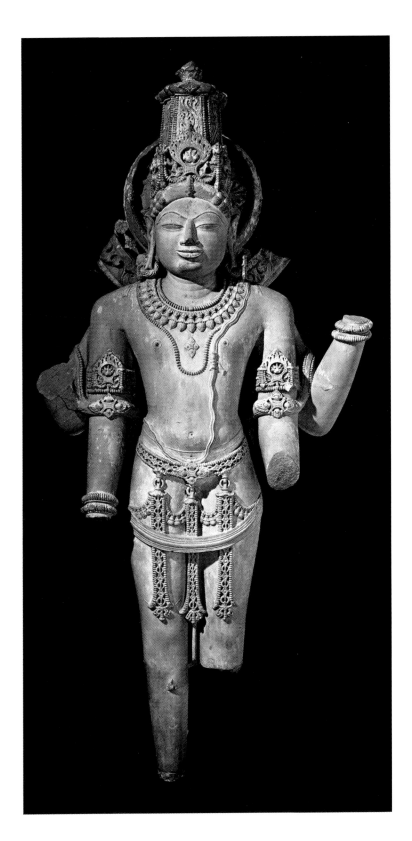

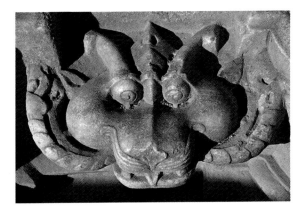

Fig. 8.
Standing Vishnu. Central India,
central-eastern Madhya Pradesh;
ca. early 11th century. Sandstone;
119.3 x 46.6 cm. Museum of Fine
Arts, Boston, David P. Kimball Fund,
25.438. Photograph © 2004 Museum
of Fine Arts, Boston.

Fig. 10.
Detail of a *kirtimukha* on a door stoop
at the Adinatha Temple, Ranakpur
(Rajasthan, India); 1377–1441. Photo
courtesy of Molly Emma Aitken.

deities on the walls of temples—in a scalloped arch (cat. no. 32), for instance, or above an arch of foliage emerging from a *kirtimukha*'s mouth (cat. no. 24). Adorned with such jewelry, the body itself becomes a temple; one is reminded of the common exhortation: to make the heart a temple and envision god within.

Clearly, jewelry in Indian culture acts as a medium for transformation. Accordingly, it too is subject to metaphoric change. Glass bangles are "silver and blue as the mountain mist";[14] the sound of toe rings makes the listener think that "swans are near"[15] and a "dark sapphire bangle [is] like a swarm of bees" crowding around a wrist.[16] Jewelry is also that to which a thing of beauty is transformed. Lips are rubies, goes a common metaphor, but such transfigurations can be quite elaborate. In Kalidasa's vision, autumn is a woman, whose ankle bells make the cries of the season's migrating geese.[17] A city is a woman in the *Manimekhalai*, an epic written around the second century. Its moats are anklets, its walls are a girdle, and its flag-festooned walls are shoulders hung with necklaces.[18]

Beyond metaphor, jewelry can virtually embody the person who wears it. It is not uncommon for early Indian writers to identify people with the jewelry they wear. Characters in the *Manimekhalai* wear their ornaments like names: the heroine is "Madhavi of the golden bracelets" and "Madhavi of the rare jewels";[19] a minor character is "Sutmati with the modest ornaments";[20] and the hero is the "Prince with the heavy ankle bracelets."[21] The beauty of jewelry can be inseparable from the beauty of its wearer, so that lovers are drawn to necklaces as well as bosoms. Keshavadasa's hero, for instance, sighs over the necklace that "charms the mind,"[22] while the Prince of the *Madhumalati* finds fulfillment from his lover's "lovely form and ornaments."[23]

JEWELRY IN LOVE

Jewelry in India is understood both as part of the wearer and apart from the wearer, hovering in the space between lovers and extending the sensual awareness of one to the other. Almost performing the role of lovers' go-between, jewelry has always been essential to the language of love. To unite lovers, a go-between fills one's ears with the other's charms, carries messages, and, at times, even enjoys the man herself, stirring up a bit of useful jealousy in the heart of his beloved. Jewelry, we find, performs all these functions as well.

Jewels could be used as tokens (or signals) passed in secret between lovers. In poetry and drama, we find men giving women rings, women addressing these rings as surrogates for their lovers, and women looking in mirror rings to catch a surreptitious look at their lovers across a room. Kalidasa's heroine, Sakuntala, received a ring from her beloved that broke a curse and reunited the lovers.[24] Radha, in a verse by the poet Bihari, used her ring to arrange a tryst:

Consenting, [she] flashed her mirrored ring at the sun and hid away her hand in the mounds of her breasts as [if] to say: "When the sun sets under the hills, lover, I will come to you."[25]

Jewelry intensifies the experience of love, enhancing its textures, weights, sounds, and movements. In sculpture and painting, necklaces accentuate bosoms, girdles emphasize hips, and earrings

dip and turn with the tilts of heads. In literature, too, jewelry emphasizes both the gestures of love and its contours. Radha's necklaces tremble, expressing her excitement, and Krishna's earrings sway, accentuating his actions. Awaiting execution, one hero remembers the sound of his beloved's bangles, made when she shook [away] bees, drawn to the scent of her hair.[26] In the *Ramayana*, it is the music of Sita's jewelry that charms Rama, even before he has seen her:

> *Hearing the tinkle of her bracelets and anklets and the bells on her girdle, Rama pondered in his heart and said to Lakshman, "It sounds as though Love were beating his drum, ambitious to vanquish the world!"*[27]

Such sounds—and Indian jewelry is noisy—can intensify sexual moments to the point of awkwardness, broadcasting furtive encounters. Heroines are often admonished to remove their anklets before trysting with their lovers lest others hear them sneaking through the night. It is also commonplace in Indian literature for anklets to ring when a woman takes the bottom position in sex; girdles ring when she is on top. Jewelry thus often betrays love making, as in this wedding song:

> *As I clamber on the bed, my anklets tinkle, the mother-in-law and her daughter lurk about.*[28]

A female author of the sixteenth century pleads with her husband in a similar vein:

> *Your brothers' wives are yet awake, watching through chinks in the wattled wall, listening to our clothes rustle, to my jewelry tinkle, waiting to tease us, to make their jokes in the morning, so no more tonight, I beg.*[29]

Jewelry comes alive in the jealous eyes of men who envy its proximity to women's bodies. One poet writes:

> *O nose-ring pearl . . . though you come from the lowly oyster, you can dauntlessly caress those lips of hers which I, despite my noble birth [cannot] kiss even once.*[30]

Another spins even greater convolutions, suggesting that a string of pearls, which are thought to grow in the heads of elephants and make them mad, is enjoying a "too-sweet atonement for its sins" by lying on the "delicious breasts" of his beloved.[31]

Above all, jewelry expresses states of mind. When her man is away, a woman tosses aside her ornaments and grieves in the plainest garb. Or her jewelry falls loose on her flesh, as she wastes away in his absence:

> *Look, my bangles slip loose as he leaves, grow tight as he returns, and give me away.*[32]

In the eyes of a spurned lover, a well-dressed woman seems to adorn herself for another man. Likewise, an educated man should know that a courtesan who dresses carefully may mean yes when she says no.[33] Kalidasa writes of his heroine, Sakuntala:

> *Bracelets of plaited lotus-fibre, bright as moonbeams, now turning brown, speak of the fever [love], unendurable, coursing like fire through her limbs.*[34]

Jewelry that is falling off or worn awry indicates a woman crazy with love. The *abhisarika nayika* (a type of heroine in Indian literature), who rushes into the night to meet her lover, braves wild animals, demons, and storms and trails jewelry in her path. Her anklets fall without her noticing, replaced by snakes that curl around her legs. Other heroines adorn themselves in irrational ways, showing their minds to be addled with love. A lovesick woman in the *Rasikapriya* places her garland around her waist, her girdle around her neck, her toe rings on her fingers, and her bracelets around her ankles.[35] Ultimately, however, it is the passionate embrace that wreaks the greatest havoc on a woman's jewels. As one marriage poem goes:

> *Torn are my silk slips, broken my pearl necklace, sprained my frail wrists, but I feel no pain. I lose my nose-ring and my jeweled pin, and as he struggles with me I sweat the whole night . . . all my sixteen points, my husband has spoiled.*[36]

JEWELRY IN SOCIETY

Jewelry in love is jewelry chosen and embraced. Lovers manipulate ornaments to convey meanings to one another or read ornaments to learn the secrets of the heart. Underlying this image of jewelry, however, is a less romantic reality: most jewelry is worn according to society's dictates. Traditionally, Indians have had little control over the kinds of clothes or jewels they wear, though specific pieces within a genre may have reflected personal taste.[37] At skin level, Indian society still codes people with the marks of status, caste, regional origins, and marital affiliation.

In painting, dress, not expressions or marks of character, defined people for the viewing public. Seventeenth- to nineteenth-century portraits meticulously reproduced the clothes and jewelry worn by their subjects, and documents from the period suggest that viewers would have paid close attention to adornment in portraits. A 1765 description of a portrait, taken from the pages of a royal paintings inventory, reads:

> *Maharaja Dhiraja Maharaja ji Shri Savai Madho Singh ji* [the ruler] *wears Farruksiyari dress, silver jewelry, a silver head ornament, a turban ornament shaped like a feather, a pearl necklace and an armband.*[38]

The source is a bit of official bureaucratic paperwork, hastily written. Yet it was not enough to say the painting showed the king on his horse, any more than it sufficed to name the king without the full complement of his titles. In portraits such as these, titles and dress were akin; both were expressions of position and, thus, identity.

What a king (or any member of Indian society) wears carries a wide range of meanings. On the crudest level, jewelry signifies status and class. Royalty wore the most lavish and expensively crafted jewelry, while a village beauty in an eighteenth-century Pahari painting adorned herself with a silver amulet and a flower garland (fig. 11).[39] Among villagers, the poorest women own very few pieces of jewelry, while those better off may sport twenty pounds of jewelry, most of it silver.[40] Yet more is not always a sign of social elevation. Today, an urban woman of the upper classes is likely to wear a few simple pieces of jewelry, while gypsy women and many

villagers wear chunky silver, mirrors, and colored glass on almost every inch of their bodies. Silver is considered more humble than gold, but gold does not necessarily express the highest refinement. Because gold was considered a sacred substance, only royalty was permitted to wear it on the feet. But as one princess archly declared:

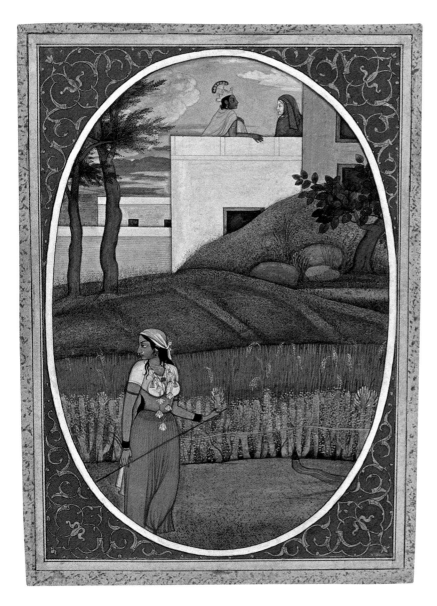

We never wore full gold bangles on our wrists, only pearl ones. It was our servants and courtiers' wives who wore gold jewellery.[41]

Indian jewelry can convey far more than status. Some designs indicate regional origins, such as the M-shaped matrimonial pendant (*tali*) of Tamil women (cat. nos. 105–109, 111, 112).[42] Other designs signify caste. Bharwad women wear studded gold collars,[43] for example, while Thakur women of Central India favor a silver ornament on the head (*rikri*).[44] Emblems of dynastic affiliation are also found on jewelry. The Cholas of South India wore jewelry imitating orchid leaves, a symbol of their dynasty,[45] and the double-crested eagle identifies several pieces in the Beningson collection with the Mysore royal family (cat. nos. 101, 138, 149). Finally, jewelry can display religious affiliations. Some of the earliest extant pieces of Indian jewelry bear the Buddhist three jewels (*triratna*) symbol. Susan Stronge has noted the differences between Hindu and Muslim jewelry worn by women in sixteenth-century paintings.[46] Today, marriage *talis* in the south often bear Shaivite and Vaishnavite sectarian marks (cat. nos. 106, 107), even crosses for Christian wearers (cat. no.

108),[47] while the *jhumar*, most often worn at weddings, is specific to Muslim brides.

Jewelry can also express allegiance to a religious community. Members of certain sects adopt distinctive ornaments. The Naths, a Shaivite group of yogis, wear hollow, round, earplugs, and temple priests (*gosains*) from the pilgrimage town of Nathdvara wear silver toe rings and gold hoop earrings hung with two pearls and a gem.[48] The Mughal emperor Jahangir (1605–1627) writes in his memoirs about his own adoption of a pearl in each ear, a fashion among Sufis of the Chhisthi order. For Jahangir, this was a gesture of allegiance to the Sufis, but it was soon picked up by his nobles and then even by commoners as a way of showing loyalty to the emperor.[49]

In each of these examples, jewelry expresses relationships—political, social, and individual. Indeed, it can be argued that all jewelry in India is ultimately about relationships. Recognizing this, Indians have often employed jewelry, strategically, to make distinctions among each other.

COURT JEWELRY

An Indian king's jewelry expressed his wealth and power. It helped create the effect of glory, making him, literally, the brightest person in a room. The most powerful kings wore unique and sometimes famous pieces that were inaccessible to lesser nobles or rulers. Jahangir boasted of a ring carved from a single ruby, given to him as a gift:

> *Until today, no such ring had ever been heard of as coming into the possession of any ruler.*[50]

Following Persian practice, the Mughals inscribed their names on the surface of prized gems, immortalizing their ownership to posterity. A large spinel from the Al-Sabah collection, for instance, bears six names, including the Mughal rulers Jahangir, Shah Jahan (1628–1658), and Aurangzeb (1658–1710).[51] Such inscriptions subtracted from the pristine surface of a gem, and yet they also increased its value by placing subsequent owners in an exalted line of possession. To inscribe a jewel was to recognize that one's name shone brighter than the gem itself.

Jewelry gave visual distinction to court hierarchies. Paintings of Jahangir and Shah Jahan, such as the illustrations of Shah Jahan's *Padshahnama*,[52] demonstrate the yoking of jewelry to status. These paintings show the nobility wearing only a few pieces of jewelry, while they picture the emperor and his sons dressed in double-stranded pearl necklaces, with pearl tassels at their waists, a string of pearls around their turbans, and a black feather aigrette, three of its strands

Fig. 12.
Detail of Maharao Ram Singh II Listening to Music in a Garden; ca. 1850. Collection: Jagdish and Kamla Mittal Museum of Indian Art, Hyderabad; 76.157.

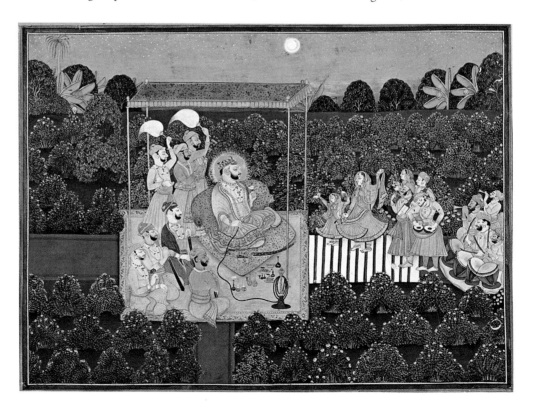

tipped with pearls. Mughal sumptuary laws rendered many of these ornaments a royal prerogative: only the emperor and his immediate family could wear the aigrette, for instance, and a noble would face dire consequences for showing up in court in a double strand of pearls.

Rulers often used jewelry, along with dress, to give a cohesive appearance to their courts. The use of jewelry to show affiliation, rather than to mark distinction, was a more common feature of Rajput courts. A warrior caste, the Rajputs were organized by clan. Though their post-sixteenth-century rulers modeled themselves on Mughal emperors, they were technically understood to be "chief among equals." Some took the double strand of pearls as their royal prerogative, but Rajput court dress also emphasized clan fraternity. Rulers and their courtiers tied their turbans in an identical fashion, often wore the same color and sometimes the same jewelry. One painting (fig. 12), for instance, shows Maharao Ram Singh II (1827–1866) and his court wearing seasonal pink with nearly identical earrings and necklaces.

If dress was a part of sovereignty, then dressing was an official duty. Indeed, for Indian rulers it was a public performance. At Hindu courts, high-ranking officials dressed kings in ceremonies that expressed a people's devotion through service to its ruler. The dressing of the king paralleled the dressing of a deity, a parallel that was not only intentional but also significant, for the Indian king was divine, having a hold on cosmic order. A Tamil ballad describes this dressing:

One [attendant] puts . . . the round forehead mark [on 'the great king'], another paints his eyes with collyrium.[53]

On nonfestival days, as well, the king's dressing was a significant and semipublic occasion. An early nineteenth-century Rajasthani painting shows a bare-chested ruler in his chambers (fig. 13). The king ties his own turban, but a full complement of nobility participates in the act: one holds a mirror, another a gold plate bearing pieces of jewelry. The painting itself makes the moment more public. Joanne Waghorne, who writes of kingship in the South Indian kingdom of Pudukottai, describes this "dressing" as the "primary ritual act of court." She notes that the word for the king seated in state literally means "fully ornamented," and argues that the dynastic legends of Pudukottai "likened the acquisition of royal status to a slow process of getting dressed, becoming ornamented with the visible signs of kingship."[54]

Fig. 13.
Maharana Bhim Singh of Udaipur (r. 1778–1828) Prepares for the Teej (Swing) Festival. India, Rajasthan, Mewar, Udaipur; ca. 1805–10. Attributed to Chokha. Los Angeles County Museum of Art, Gift of Paul F. Walter in memory of Mark Kaminski; AC1993.191.2. Photograph © 2004 Museum Associates/LACMA

Yet much of a ruler's jewelry was officially owned by the state and could not be sold or given away. State jewelry, which the people called "ours," included jewelry for the king, male and female family members, and even servants. The *jananis*, for instance, were maidservants whom female family members sent to another court to investigate a prospective bride. For the occasion, they wore extensive sets of state jewelry (*valna*), which they returned to the treasury when their journeys were complete.[55] Even for the aristocracy, there was not the pleasure of choice in state jewelry. Charles Allen quotes a princess from Baroda:

> There was no "I'd like this" or "I'll wear that." You had to wear all these things from the Jamdar Khana [treasury] according to turn; one group of earrings, necklace and bangles one evening, the next evening another set. Then after dinner you removed your jewellery and next morning the maid took it back to the Jamdar.[56]

If the gift of jewelry to a subject or lesser ruler expressed an "incorporation" into the king's sovereign mantle, then the fact that state jewelry belonged, in some sense, to the people, reciprocally enfolded the king into the public's mantle, recalling his duty as body politic.

A lot of jewelry at courts circulated as gifts. Jahangir's memoirs describe the many rings, necklaces, gems, aigrettes (and the like) that were presented to him; a gift was a prerequisite for audience at the Mughal court. Rulers also presented copious gifts to their subjects, often to denote an elevation of status. Throughout India, gold was associated with royalty, and, as previously noted, only aristocrats could wear gold on their feet. The king gave gold anklets to privileged nobles, to his wives, and to his most cherished courtesans, the *pardayats*, who enjoyed wifelike status. By offering such symbols of status as gifts, rulers effectively signified that status was theirs to give and that they were the source of power. In a similar gesture, rulers weighed themselves in gold and gems, which they distributed to their subjects.[57] This custom made an equation between royal flesh and gifts, suggesting that prosperity was a part of the king's body, to be shared with his people. Giving of the sovereign body was a theme with the robe of honor (*khilat* or *sir o pau*), as well. The robe of honor, which generally included a necklace, was presented to favored courtiers, to someone whom the king had defeated, or to a subordinate ruler upon his accession to the throne. The gift indicated that the recipient ruled under the king's sovereign's mantle. Symbolically, according to Bernard Cohn, the robe of honor incorporated the recipient into the ruler's body, for it was initially a robe removed from the king's back and imbued with his physical touch.[58]

DIVINE JEWELRY

In India, there are striking and purposeful parallels between the use of jewelry at royal courts and its deployment at temples; this is because of the close relationship that subsisted between kings and deities. Many Hindu kings were considered either manifestations of a god or regents ruling on behalf of a god.[59] Rituals drew further parallels between gods and kings, sanctifying the latter. Both deities and kings were honored through service, such as fanning, adorning, and entertaining. Both offered sight (*darshan*) to devotees/subjects. In addition, by the eighteenth century many temples were modeled on palaces, and some of their rituals reflected court practices.

Conversely, palaces had long been built in proximity to or on a cardinal alignment with temples.

Jewelry was, moreover, used to establish relationships between kings and gods. A passage from the travelogue of the sixteenth-century Portuguese visitor to Vijayanagara, Domingos Paes, illustrates the strategic relationships established between deities and rulers in that empire and describes the gold, gems, and jewelry used to glorify and link the two. Paes wrote that the king sat on the edge of a dais, before an idol who was enthroned on a jeweled, lion-footed throne (kings also sat on lion-footed thrones). The idol was "of gold" and flanked by a jeweled crown and anklet. Of its headdress, Paes wrote:

> [It was] all full of pearls and rubies and all other precious stones, and on the top of it [was] a pearl as large as a nut, which is not quite round . . . [T]he anklet . . . another state jewel . . . [was] full of large pearls and of many rubies, emeralds, and diamonds and other stones of value; it [was] of the thickness of a man's arm.[60]

Paes described these pieces as "state jewels," but they were probably gifts that the king had presented to the idol. Because the idol resided within the palace complex (further linking king and god), the gift remained, in a sense, under palace control and may also have been considered "state."

Lavish ornaments were presented to both kings and gods. Like royal treasuries, temples were the repositories of vast wealth in gold and gems, much of it in the form of jewelry—like the jewelry Paes described—that had been given to deities over the centuries by wealthy devotees. Some jewelry was made for specific idols. Several spectacular examples in the Beningson collection include an enamel crown for a Krishna (fig. 14), jeweled sandals (fig. 15), and a large gold armband for an image of Vishnu (fig. 16). Other temple jewelry was made for mortal wearers and only later donated to a deity (see, for instance, cat. no. 22). As we have seen, the act of adornment in both palaces and temples was—and still is—a ritual, public act. Indeed, in many places, it was the king's right to adorn the deity, so that service to him was translated, through him, as service to the state deity.

The gift of jewelry to the gods brings great merit to the one who gives:

> Those who spend all that they can to adorn the God of Gods with unsurpassed shining ornaments of gold and magnificent ornaments made from jewels gain a fruit so great that none but Vishnu even knows what it is.[61]

Such gifts feature in devotional songs, such as one to the goddess Sitala Mata that promises a pendant for her forehead and a jewel for her forehead ornament.[62]

Temple inscriptions also record these gifts. A Chola bronze of Uma, for example, was given two crowns, a garland, a pendant, three sets of earrings, a beaded string for her *tali*, three necklaces, a pair of armlets, two sets of bracelets, two sets of anklets, and a set of toe rings.[63] Some of this jewelry would have been made for a deity; other pieces were simply gifts. Some experts have also proposed that jewelry lacking adornment on its underside was intended for temples. This may be the case for a pair of necklaces in the Beningson collection (cat. nos. 22, 87), but it does not prove to be a hard and fast rule.

For the gods, jewelry has often served an iconographic purpose. Some river goddesses wear armbands decorated with watery designs, while a group of fierce, feared goddesses (*yoginis*), wear appropriately terrifying jewelry: owl earrings, skull garlands, and snake or lion-faced armbands. The Great Goddess, in her terrifying form, becomes the inverse of her manifestation as Shiva's beautiful wife: in place of a serene smile, luxuriant coif, and glittering jewelry, she grows fangs, sprouts thick, tangled hair, and wears garlands of skulls or intestines. Though Bodhisattvas are Buddhist saviors unattached to material things, they are distinguished from Buddhas by the fact that they wear jewelry, a sign that they have remained in the world to help others (fig. 17).

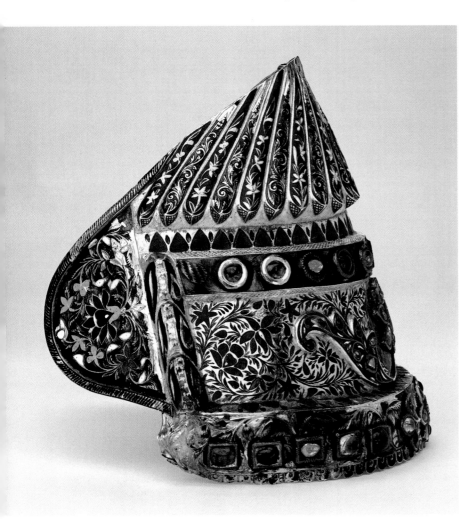

Fig. 14.
Gold crown for the image of a deity, enameled and set with rubies, emeralds, and diamonds. Central India; late 18th or early 19th century. Susan L. Beningson Collection; cat. no. 16.

Krishna and the humble villagers with whom he lived presumably wore the simplest of jewelry. Yet miniaturists depict them in pearls and gold to indicate their sacred status. Theirs is conceptual ornamentation, signifying an extra-narrative honor rather than objects literally worn in the story.

According to the sacred Hindu texts, jewels are literally considered "accessory limbs" for a deity, like the limbs that a priest may attach to an icon when he decorates it. Together with bathing, anointing, feeding, and otherwise serving a deity, decoration (*alankaram*) is part of worship (*puja*). The anthropologist Anthony Good wrote:

Etymologically, alankaram *conveys ideas of adequacy, completeness, and making ready; it is not mere decoration, but a means of imbuing the image with form and strength. Finery is thus an integral part of the deity, not an optional extra.*[65]

Because jewelry is intrinsic to divinity, deities appear fully adorned to their worshipers. Though temple priests drape an icon in rich clothes, jewelry, and garlands, a sculptor always carves (or paints) adornment directly onto an icon's figure. The *Chitrasutra*, a fifth-century painters' treatise, prescribed a celestial's ornaments as follows:

[Celestials] should be always beaming in their countenance, almost smiling in their looks, adorned with crown, earrings, necklets, armlets and bracelets. . . . They should wear auspicious flower garlands, large waist cords, anklets and ornaments for the feet.[66]

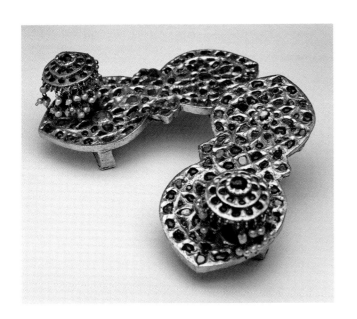

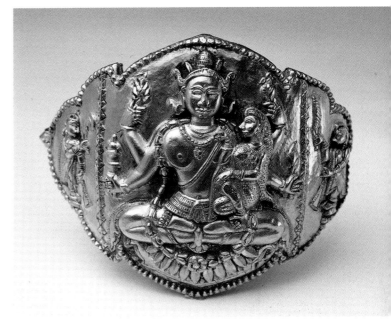

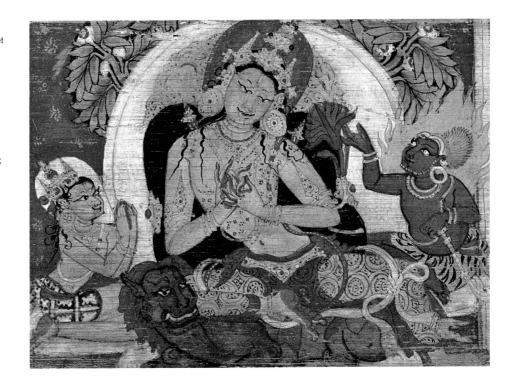

Fig. 15.
Sandals for a deity (*padukas*) of sheet
gold over lac, set with rubies, emer-
alds, and diamonds and hung with
pearls. Deccan; 17th–18th century.
Susan L. Beningson Collection;
cat. no. 19.

Fig. 16.
Armband of gold around a lac core,
for the image of a deity. Central India;
17th to early 18th century. Susan L.
Beningson Collection; cat. no. 23.

Fig. 17.
Detail of Bodhisattva Manjushri from
Five of the Leaves from an
Ashtasahasrika Prajnaparamita
Manuscript. India, Bihar, Nalanda
monastery; Pala period, about 1073.
Mr. and Mrs. John D. Rockefeller 3rd
Collection, 1987.001. Photo by Carl
Nardiello.

Temple jewelry was meant to be worn. It is believed that an icon's power increases when it is more splendidly dressed, and wealthy devotees pay to obtain a private viewing of a deity in his or her richest jewelry.[67] A deity's jewels, like a woman's, were an essential part of its beauty and symbolized its purity, power, and sacredness. Hindu deities take on forms for the sake of their worshipers, to make themselves accessible to mortal imagination. Jewelry is as intrinsic to these forms as multiple arms or perfect proportions. The *Devi Mahatyma*, a hymn to the Great Goddess, describes the male gods creating her from their fiery energies (*tejas*) and the minor gods completing her with their gifts. While Kubera created her nose and Agni her three eyes, for example, the Sea of Milk presented her with:

> *A flawless necklace and two unaging garments, a heavenly crest-jewel, two earrings and bracelets, a heavenly half-moon [ornament], armlets on all her arms, two spotless anklets, likewise a neck ornament without parallel, and bejeweled rings on all her fingers.[68]*

The temple is considered a mirror of the cosmos, and jewelry in temple sculpture typically reflects real social hierarchies—or, at least, *desired* social hierarchies. At the top of the hierarchy, deities—and the temples and accoutrements of worship that, in a real sense, clothe them—are richly adorned. In South India, in particular, kings and queens were rendered almost indistinguishable from deities, in an effort to blur the lines between royalty and divinity. However, saints and donors often stood out, by contrast, in the comparative simplicity of their adornment. Chola renditions of Saint Manikkavachakar show him in nothing more than a loin cloth and a sacred thread, his pendulous ear lobes empty of earrings. A tenth-century Chola bronze of a Shaivite devotee imagines her in a simple skirt, wearing a humble necklace with a pair of unadorned balls in her ears (fig. 18).[69]

Gold and jewels have affinities to the sun, moon, and planets and help focus celestial influences on the mortal realm. Deities are often associated with precious metals and stones, and the heavens are conceived to radiate with gemstone light. Even in Buddhism:

> *Buddha-lands [are] adorned with every precious thing, many-hued with lapis lazuli and crystal.[70]*

Thus, the temple, which shapes passage from the everyday to the transcendent realms, must convey the sensual pleasures of paradise. To delight the gods, it must be redolent with sweet smells, sounds and sights; its pleasures must include the glitter of gold vessels, thrones, bells, and jewelry. With imaginative exaggeration intended to glorify a temple, a twelfth-century poet praised its interior as a crush of ubiquitous wealth:

> *People jostled against each other, and as they rubbed chests, sparkling jewels fell from their long pearl necklaces. The floor became studded with these gems and pearls as if with tiny stones, and as they tried to step over them so as not to hurt their feet, people seemed to break into dance with every single step.[71]*

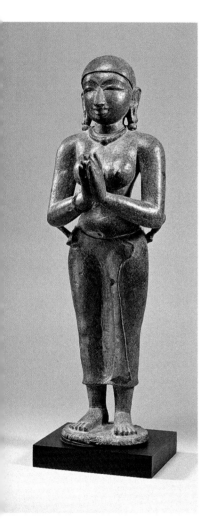

Fig. 18.
Shaiva Devotee. Chola period, ca. 980. Bronze; 38.1 cm height. Collection of Zina and Ernest Stern, New York. Photo courtesy of Zina Stern.

WEDDING JEWELRY

It is human weddings, not divine weddings nor temple giving, that primarily support jewelers in India. More than six billion dollars are spent in India on weddings each year, and it is thought that more than half of this is spent on jewelry. So crucial is jewelry to weddings (and vice versa), goldsmiths can face hard times when India's astrologers deem a year unsuitable for weddings.[72]

From earliest times, jewelry has been considered a blessing in India. The ancient Indian hymn, the *Ṛgveda*, understood jewelry to be the essence of good fortune:

May all the divinities secure to us a life rich with gold earrings and a jeweled necklace![73]

During times of transition, such as birth, adolescence, marriage, and widowhood, people are considered particularly vulnerable to evil influences, and jewelry's associations with good fortune and the blessings of the gods make it a vital part of Indian rites of passage. Many women wear special jewelry for a protective rite in the sixth or seventh month of pregnancy;[74] Tamil women drape gold amulets on their babies at their cradling ceremonies;[75] boys and girls have their ears pierced in their first year to "denote entry into this world and as protection against disease";[76] and Nayar girls wear heirloom jewelry to celebrate the onset of their menstruation.[77]

Marriage is a girl's initiation into womanhood, her entry into sexuality. Traditionally, it is during a wedding that a woman wears bright colors and expensive jewelry for the first time. From this day forward, she will enjoy more brilliant colors, a larger wardrobe, and far more jewelry, much of it symbolizing her married state. She will model herself on Lakshmi, the goddess of wealth, in the belief that her adornment will bring prosperity to her home. Yet, it is at this same time that many Indian women begin to conceal themselves from the public, drawing a veil over their newly expressed charms and even remaining in the home.[78] Female sexuality in India is regarded as highly potent; it is guarded, channeled, and regulated, even as it is celebrated and revered.

Whether in temples, courts, cities, or villages, weddings are an occasion for some of the most splendid displays of jewelry and wealth. The weddings of the gods closely parallel those of people, particularly of Brahmins. Like a human couple, a god and goddess exchange garlands and circle the sacred fire. In the south, at one Murukan temple, the god receives a dowry of silver ornaments from the goddess and, by way of the priest, places a *tali* pendant around her neck.[79] These customs reflect human practice. But human weddings reciprocally treat grooms and brides like gods and goddesses, placing them on a throne, anointing, feeding, and adorning them. Such *puja*-like rituals turn weddings into "acts of worship."[80]

As in the romantic love described by poets, so too in marriage, jewelry and adornment express a woman's relationship to her mate. Among orthodox Hindus, a woman is expected to worship her husband. For her, marriage is an initiation rite, like that of a practitioner entering into a sacred path. Her marital jewelry is understood to symbolize her path, and her *tali* is considered akin to her husband's "sacred thread."[81] Certain of her adornments convey specific

meanings. Her turmeric and perfume show that she is not menstruating but sexually available to her husband. Her collyrium indicates that her husband is not away, for it is not to be worn in his absence. And her marriage jewelry—bangles, toe rings, and a *tali*—show that her husband is alive, maintained by her virtuous devotion to him.[82] Such rules are not fixed, however. The author of the *Kama Sutra* (and presumably his contemporaries) expected all marital adornments to be removed during a husband's absence:

> When her husband departs on a journey abroad, she removes the married woman's marks and her jewels, dedicates herself to devotion and looks after the house according to the rules established by her husband.[83]

Vatsyayana's remarks suggest that marriage jewelry during the fifth century was a sign more of a husband's presence than that a woman was married.

As one delves into the intricacies of marriage jewelry, it can seem that jewelry for wives was all rule and no play. However, a strange edict from an eighteenth-century Sanskrit text on morality prohibited married women from wearing heavy earrings during love play.[84] This reminds us that the jewelry of poetry did intersect with the jewelry of marriage. After all, what is prohibited usually reflects what is practiced.

These days, the process of adornment in a wedding often begins with the engagement. Possibly inspired by Western weddings, an exchange of gold rings is now a common ritual on the engagement day (*misri*). The rings are to be worn on the fourth finger that, according to one popular belief, contains a vein leading directly to the heart. Diamond engagement rings have also become common, and wedding websites urge the groom to purchase one for his bride. "The most special gift of love that a woman can receive is a diamond," urges www.modernshaadi.com. Traditionally, however, it is on the wedding day that jewelry becomes most important for it is then that a woman begins to wear the jewelry that she will wear for the rest of her married life. Depending upon her religion and community, this jewelry will include a marriage pendant (either a *tali* or a *mangalsutra*), nose ring, toe rings, bracelets, anklets, and a forehead pendant (*tikka*).

Much of the jewelry a bride wears on her wedding day is given to her by her own family. Some of it is new, while other pieces may be handed down to her by her mother or grandmother. Many older women choose to ornament themselves less extensively in their advancing years and use the occasion of a wedding to give some of their jewelry away. Pieces are also given to the bride by the groom's family. In a Tamil Chettiar wedding, the exchanges are fairly complex. The groom's family provides some of the gold for the bride's *tali*. The bride's family uses the gold to have the *tali* made to the bride's taste, and then the groom comes to the bride's family to receive it back. Finally, on the wedding day, the groom puts the *tali* around his bride's neck. Among the Chettiars, the central ornament on the *tali* (*tirumangalyam*) is considered the groom's.[85] However, the rest of the *tali* and the other jewelry a woman receives on her wedding day are considered hers to keep, should her husband die or the marriage fail. As one girl said:

If I am not given my gold jewelry, I have nothing if my husband throws me out.[86]

Yet pressure is sometimes put on a woman to pawn or sell her jewelry in the event of a family emergency. Dowry agreements sometimes specify the total weight of precious metals to be given a woman as jewelry,[87] and, increasingly, jewelry is regarded—contrary to custom—as a part of the dowry.

During her wedding, a woman wears most of her new jewelry, in addition to flower garlands, voluminous clothes, and veils. Jacobson describes the appearance of a Thakur bride she had seen on her way to her new home:

> [She was] *wearing, in addition to a massively full skirt, sari and cover—all veil, four heavy head ornaments, three sets of clanking anklets, rings on her ears, fingers and toes, several necklaces, a chain belt and on each arm seven heavy silver bracelets reaching almost to the elbow.*[88]

A Western author, at the wedding of a Brahmin friend, described the bride as:

> [Looking] *like nothing but a bundle of veils wrapped one round another, the pinnacle being completed by a gold tiara.*[89]

The rites leading up to this moment (and the jewelry involved) vary considerably from one community to the next. Different religious groups, castes, and regions understand different pieces of jewelry to symbolize the happily married woman (*sumangali*).

Throughout India, one of the most symbolically important pieces of jewelry has traditionally been the bangle. In the past, the bangle was not just the symbol of wifely virtue, but it also served as a representation of the virtuous wife herself. Thus, women who immolate themselves on their husbands' funeral pyres (*satis*), were memorialized on stone reliefs as hands wearing bangles.[90] Worn by unmarried women and even men, bangles are not the exclusive prerogative of wives, but custom strongly associates them with marriage. In Rajasthan and Gujarat, married women wear bone bracelets up to their underarms, while adolescent girls wear bone only to their elbows. Women in some Punjabi communities wear ivory bangles (now lac or plastic) for the first three to six months of marriage. Too heavy for housework, these are removed before the women undertake household duties. Glass bangles surpass gold in their symbolic weight: throughout India, it is customary for new widows to smash their glass bangles, while queens in some parts of India are said to have continued wearing gold bangles even after they were widowed.[91]

Though the bangle was the wife's most significant ornament in earlier times and is still a primary symbol of marriage in West India, in many parts of the country bangles have been surpassed in importance by the *tali*. Interestingly, though some Vedic texts mention a thread that should be tied around the bride's wrist, none mentions the tying of a *tali* (nor a *mangalsutra*).[92] The custom seems to have become common in around the eleventh century,[93] and today it forms the centerpiece of many marriage rituals, just preceding the couple's seven steps around the

sacred fire. Marriage necklaces come in a wide variety of forms. Some imitate the hoods of cobras, some represent sectarian affiliations, some are simple circles (or conjoined circles), and some string together emblems of auspiciousness, such as vegetables and fruits. Many function as amulets, containing sacred mantras.

The term *mangalsutra* is easy to translate; it simply means "auspicious thread." However, a surprising number of both authoritative and popular definitions of *tali* disagree with one another. Vidya Dehejia traces the word *tali* to the word *taludal* meaning "that which is suspended."[94] Untracht understands *tali* to come from the vernacular name for the *palmyra* palm.[95] At the same time, an Indian marriage website gives us a glimpse of popular interpretations, suggesting that *tali* derives from the two syllables "tha" and "ni" representing a Tamil phrase that means "you and I are not separate. We are in this together."[96]

Equally divergent are attempts to explain the form of the most common Tamil *tali* (see cat. nos. 105–107), often described as M-shaped. One scholar illustrated the Tamil *tali* upside-down and described it as looking like a buffalo mask, while admitting that "*thali* [*sic*] have been interpreted in every possible way."[97] Usha Bala Krishnan speaks of tiger claws as the model for the *tali's* distinctive shape,[98] and Untracht describes the form as that of an "anthropomorphic male."[99] Michel Postel suggests that the *tali* may derive from the taurine, an ancient fertility sym-

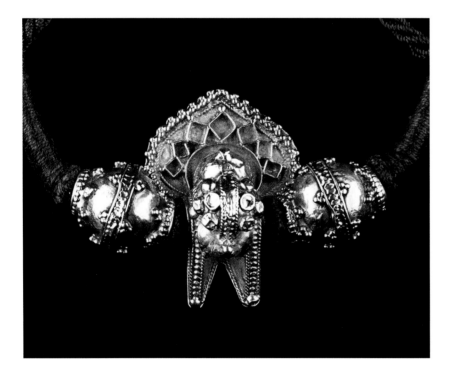

bol (*nandipada* in Hindi) that was associated with the Great Goddess and sometimes anthropomorphized. He interprets the form as having two legs, and views the V shape between the legs as genitals.[100] Finally, a few jewelers have given a peacocklike aspect to the *tali*, turning its round top into a tail fan (fig. 19). This last treatment is in keeping with marriage fashions that favor the peacock as a decorative motif.

As for the intrinsic meanings of the *tali*, one website promoting contemporary Hinduism speaks of it as "representative of the husband himself," with the power to:

[Ward] *off any negativity attracted to the husband and to assure his long life and well-being.*[101]

Fig. 19.
Gold *tali*. Tamil Nadu, 18th century. Susan L. Beningson Collection; cat. no. 107.

A 1988 article interprets the *tali* similarly as:

Associated with male power . . . a protective amulet and a symbol of the male's responsibility for the family's well-being.[102]

One anthropologist links the *tali* with the sacred thread: the *tali* and the sacred thread "do not merely symbolize the wearer's status, but constitute it."[103] For the Nambutiris, however, the *tali* turns the bride into "the gift of a virgin."[104]

Rituals for tying the *tali* also vary extensively. Many of these rituals are described in a fascinating array of websites that have sprung up on the Internet.[105] Designed primarily to explain and promote Indian rituals to India's expatriate community (and often to sell relevant products), these websites offer a cross-section of current popular beliefs and practices. The accounts that they provide are far richer than the comparatively monocular descriptions of wedding practices found in academic books. While a general survey finds it common for the groom to put the *tali* on his bride and for the tying to be accompanied by music or ululation (to ward off inauspicious sounds), in most respects, *tali* customs differ from place to place.

In some communities, the bride sits on her father's lap while the *tali* is tied;[106] in others, she stands. In parts of South India, the groom's sister helps to tie the *tali*: depending on her community, she may tie the second knot, or the last two knots, or even the first knot, with the groom, her brother, tying the others.[107] In some Malayalam weddings, the bride's father performs a *tali puja* and then sends the *tali* around the room on a platter. Guests place money on the platter, the total of which exceeds the cost of the *tali*. Their donations express their collective share in the financial burden of the wedding.[108] Alternatively, some couples adhere to the older practice of tying a simple yellow ribbon around the bride's neck. As one website dictates, such a *mangalsutra* should be replaced with one or two permanent gold ones after three months: one for a younger daughter and two for an eldest daughter.[109] (Surely, we see here the influence of commerce on wedding customs.) Yet another site speaks of a Tamil rite in which the bride's head is crowned by a ring of grass covered with a yoke; the *tali* is placed over the opening in the yoke, water is poured through the opening, and a chant is sung as follows:

> *Let this gold multiply your wealth, let this water purify your married life, and may your prosperity increase. Offer yourself to your husband.*[110]

The bride, looking east, may also sit on a sheaf of grain-laden hay, while her groom, facing west, ties a *mangalsutra* around her neck.[111]

An interesting feature of the *tali's* history and function in India is its role in puberty ceremonies. Among the Chettiars, pieces of the weighty necklace are given to a girl when she reaches puberty. The Nayars, who are matriarchal (and do not observe weddings in the same manner in which most Indians do), hold a *tali*-tying ceremony just before a girl reaches puberty. At this time, the girl is sequestered with a chosen mate (here called her *tali*-tier), with whom she may or may not make love. Following the ceremony, she is regarded as an adult woman and may then accept other mates from her caste or from higher castes. Though she will observe death rites when her *tali*-tier dies, the two bear no other obligation to one another following this initial ceremony. For the Nayar bride, then, the *tali* is associated with her entrance into sexuality rather than with marriage.[112]

Unlike court jewelry, the *tali* derives from ancient, related but distinct traditions whose origins are now mostly unknown. It is among the most symbolic looking piece of jewelry that Indians wear. Whether round, M-, cone-, or finger-shaped, the *tali* tends to look like an amulet. So precise and distinct are *tali* forms, they seem to demand equally precise and distinct definitions. In fact, the variety of meanings provided by scholars and wearers prove that original meanings are, for now, lost. Yet current definitions are not wrong, for they are accepted in practice and inform us of people's feelings about what they wear. What we have now for the *tali* are meanings informed by designs, that is, interpretations after the fact, rather than designs informed by meanings.

This proliferation of meanings is partly driven by the importance of the *tali* in a woman's life. Women often turn to marriage jewelry at times of crises. One woman, sorely taxed by her husband's infidelities, speaks of her resolve to remain a good wife:

> *I, too, touch his feet and pray that my* tali *stays around my neck till the day I die.*[113]

Another woman, less patient, throws her *tali* off when her husband beats her, and is persuaded to don it again only at the urging of her female neighbors.[114] Alternatively, the lawyer of a husband, petitioning for divorce on the grounds of mental cruelty, states that the man's wife:

> *Took out her* mangalsutra *and threw it at the appellant and walked out of her marital home.*[115]

Given the significance of this piece of jewelry, in particular, it is not surprising to read in the Indian papers of the "consternation" among married women that ensued when the *mangalsutra* of the goddess enshrined at the Tiruchanoor temple slipped from her neck. The article states:

> *On Monday, January 29, when the news of what . . . happened in Tiruchanoor broke, hundreds of women rushed to get yellow threads to tie around their necks, in a feverish attempt to ward off ill effects.*[116]

The *tali* is the high point of a wedding, but other pieces of jewelry also feature in the three days customarily devoted to the wedding ceremony. A groom may place toe rings on the bride's feet[117] or, in some places, his brother may do it.[118] The bride's brother may put a ring on the groom's finger.[119] During Chettiar weddings, the groom wears a string of gold pendants (*mangaliyam*) and the bride may be adorned in gold chains after receiving a ritual bath. The Nadar groom also wears a *mangaliyam*, made with gold provided by his sister(s).[120] In a ceremony designed to help introduce the couple to one another, the Rajputs have the two search, while blindfolded, for rings in a bowl of milk. Among the Marwaris, the groom's family brings the bride a suit of wedding clothes and jewelry, traditionally of uncut diamonds set in gold,[121] and the mother-in-law places bangles on the bride's wrists.[122]

JEWELRY AND WOMEN'S IDENTITY

For Hindu and Jain wives, the emblems of the happily married wife (*sumangali*) generally include a *tali* (or a *mangalsutra*), bangles, toe rings, often a nose ring, and sometimes anklets, a *tikka*, or a

red *bindi* on the forehead, and a line of red pigment drawn down the center part of the hair (*sindur*). Fundamentally, these emblems symbolize who a woman is; most important, they show her to be married. But, as stated earlier, they also indicate her regional, caste, and religious identities through symbols, variations in style and design, and customs of wearing. Many marriage necklaces include sectarian symbols and thus define a woman as married, from a particular region (Bengali, for instance, or Tamil), and belonging to a particular sect (Vaishnavite, Shaivite, or Christian).

A woman's jewelry "constitutes" her identity, suggest several scholars. A woman's *tali*, writes Anthony Good, does "not merely symbolize [her] status, but constitutes it."[123] Julie Leslie writes of a woman's marital ornaments: "They constitute her ritual purity. They establish her authority in the home."[124] If jewelry makes the woman, it also, in some rituals, becomes the woman. A small female face is carved on an amulet and worn around the neck by second wives. The necklace is the first wife and must be treated with respect, or the dead spouse will "twist . . . and kill" her successor.[125] Similarly, an earring stands in for a first wife in a Central Indian ritual. Men who have not yet married cannot marry women who have been married. To circumvent this rule, some men marry an earring. Their human brides then become second wives to the earring. If the earring is lost or broken, death rites are held for it.[126]

Fig. 20.
Detail from a short face of a rectangular tomb for a woman. Chaukandi (Sindh, Pakistan), 17th–18th century. Photo courtesy of Molly Emma Aitken.

When a married woman dies, it is her jewelry that represents her. Among orthodox Hindus, a *sumangali* who dies before her husband is celebrated by other women, who may take her *sindur* or bangles to influence their own chances of preceding their husbands to the funeral pyre. Unlike widows, who must remove their marital jewelry, these women are carried to their cremations in all their wedded glory. Sindh desert memorial stones for women (late 17th–18th century) bear replicas of jewelry carved in relief (fig. 20). These may memorialize actual pieces of jewelry, since jewelry differs from one tomb to the next, and designs change over time. The jewelry is arranged in relation to the body, with earrings, necklaces, bracelets, and rings at the head of the tomb and anklets at the foot.[127] For women, these reliefs are the equivalent of the swords and horses carved on men's tombs. For people of that time and place, these pieces of jewelry were who a woman was and how she was to be remembered.

THE BURDEN OF JEWELRY

On the skin, jewelry lies at the point of contact between the self and the world, and it often expresses an individual's changing relations to his or her community. For the most part, these relations (and changes in these relations) are formalized and highly predetermined. But some

rebel at the places they must occupy in society, and others rebel against society itself. In these tales of rebellion, jewelry often betokens far larger personal and societal struggles.

A character in a novel by the early twentieth-century author Sahsrabudde understands her wedding jewelry to be emblematic of her wedded misery:

> I had rich, brocade saris, clothes made out of expensive, finely woven cloth, as well as gold, pearl and diamond studded jewelry. . . . When I looked at the jewelry all it reminded me was of my slavery. It was to this jewelry that Father had sold me. Because of this jewelry I had lost my freedom and [had] become someone's slave.[128]

While jewelry partakes in political and familial relationships, some of these relationships may be onerous, forged without a wearer's consent. The rare memoir or song, which emerges from the silence that historically surrounded women's experiences, shows jewelry to have been a burden for some women. The nineteenth-century Bengali author Tanika Sarkar wrote:

> I am filled with loathing when I look back on all that . . . the coarse clothes, the heavy cumbrous jewellery, the conchshell bangles, the vermilion mark.[129]

For Sarkar, jewelry was a burden because of what it represented. For others, jewelry was simply a physical burden. Disabled by jewelry, queens were often carried. Even their "maids of honor" could be hobbled by the weight of their jewelry on a festival day. In 1520, Domingos Paes wrote:

> So great is the weight of the bracelets and gold and jewels carried by them . . . that many [of the women] cannot support them, and women accompany them, assisting them by supporting their arms.[130]

Jewelry could also be painful. Jaipur's Raj Mata, Gayatri Devi, remembers that, with all the dressing and undressing during her wedding, "removing [my] ivory bangles became increasingly painful."[131] Heavy jewelry was inhibiting, as well. A spirited complaint is found in a Rajput woman's song:

> My dear sister-in-law! In this fierce battle I can successfully hit the heads of the enemies' elephants. But I am unable to use my sword properly because the tassels of the armlet are getting in my way. Can you tie them a bit higher for me?[132]

For the most part, women's experiences of jewelry remain unrecorded. Jewelry is the obvious and the everyday; with all its public meanings, its wearing is a private matter, and premodern histories were not concerned with private lives. It has often taken nineteenth- and twentieth-century visitors to offer and instigate critical perspectives on jewelry. The anthropologist Emma Tarlo, who studies clothing in India, has chronicled her own sometimes comic attempts to compromise between Western dress codes and the codes of the Indian village where she conducted her research. She wore bangles, for instance, so that she would not appear inauspicious, yet her lack of a nose ring led several to consider her a man "despite having long hair and women's clothes." Such confusions indicate how deeply jewelry functions as identity in rural India. Yet some of the villagers whom Tarlo met admitted to finding jewelry a bother and a danger. Tarlo writes:

Sometimes old women informed me that I was wise not to wear jewellery, since it meant I had nothing to fear and was free to move around; their young women, by contrast, were afraid to go out alone for fear that thieves might snatch their large gold earrings.[133]

Observers—more than wearers—frequently mention the physical distress that Indian jewelry can cause. Untracht reproduces a twenty- to thirty-pound anklet intended to "prevent [a young bride] from running away," and notes that Gujarati women wear cloth around their ankles to keep their anklets from injuring them.[134] Tarlo cites a village story about a woman whose arms became septic from overtight bangles. Hendley, an English scholar of the early twentieth century, wrote of tight glass rings that broke the skin, gold chains on well-off children that inhibited their play, and "enormous bracelets or rather handcuffs" intended to weigh a woman down and "prevent her from running away [from] home."[135] He quotes a Master Willington:

Women of the Rajputs were brought up from their childhood with shackles, some of silver, some of gold, and some of iron on their legs.[136]

Because jewelry signifies so much about a person's place in Indian society, it has suffered the criticisms of reformists and counterculturalists. Buddha exhorted the renunciation of worldly ties to wealth, family, and social position—all things that are expressed, in part, through jewelry. To Buddha, jewelry was fundamentally a symptom of desire, which is the hook that holds one in *samsara*, the cycle of life and death that followers strive to escape. A two-thousand-year-old account of Buddha's life sets the false beauties of jewelry against the grim realities of the flesh; as he leaves home, he observes the women of his palace drooling and snoring through their ornaments. The young Buddha concludes:

Such is the nature of women, impure and monstrous in the world of living beings; but deceived by dress and ornaments a man becomes infatuated by [their] attractions.[137]

Naturally, Buddhist nuns were expected to reject jewelry and its false seductions. Though the songs of the Buddhist nuns are now thought to have been written by men, they often mentioned jewelry as one aspect of a life left behind on the path to enlightenment:

My hands were beautiful
set off by rings gold as the sun.
Now because of old age
they are radishes or onions.[138]

Yet such positions were not always consistent with common practice. Evidence suggests that many monks and nuns held on to their wealth.[139] Jewels were depicted as blessings on the stupa at Bharhut, and Buddhist offerings often included gold, gems, and items of jewelry.

Countercultural rejections of jewelry seem to have become more common in the nineteenth century. Followers of the South Indian reformer Ramaswamy Periyar denounce the *tali* as an expression of the inequality between the sexes in marriage. Gandhi was also critical of women's

jewelry because it was incompatible with the simple handspun, undyed cotton cloth (*khadi*) he urged Indians to wear and with the life of humility that *khadi* represented. He called on women to donate their jewelry to public causes and criticized village women for their cumbersome ornaments.[140] Ironically, his remarks on the "unbearable heavy ankle hoops" of village women sound strikingly like the criticisms of British observers such as Hendley. One of Gandhi's problems with village dress, however, was precisely that it encoded class and caste distinctions, which he had hoped to erase. It was for this reason that he himself turned away from the dress of his native village,[141] which he had briefly worn, in favor of the homespun-cotton (*khadi*) loin cloth.

Followers of Gandhi embraced wedding practices consistent with his ethos: wearing *khadi* and replacing jewelry with flowers. Nehru's sister is said to have complained about the simplicity of her wedding, disliking the simple pink *khadi* sari her family expected her to wear.[142] Dr. Vishakha Desai, Director of Asia Society Museum (now President of the Asia Society), tells a different story of her parents who were freedom fighters and close supporters of Gandhi. Their wedding, which was intercaste, was held without dowry, without an expensive and wasteful feast, and without jewelry. The bride wore flowers and a *khadi* sari that her fiancé (Dr. Desai's father) wove while he was in jail for activism. One of only two photographs taken at the wedding (fig. 21), shows the bride wearing a single article of jewelry, the glass bangle, to symbolize her newly wedded status.

Even today, some Indians choose flowers over jewelry at their weddings. For some, it is an aesthetic choice, a day of flowers, offsetting days of jewelry, leading up to the wedding. For others, it is a moral choice, a decision to reject expenses that often visit hardships on women and their families. In most of India, a woman's family is expected to give a dowry to the family of her groom, and increasingly dowry demands escalate out of control. Though a woman's jewelry is supposed to be her own, the groom's family often ignores this custom, and jewelry now features in many dowry disputes. A great deal of notoriety surrounds

Fig. 21.
Photograph of the wedding of Nirubhai Desai and Nirmala Desai; March 11, 1945. Photo courtesy of Vishakha N. Desai.

instances when the groom's family immolates a new bride whose family cannot answer their mounting demands for jewelry, cars, appliances, and cash. According to the Indian government, seven thousand women were killed in 2001 in dowry-related deaths,[143] and a government hospital in Delhi reported around three thousand cases of immolation of women per year, nine-tenths of which doctors assumed to involve dowry disputes.[144] Even leaving aside questions of dowry, however, the costs of weddings alone can break a family's finances. The sheer prospect of such money being hemorrhaged into a girl's wedding has been linked to female infanticide in poorer and less-educated parts of the country. Many families cannot afford the costs of daughters.

Gold is a painful symbol in India of the gap between rich and poor. Despite the country's extensive poverty, India consumes more gold per year than any other nation in the world. Eight hundred fifty-five tons were bought in 2001 alone, and the country possesses roughly one-third of the world's circulating gold.[145] Most of this gold is imported, and demand can make the price of gold in India more than twice what it is outside the country. In 1963, the government tried to rein in its citizens' expenditures, reasoning that so much stashed gold stagnates when it could be stimulating the economy. Gold more than 14 karats in purity was made illegal, but protests were so extensive that the law was soon repealed.[146]

Indian jewelry is about identities and relationships, but it is above all about pleasure. Its pleasures lie not in its meanings but in its forms. On dazzling textiles and amid competing pieces of jewelry, an ornament may get little appreciation from those who see it. It is those who finger it—its makers, merchants, and owners—who most appreciate its subtleties of design and craft.

Among the middle and lower classes, jewelry is judged more for its weight and purity than for its craftsmanship.[147] But the royal courts of India held craftspeople to high standards and stimulated a skilled jewelry tradition. Even among silversmiths, a great deal of ingenuity went into making linked units and chains. Coiled silver discs, for example, encircle a anklet in two adjacent rows (cat. no. 139). From the outside, they appear unattached, yet their coils unwrap below, feeding single wires into a flexible braided ring. More subtle and splendid is a gold chain necklace from Tamil Nadu (cat. no. 99). Its pieces also seem to be united organically; they move together with the suppleness of a reptile's skin. The necklace's mechanics are hidden; its pieces—gold tongues and loops—are joined, but we cannot see how. The necklace's clasp has an outer structure housing its joints and offers what seems a teasing glimpse of inner complexity. Who sees these details? The woman who once owned it, one imagines, who took it out for important occasions, fingered it, and enjoyed its cool, smooth textures on her skin.

Hidden spectacle is a specialty of the Indian arts. Temples built at the height of the Hindu and Jain architectural traditions (10th–12th century) are carved into more intricate details than the eye can see. Tiny geese, dancing women, rolling waves, and sitting ascetics disappear into dark nooks in ceilings or are lost in the sheer multitude of things to see. While it was the overall effect most viewers would grasp, artists lavished care—perhaps for the omniscient gods—on figures beyond routine attention. The best pieces of devotional jewelry seem crafted in this tradition. A tiny Krishna dances on a snake in a Mysore piece that would have topped an ornament for a woman's braid (fig. 22; cat. no. 43). The texture and ribs of the many-headed cobra's hood are carved on the back where, against a woman's hair, they would remain unseen. Far more astonishing and delightful, however, is the tiny emerald face of Krishna: a close look reveals a perfectly carved, round-cheeked prince.

The backs of Indian ornaments often surpass their fronts in beauty. Enamelwork, which developed into a fine art at the Mughal court, was a North Indian specialty. Turning over a diamond and emerald necklace, one finds red poppies or pink roses, delicate green leaves, and birds.

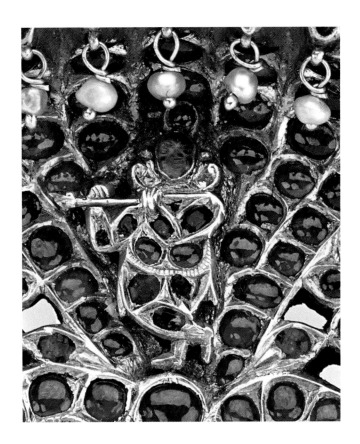

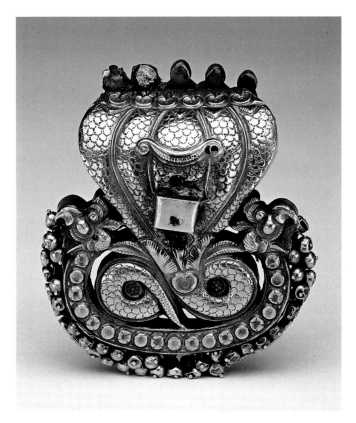

Fig. 22.
Detail of Krishna's face on a gold
braid ornament (nagar) set with
rubies, emeralds, diamonds, and
pearls. South India; 18th century.
Susan L. Beningson Collection;
cat. no. 43.

Fig. 23.
Gold pendant set with rubies, emer-
alds, and diamonds. South India;
18th century. Susan L. Beningson
Collection, cat. no. 103.

Fig. 24 (overleaf).
Globular seed earrings with gran-
ulation; modern earwires. 9th–
12th century. 7 x 2.4 cm. Susan
L. Beningson Collection.

Etched gold lines shine through the figures to give definition to petals, stalks, and wings. These hidden gardens almost shame the diamonds, emeralds, and rubies that the jewelers had intended for display. Today, women sometimes wear the enameled backs of their jewelry turned forward,[148] but this practice undermines earlier respect for the possibility that beauty could be a private pleasure.

Like paint, enamelwork allows for the freedom to be playful, suggest stories, and create an illusion of reality. In the Beningson collection, five square pendants, strung together on a necklace, are set with crystal squares. Enameled birds perched on flowering trees enliven their backs (cat. no. 90). Each scene is slightly different, but on one, two birds flap their wings and chatter face-to-face. On this piece alone blooms a single blue flower. Enameled tigers on a bracelet in the Beningson collection are also worth noting, with their black whiskers and eyebrows, their white enameled teeth, black-spotted snouts, and sculpted yellow noses (cat. no. 100). Even on the finest pieces, jewelers worked anonymously. On the back of one enameled necklace are symmetrically placed two tiny blue X's set in circles (cat. no. 89): might these be a workshop signature? Perhaps, but their meaning is now lost. Scholars know almost nothing about individual jewelers' ateliers.

Motifs that fit like puzzle pieces to make up a larger whole and tiny figures that nestle almost invisibly in a larger design are also typical of the taste for surprise in Indian jewelry. A ruby necklace from South India is made of small crescents that fit together seamlessly, front to back (cat. no. 22). Figures at the base, flanking the pendant, resolve themselves into tiny peacocks that are hidden at first glance. Similarly discrete are the peacocks on a ruby, emerald, and diamond pendant whose forms only gradually become visible. Yet these fowl are obvious, compared to the tiny birds subtly indicated to the left and right—ruby bodies with dark emerald heads that turn back to peck at jeweled foliage (fig. 23; cat. no. 103).

These objects of beauty—here and in the galleries—suggest both what we can and cannot see. Hidden backs are revealed for public scrutiny. Meanings are proposed and contexts discussed. Beyond our intellectual reach, however, are the personal lives through which these objects have traveled. A necklace or ring may have once heightened desires, taken the brunt of a moment's anger, or expressed the contentment of a quiet life. The knowledge of that which we do not know is one of the pleasures of these venerable objects; it makes them more than the sum of their material parts. Like Indian poetry, which relishes the mutability of things (or our perceptions of things), these ornaments are defined by what we know about them, what we imagine about them, and what we make of them now. Indian jewelry is (and was) meant to delight, and any piece that did not give pleasure before can do so now.

A collection may be abandoned, but it is rarely completed. Less favored pieces are sold and new ones purchased as collectors gain knowledge and refine their tastes. Ms. Beningson is still adding to her collection, and since this essay was completed, has purchased two new pairs of very early gold earrings (figs. 1 and 24), which appear here and will delight visitors to the exhibition.

1. Ramdev P. Kathuria, *Life in the Courts of Rajasthan during the 18th Century* (New Delhi: S. Chand, 1987), 193.

2. Thus the Buddha is recognized in part by his pendulous, empty ear lobes, pulled down by the heavy earrings he wore before he became an ascetic.

3. Frédérique Apfell-Marglin, *Wives of the God-King: The Rituals of the Devidasis of Puri* (New Delhi: Oxford University Press, 1985), 53, 157 (hereafter cited in text as *WG-K*). Traditions of widowhood vary from place to place, and from one caste to the next. According to Apfell-Marglin, Puri widows must renounce all ornamentation, but the widow of a king in the south removes only her glass bangles, continuing to wear gold bangles and a few other pieces of jewelry. In pre-independent India (before 1947), high-ranking courtesans and queens in Rajasthan gave up wearing jewelry when the king died. These days, particularly among the urban upper and upper-middle classes, such traditions are considerably relaxed, if not abandoned altogether.

4. Of ascetic orders that embrace full nudity, Crooke writes: "As regards the custom of nudity by the religious orders, it symbolizes death to this world, the renunciation of all family and social ties." William Crooke, "Nudity in India in Custom and Ritual," *Journal of the Royal Anthropological Institute* XLIX (1919): 237–251.

5. Apfell-Marglin, *WG-K*, 56.

6. Abu'l Fazl Allami, *Ain I-Akbari* III, transl. H. S. Jarrett (New Delhi: Oriental Books Reprint Corporation, 1978), 341–344.

7. Vatsyayana, *The Complete Kama Sutra*, transl. Alain Daniélou (Rochester, Vt.: Park Street Press, 1964), 63–64.

8. For a discussion of the temple conceived as a living entity, see Michael Meister, "Fragments of a Divine Cosmology: Unfolding Forms on India's Temple Walls," in *Gods, Guardians and Lovers: Temple Sculptures from North India A.D. 700–1200*, ed. Vishakha N. Desai and Darielle Mason (New York: The Asia Society Galleries, 1993), 94–115 (hereafter cited in text as *GGL*).

9. Manjhan, *Madhumalati, an Indian Sufi Romance*, transl. Aditya Behl and Simon Weightman (Oxford: Oxford University Press, 2000), 39.

10. Apropos, Vidya Dehejia quotes an Orissan text which reads: "As a house without a wife, as frolic without a woman, so, without the figure of woman the monument will be of inferior quality and will bear no fruit." Vidya Dehejia, *Indian Art* (London: Phaidon, 1997), 164–165.

11. A connection made explicit in the goddess Lajja Gauri, represented as a flowering pot terminating in a vulva between spread legs. See Carol Radcliffe Bolon, *Forms of the Goddess Lajja Gauri in Indian Art* (University Park, Pa.: Pennsylvania State University Press, 1992).

12. Choodamani Nanda Gopal, "Jewellery in the Temples of Karnataka," in *Jewels of India*, ed. Susan Stronge (Bombay: Marg Publications, 1995), 38.

13. Stella Kramrisch, *The Hindu Temple* Vol. I (Delhi: Motilal Banarsidass, 1976), 322.

14. Sarojini Naidu, "The Bangle Sellers," in *Women Writing in India: 600 B.C. to the Present*, ed. Susie Tharu and K. Lalita (New York: Feminist Press at the City University of New York, 1991), 332 (hereafter cited as *WW*).

15. Keshavadasa, *The Rasikapriya of Keshavadasa*, transl. K.P. Bahadur (Delhi: Motilal Banarsidass, 1972), 94 (hereafter cited as *RK*).

16. Jayadeva, *Love Song of the Dark Lord: Jayadeva's Gita Govinda*, transl. and ed. Barbara Stoler Miller (New York: Columbia University Press, 1977), 101.

17. Kalidasa, "Rtusamharam (The Gathering of the Seasons)," in *The Loom of Time: A Selection of His Plays and Poems*, transl. Chandra Rajan (New Delhi: Penguin Books, 1989), 116 (hereafter cited as *LT*).

18. Merchant Prince Shattan, *Manimekhalai (The Dancer with the Magic Bowl)*, transl. Alain Daniélou (New Delhi: Penguin Books, 1989), 22.

19. Ibid., 9.

20. Ibid., 34.

21. Ibid., 19.

22. Keshavadasa, *RK*, 63.

23. Manjhan, *Madhumalati*, 33.

24. Kalidasa, "Abhijnanasakuntalam (The Recognition of Sakuntala)," in *LT*, 165–281.

25. Bihari, *The Satasai*, transl. Krishna P. Bahadur (New Delhi: Penguin Books/UNESCO, 1990), 46.

26. Bharitrihara and Bilhaha, *The Hermit and the Love-Thief: Sankrit Poems of Bharitrihara and Bilhana*, transl. Barbara Stoler Miller (New York: Columbia University Press, 1978), 116.

27. Cited by Doranne Jacobson, "Women and Jewelry in Rural India," in *Family and Social Change in Modern India*, ed. Giri Raj Gupta (Durham, N. C.: Carolina Academic Press, 1971), 153 (hereafter cited in text as "WJ").

28. William G. Archer, *Songs for the Bride: Wedding Rites of Rural India* (New York: Columbia University Press, 1985), 121.

29. See Tharu and Lalita, *WW*, 105.

30. Bihari, *The Satasai*, 114.

31. Keshavadasa, *RK*, 169.

32. Daud Ali, "From Nayaka to Bhakta: A Genealogy of Female Subjectivity in Early Medieval India," in *Invented Identities: the Interplay of Gender, Religion and Politics in India*, ed. Julie Leslie and Mary McGee (Oxford: Oxford University Press, 2000), 172.

33. Vatsyayana, *Kama Sutra*, 338.

34. Kalidasa, "Abhijnanasakakuntalam," *LT*, 202.

35. Keshavadasa, *RK*, 96.

36. Archer, *Songs for the Bride*, 161.

37. Indian men's adoption of Western clothes can be a form of escape: unlike traditional garb, shirt and pants signify nothing about caste, village, or status.

38. Pages of the Jaipur painting department inventory, the *suratkhana tozis*, Rajasthan State Archives, Bikaner, India.

39. In fact, the significance of her jewelry is complex: she wears a few pieces of gold jewelry to ally her to Krishna, while the silver amulet and flowers denote her rural simplicity. See Steven Kossak, *Indian Court Painting, 16th–19th Century* (New York: The Metropolitan Museum of Art, 1997),106.

40. Jacobson, "WJ," 151.

41. Charles Allen and Sharada Dwivedi, *Lives of the Indian Princes* (London: Century Pub, 1984), 204.

42. *Tali* is the South Indian term for a matrimonial pendant, while *mangalsutra* is the term used in the North.

43. Emma Tarlo, *Clothing Matters: Dress and Identity in India* (Chicago: University of Chicago Press, 1996), 156 (hereafter cited as *CM*).

44. Jacobson, "WJ," 151.

45. Shattan (*Manimekhalai*, 15) describes his hero's necklace as the only thing that distinguishes him from a god in the following passage: "It was only by looking at the necklace that adorned his breast that the people knew that this hero was not the god Murugan himself, but only a prince of the Chola dynasty, since Murugan wears a necklace of tamarisk flowers, which only blossom during the rainy season, while he was wearing a necklace of orchid-tree leaves, the symbol of the Chola dynasty."

46. Susan Stronge, Nima Smith and J.C. Harle, *A Golden Treasury: Jewellery from the Indian Subcontinent* (New York: Rizzoli in association with the Victoria and Albert Museum and Grantha Corp., 1988), 30.

47. Oppi Untracht, *Traditional Jewelry of India* (New York: Harry N. Abrams, 1997), 158 (hereafter cited as *TJ*).

48. The distinctive ornaments of the Naths and *gosains* are depicted in 18th- and 19th- century paintings from Rajasthan. See, for instance, the Jodhpur images of Naths in Rosemary Crill, *Marwar Painting: A History of the Jodhpur Style* (Mumbai: India Book House, n.d.). Representations of *gosains* can also be seen in the Nathdvara temple paintings reproduced in Amit Ambalal, *Krishna as Shrinathji: Rajasthani Paintings from Nathdvara* (Ahmedabad: Mapin Publishing, 1987).

49. Jahangir, *The Jahangirnama: Memoirs of Jahangir, Emperor of India*, transl., ed. and annot. Wheeler M. Thackston (Washington DC: Freer Art Gallery, Arthur M. Sackler Gallery in association with Oxford University Press, 1999), 161.

50. Ibid., 89.

51. Manuel Keene and Salam Kaoukji, *Treasury of the World: Jewelled Arts of India in the Age of the Mughals; The Al-Sabah Collection, Kuwait National Museum* (New York/London: Thames and Hudson, 2001), cat. no. 12.1.

52. See Milo Cleveland Beach and Ebba Koch, *King of the World: The Padshahnama, an Imperial Mughal Manuscript from the Royal Library, Windsor Castle* (London: Azimuth Editions, 1997)

53. Nicholas B. Dirks, *The Hollow Crown: Ethnohistory of an Indian Kingdom* (Ann Arbor: University of Michigan Press, 1993), 64–65.

54. Joanne Punzo Waghorne, *The Raja's Magic Clothes: Revisioning Kingship and Divinity in England's India* (University Park, Pa.: Pennsylvania State University Press, 1994), 226.

55. Varsha Joshi, *Polygamy and Purdah: Women and Society among Rajputs* (Jaipur / New Delhi: Rawat Publications, 1995), 163.

56. Allen, *Lives of the Indian Princes*, 205.

57. For an illustration of this practice, see a picture of Emperor Jahangir weighing Prince Khurram in Stuart Cary Welch, *India: Art and Culture 1300–1900* (New York: The Metropolitan Museum of Art, 1985.), cat. no. 118.

58. Bernard Cohn, "Clothes, Cloths, and Colonialism: India in the Nineteenth Century," *Cloth and Human Experience*, ed. Annette B. Weiner and Jane Schneider (Washington: Smithsonian Institution Press, 1989), 303–353.

59. C. J. Fuller, *The Camphor Flame: Popular Hinduism and Society in India* (Princeton, N.J.: Princeton University Press, 1992), 107.

60. Robert Sewell, "Narrative of Paes," *A Forgotten Empire: Vijayanagar, A Contribution to the History of India* (New Delhi: National Book Trust, India, 1970), 256.

61. Phyllis Granoff, "Halayudha's Prism: The Experience of Religion in Medieval Hymns and Stories," *GGL*, ed. Desai and Mason , 90.

62. Ann Grodzins Gold, "From Demon Aunt to Gorgeous Bride," in *Invented Identities*, 220.

63. Vidya Dehejia. *The Sensuous and the Sacred: Chola Bronzes from South India*. With essays by Richard H. Davis, R. Nagaswamy and Karen Pechilis Prentiss. (New York: American Federation of Arts; Seattle: University of Washington Press, 2002), 255 (hereafter cited as *SS*).

64. Untracht, *TJ*, 195.

65. Anthony Good, "The Structure and Meaning of Daily Worship in a South Indian Temple," *Anthropos*, 96 (2001): 491–507 (hereafter cited as "SM")

66. C. Sivaramamurti, *The Chitrasutra of the Vishnudharmottara* (New Delhi: Kanak Publications, 1978), 174.

67. Ibid., 195.

68. Thomas B. Coburn, *Encountering the Goddess: A Translation of the Devi-Mahatmya and a Study of Its Interpretation* (Albany, N.Y.: State University of New York Press, 1992), 40–41.

69. See Dehejia, *SS*, cat. nos. 30, 36.

70. *The Threefold Lotus Sutra*, transl. Bunno Kato, Yoshiro Tamura and Kojiro Miyasaka (New York: Weatherhill, 1975), 36.

71. Phyllis Granoff, *GGL*, ed. Desai and Mason, 90.

72. Story from Agence France-Presse, by Uttara Choudhury published on the internet at http://quickstart.clari.net/qs_se/webnews/web/ab/Qindia-gold-marriage.RWb7_DaB.html.

73. Cited in Choodamani Nanda Gopal and Vatsala Iyengar, in *Temple Treasures Vol. II* (Bangalore: Crafts Council of Karnataka, 1997), 4.

74. Usha R. Bala Krishnan and Meera Sushil Kumar, *Dance of the Peacock: Jewellery Traditions in India* (New Delhi: India Book House Limited, 1999), 233 (hereafter cited as *DP*).

75. Pria Devi and Richard Kurin, *Aditi: the Living Arts of India* (Washington DC: Smithsonian Institution Press, 1985), 115.

76. Bala Krishnan and Kumar, *DP*, 234.

77. In a rite called *tirandukalyanam*. See Melinda A. Moore, "Symbol and Meaning in Nayar Marriage Ritual," *American Ethnologist*, Vol. 15, no. 2 (May 1988): 254–273.

78. Tharu and Lalita, *WW*, 157.

79. Anthony Good, "Divine Marriage in a South Indian Temple," *Mankind*, Vol. 19, no. 3 (December 1989): 187–190.

80. Ibid., 190. Good writes: "Weddings themselves imitate the worship of gods. All brides and groom, not just Brahman ones, are temporarily deified, and weddings are partly acts of worship towards them." See also Lawrence A. Babb, *The Divine Hierarchy: Popular Hinduism in Central India* (New York: Columbia University Press, 1975), 84. Babb writes: "The bride and the groom are treated quite literally as deities, as objects of worship in their own right."

81. Good, "SM," 2001.

82. Julia Leslie, "The Significance of Dress for the Orthodox Hindu Woman," in *Dress and Gender: Making and Meaning in Cultural Contexts*, ed. Ruth Barnes and Joanne B. Eicher (New York / Oxford: Berg, 1992), 198–213 (hereafter cited as "SD").

83. Vatsyayana, *Kama Sutra*, 284.

84. Leslie, "SD," 199.

85. Carol Radcliffe Bolon and Amita Vohra Sarin, "Metaphors in Gold: The Jewelry of India," *Asian Art* (Fall 1993): 19–20 (hereafter cited as "MG").

86. Dorothy Stein, "Burning Widows, Burning Brides: The Perils of Daughterhood in India," *Pacific Affairs*, Vol. 61, no. 3 (Autumn 1988): 485.

87. Untracht, *TJ*, 160.

88. Jacobson, "WJ," 158.

89. Lizelle Reymond, *My Life With a Brahmin Family*, transl. Lucy Norton (London: Rider and Company, 1958), 116.

90. See S. Settar and Gunther D. Sontheimer, *Memorial Stones: A Study of Their Origin, Significance and Variety*, South Asian Studies, no. 11 (Dharwad: Institute of Indian Art History, Karnatak University, 1982).

91. Apfell-Marglin, *WG-K*, 157.

92. Pauline Kolenda, "Woman as Tribute, Woman as Flower: Images of 'Woman' in Weddings in North and South India," *American Ethnologist*, Vol. 11, no. 1 (1984): 98.

93. The first mention of *"tali"* is in the *Kanda Purana*, variously dated to the 11th and 12th centuries. Dehejia, *SS*, 226; Bolon and Sarin, "MG," 16.

94. Dehejia, *SS*, 226.

95. Untracht, *TJ*, 168.

96. www.bhattar.com/html/ rituals_of_hindu_marriage.html.

97. Stuart Cary Welch, *India: Art and Culture 1300–1900* (New York: The Metropolitan Museum of Art, 1985), cat. no. 42.

98. Bala Krishnan and Kumar *DP*, 150.

99. Untracht, *TJ*, 168.

100. Michael Postel, *Ear Ornaments of Ancient India* (Bombay: Project for Indian Cultural Studies, Publication II, 1989), 198.

101. www.hinduismtoday.com/archives/ 1988/09.

102. Bolon and Sarin, "MG," 16.

103. Good, "SM," 503.

104. Moore, "Symbol and Meaning," 266.

105. All these websites were available during fall and winter 2003 when this essay was being written.

106. According to http://www.edulhadulhan.com, this is a feature of South Indian Brahmin marriages. See also www.umiacs.umd.edu/users/ sawweb/sawnet/wedding/tamil_vedic.html.

107. www.edulhadulhan.com; http:// www.umiacs.umd.edu/users/sawweb/sawnet/wedding/tamil_vedic.html; http://www.mypandit.com/mypandit/user/ c_rituals5.jsp.

108. www.mryamrs.com/Malayali/ ritual.asp.

109. members.tripod.com/~HerIndia/ stories.marriage_en.html.

110. www.umiacs.umd.edu/users/sawweb/ sawnet/wedding/tamil_vedic.html.

111. See note 109 above; www.mypandit.com/ mypandit/user/c_rituals5.jsp.

112. Kathleen Gough, "The Nayars and the Definition of Marriage," *Marriage, Family and Residence*, ed. Paul Bohannan and John Middleton (Garden City, N. Y.: The Natural History Press, 1968), 49–71.

113. www.umiacs.umd.edu/users/sawweb/ sawnet/news/sexuality.html.

114. www.hinduonnet.com/mag/2002/03/ 24/stories.

115. servlet.indiainfo.com/indiainfo/printer.

116. A.A., *The Hindu*, Sunday, February 4, 2001, features section.

117. www.webindia123.com/women/attire/ orna.htm; http://www.edulhadulhan.com.

118. www.chennaionline.com/columns. DownMemoryLane/diary158.asp.

119. Ibid.

120. Pauline Kolenda, "Woman as Tribute, Woman as Flower: Images of 'Woman' in Weddings in North and South India," *American Ethnologist*, Vol. II, no. 1 (February 1984): 110.

121. www.shadionline.com/sol/asp/rnc/ gettin-greadyrcmarwarijain2.asp.

122. www.shadikaro.com/ articles_marwari_matri-monials.asp.

123. Good, "SM" 503.

124. Leslie, "SD," 210–211.

125. Jacobson, "WJ," 158; Untracht, *TJ*, 170.

126. Jacobson, "WJ," 154.

127. For a detailed description of the jewelry on the Chaukandi tombs, see Salome Zajadacz-Hastenrath, *Chaukandi Tombs: Funerary Art in Sind and Baluchistan*, transl. Michael Robertson (Oxford/ Karachi: Oxford University Press, 2003), 99–113.

128. Tharu and Lalita, *WW*, 386–387.

129. Tanika Sarkar, "A Book of Her Own. A Life of Her Own: Autobiography of a Nineteenth-Century Woman," in *From Myths to Markets: Essays on Gender* (Shimla/New Delhi: Indian Institute of Advanced Study with Manohar Publishers and Distributors, 1999), 106.

130. Cited by Sewell, *A Forgotten Empire*, 263.

131. Gayartri Devi and Santha Rama Rau, *A Princess Remembers: The Memoirs of the Maharani of Jaipur* (New Delhi: Tarang Paperbacks, 1990), 155.

132. Joshi, *Polygamy and Purdah*, 91.

133. Tarlo, *CM*, 134.

134. Untracht, *TJ*, 273–274.

135. Cited in Bala Krishnan and Kumar, *DP*, 182.

136. Hendley, Thomas Holbein, "Indian Jewellery," *The Journal of Indian and Industry*, Vol. xii, no. 107 (July 1909): 20 and 24.

137. Edward Byles Cowell, *Buddhist Mahayana Texts* (New York: Dover Publications, 1969), 57–58.

138. Susan Murcott, *The First Buddhist Women: Translations and Commentaries on the* Therigatha (Berkeley: Parallax Press, 1991), 133–134.

139. Gregory Schopen, "What's in a Name: The Religious Function of the Early Donative Inscriptions" in *Unseen Presence: the Buddha and Sanchi*, ed. Vidja Dehejia (Mumbai: Marg Publications, 1996), 60–73.

140. Tarlo, *CM*, 88, 128.

141. Susan Bean, "Gandhi and Khadi, the Fabric of Indian Independence," in *Cloth and Human Experience*, ed. Annette B. Weiner and Jane Schneider (Washington: Smithsonian Institution Press, 1988), 366.

142. Ibid., 372–373.

143. Lucy Ash, "India's Dowry Deaths," July 16, 2003, for the BBC News UK Edition.

144. Dorothy Stein, "Burning Widows, Burning Brides: The Perils of Daughterhood in India," *Pacific Affairs*, Vol. 61, no. 3 (Autumn 1988): 465–485.

145. http://quickstart.clari.net/qs_se/webnews/ wed/ab/Qindia-gold-marriage. RWb7_DaB.html.

146. Untracht, *TJ*, 279; Stronge, Smith and Harle, *A Golden Treasury*, 116.

147. Jacobson, "WJ," 150.

148. Jamila Brij Bushan, *Masterpieces of Indian Jewellery* (Bombay: Taraporevala, 1979), 28–29.

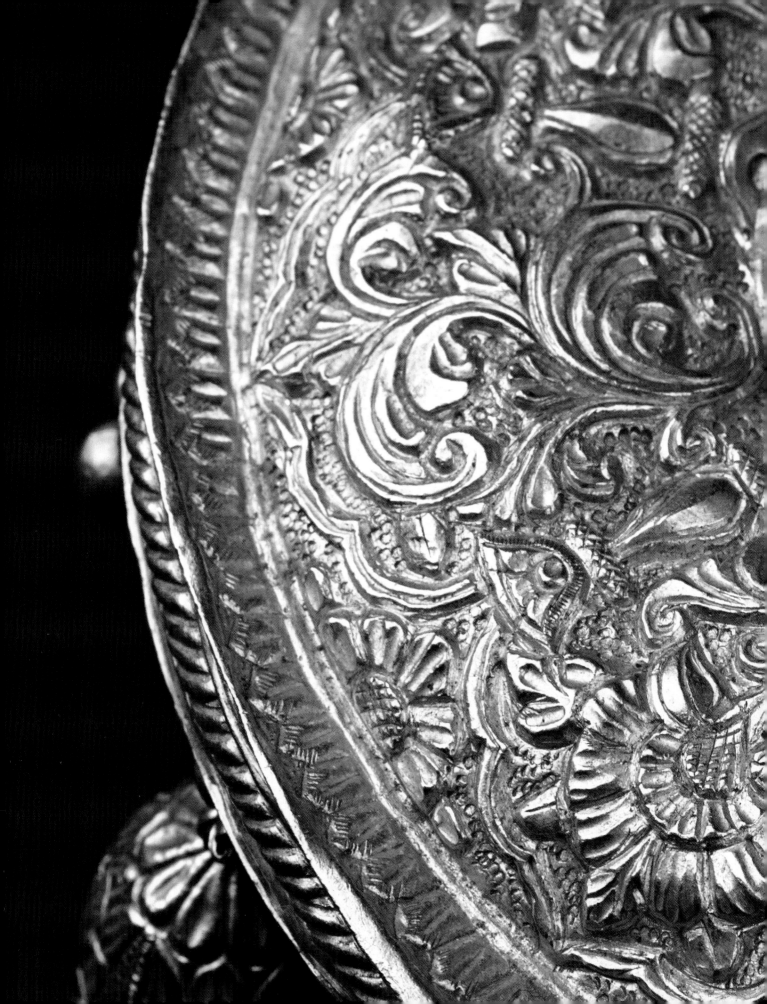

Catalogue

Introduction

Because jewelry is light, small, and worn on the body, it moves with its wearers across continents. Consequently, it reflects awareness of a wide range of geographic idioms and techniques. A case in point is the first- to second-century jewelry of Gandhara (northwestern Pakistan and eastern Afghanistan). Like Gandharan sculpture of the period, it is strikingly Hellenic in style, influenced (and in some cases produced) by Bactrian artists and craftsmen who had migrated to the region. In the sixteenth and seventeenth centuries, Persian designs similarly inspired Mughal jewelry. The Mughals employed Persian artisans and drew inspiration from the Persian taste for flowering, nonfigurative ornament. Techniques travel as well as styles. The earliest jewelry in India is decorated with granulation, a technique that may have originated in Mesopotamia and that spread to the Middle East, Central Asia, and North Africa. Granulation remains an essential element of the Indian jeweler's repertoire today (see for example cat. nos. 63 and 75).

Yet, for all its various influences, Indian jewelry is unmistakably Indian. It is also rich with regional idioms, particularly from rural areas. Most obvious in this publication and exhibition are the distinctions between northern and southern jewelry. Southern jewelry is more dominantly gold, often figurative, and, when set with gems, red with rubies. Northern jewelry tends to prefer jewels to large areas of gold and is often enameled on the back. Southern jewelry employs more muscular and geometric designs. Northern jewelry tends to be light and scrolling.

Gem setting techniques also differentiate the two. *Kundun*, a technique developed at the Mughal court, is a northern signature. Southern jewelers also use *kundun*; however, their technique, which is slightly different, makes gems seem more shallowly set. To create a *kundun* setting, the Northern jeweler places a gem on a bed of lac (a resinous insect secretion). He then layers leaves of twenty-four karat gold over the lac and into the area around the gem to hold it in place. Southern jewelers use a similar technique, but it does not involve the same painstaking layering of gold. Such broad distinctions are hardly rigid and offer mere guidelines to looking.

Methods of gem cutting also contribute to Indian jewelry's distinctive appearance. Indian gem cutting is dictated by a preference for size over clarity. Giving primary value to the weight of a stone, Indian jewelers leave many stones almost in their natural forms, simply polishing them. Often the result is an irregularly shaped, pebblelike stone, which was sometimes carved into decorative forms or inscribed. (Delhi was the center for gem engraving, though artisans in Lucknow were also proficient in the art.[1])

Indian jewelry is partly characterized by the techniques it employs. Repoussé (hammering from behind) and molds are common means of giving shape to gold or silver, and granulation is an ancient, still-popular form of decoration. Indian jewelry from the north also employs a good deal of enamelwork (*minakari*). Enamel (*mina*) is a glasslike substance colored with metallic oxides. Most enamelwork in India is champlevé, that is, applied to a gold surface that has been carved into a subtle texture or pattern, such as the veins of leaves.

Detail of cat. no. 86
Example of *kundun*

Example of gem carving

Detail of cat. no. 63
Example of granulation

Example of enamel

Detail of cat. no. 92
Example of repoussé

1

Enameled pendant with diamonds and large engraved spinel on gold chain

North India; Spinel: probably engraved in the
18th century; setting: 19th century
2.5 x 3.25 cm without chain

The spinel in this pendant seems to have passed through several settings. Plugs, visible as two darkened circles to the left and right of the gem, would have served an earlier setting. These plugs have been filled, after which an inscription has been engraved. The inscription, which includes the word "babshah" for "badshah," or emperor, would have inspired the picture of a Mughal emperor enameled on the back. Note the glimmer of gold on the emperor's turban.

2A–G, clockwise from left:

Cast brass jewelry molds

India; 19th–early 20th century
Diameters range from 2 to 4 cm

2H

Cast brass jewelry mold

India; 19th–early 20th century
9 cm diameter

2H

2I–K

2L–M

2N–Q

2I–K

Cast brass jewelry molds

India; 19th–early 20th century
Left: 4 x 4 cm; middle: 5.5 x 2 cm; right: 6 x 5.5 cm

2L–M

Cast brass jewelry molds

India; 19th–early 20th century
Left: 3.5 x 3 cm; right: 4.5 x 1.5 cm

2N–Q

Cast brass jewelry molds

India; 19th–early 20th century
Clockwise from top: 5 x 1 cm, 4 x 1.5 cm, 3 x 2 cm,
4 x 2 cm

Indian jewelry relies on a number of basic
natural and geometric motifs, and jewelers
turn to molds like these to reproduce com-
mon designs. Mold E is probably for a
circular hair ornament, mold D for a *tali*,
and mold M for a fish-decorated toe ring.
Note the shallow incisions on mold G
depicting the double-headed bird insignia
of the Mysore royal family (see cat. nos. 101,
138, and 149). These molds were used to
create repoussé designs and wax forms for
casting gold.

3 and 4
Steatite seals

Indus Valley; ca. 2600–1900 B.C.E.
2 x 2.25 cm, each

These were not ornaments, but they demonstrate one of the earliest decorative techniques in India, the seal. Thousands of these seals have been found, some with traces of packing materials on them, indicating that they were affixed to goods packed for trade. They are inscribed in the Indus Valley script, which has yet to be deciphered. These two examples picture unicorns standing in front of troughs.[2]

5
Sandstone seal depicting large and small stupas

Gandhara (present-day Pakistan); 1st–2nd century C.E.
6.75 cm diameter, 7.75 cm depth

6
Schist reliquary

Gandhara (present-day Pakistan); 1st–2nd century C.E.
16 cm height, 10.4 cm diameter

7
Schist reliquary containing relics

Gandhara (present-day Pakistan); 1st–2nd century C.E.
13 cm height, 12 cm diameter

As soon as the Buddha passed away (entering *paranirvana*), the question of relics became a pressing one. Since the time of the Buddha, devotees have venerated what are called the "three refuges" or "three jewels": the Buddha, the community of monks and nuns (*sangha*), and the Buddhist doctrine (*dharma*). It is clear from early texts that they understood relics to be the Buddha. An inscription on an early reliquary described its contents as "the body, endowed with life, of the Blessed Sakyamuni."[3] Funerary monuments that contained relics and which were worshiped (*stupas*) were also identified with the Buddha. The first reliquary illustrated here is in the form of a *stupa*. The second, a simple vessel, still contains its relics. Both would have been placed inside *stupas*. While devotees preferred relics of the body such as bones, hair, and nails, substitutes were accepted in their absence. Images of the Buddha were commonly used as relics, but reliquaries like the one shown here were filled with beads, semiprecious or precious gems, and pieces of gold. Such relics point to early associations—even identifications—of precious stones and gold with the divine.

3, 4

5 (front) 5 (side)

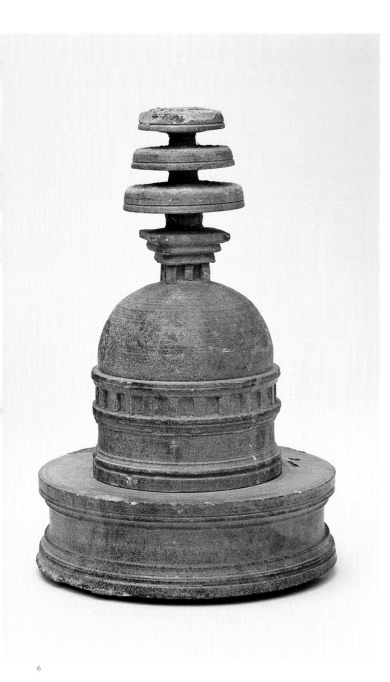

6

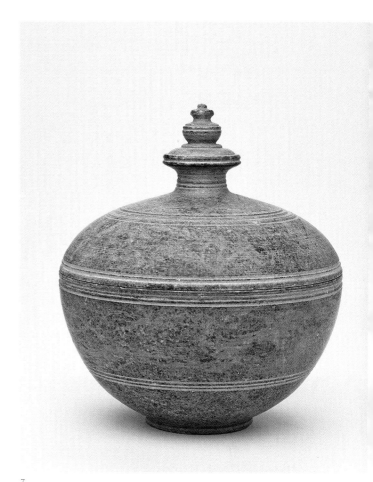

7

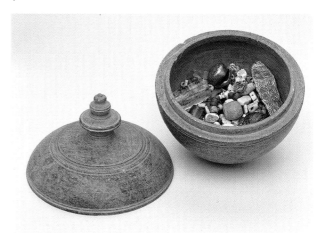

7

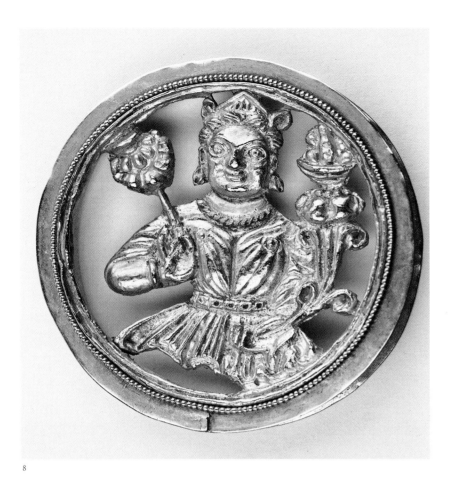

8

8
Gold ear plug

Gandhara; ca. 1st–2nd century C.E.
6 cm diameter

Once the ogre Hariti, who ate children, was converted to Buddhism, she became a protector of children and was worshiped as a goddess. Here, she holds a cornucopia in one hand and a flower in the other. She is represented in the Greco-Roman figurative style that was current in the Gandharan region and wears the clothing and crown of a Hellenistic deity. Two similar repoussé figures appear on Gandharan medallions in the Victoria and Albert Museum and in the Cleveland Museum of Art.[4] Other Gandharan ear plugs of this type have also been found in Gandhara. This is an unusually large and elaborate example, however. The earlobe would have been pulled to fit into a groove that runs along its rim.

9
Gold band

Gupta period (ca. 319–500), ca. 5th century
2.75 cm height

10
Gold band

Gupta period (ca. 319–500), ca. 5th century
2.5 cm height

Several examples of these bands survive and have been published. With its sliding latch intact, catalogue number 10 is one of the finest. No one knows how these bands were used. The latches do not appear to be suitable for pierced ears. They are generally described as beads, but beads do not require latches. Derek Content, a gemologist and scholar of classical jewelry, has noticed the striking resemblance of these pieces to gold Javanese bands that were put around the legs of birds.[5] Certainly Indra, associated with the sky (rain/clouds), seems an appropriate figure to ornament a bird, as do the celestial beings (*apsaras*) to his left and right, their legs held in conventional Indian flying poses (cat. no. 10). The figures on the other bead (cat. no. 9) are less easy to discern. They appear human, but the crisscross pattern on their legs may represent the feathers on the legs of celestial creatures who are half bird, half human (*kinnaras*). Needless to say, *kinnaras* would also be appropriate subjects for bird bands, should that prove to be what these bands are. A *kinnara* couple sits on the front of the bead, and two male *kinnaras* flank the pair.

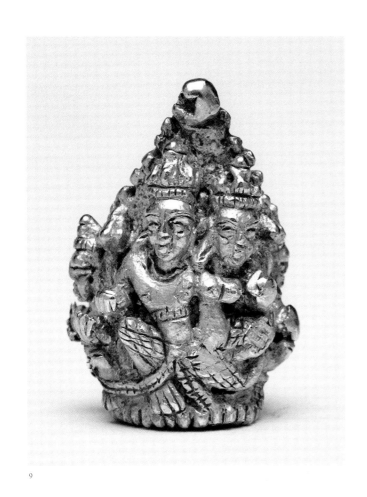

9

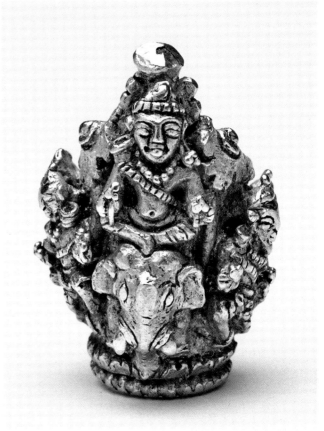

10 (front)

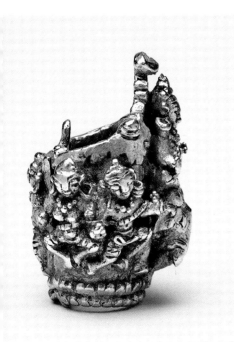

10 (left)

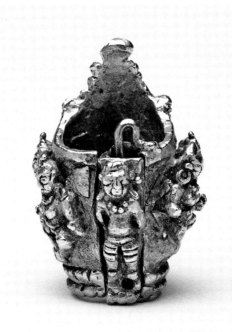

10 (back)

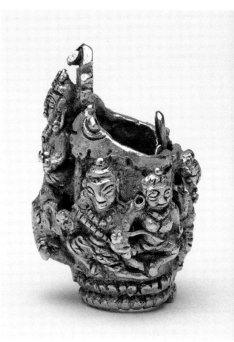

10 (right)

53

11

Ceramic jewelry and a lead bull (Nandi) inlaid with gold

Aurangabad region; possibly 8th century
Nandi: 1.5 x 2 cm

11

These pieces were surface finds in the Aurangabad region.[6] The collection includes a small lead bull representing Shiva's vehicle, Nandi. With its slender gold inlay, it was probably an offering to a Shiva shrine. Also part of the group is a ceramic piece stamped with a female figure, probably a Mother Goddess. The other pieces in the group are ceramic jewelry. Crescent earrings and earplugs like these have been found in ivory, stone, and metal. The baked clay may have been gilded, though at least one published example bears remnants of red paint.[7] Scholars do not yet know how these pieces were used. It is possible that they were worn by people of lesser means. However, the refinement of the styles suggests that they belonged to the realm of the upper classes. Like the Nandi, they may have been offerings to shrines, perhaps at the Hindu temples of Ellora, near where they were found. Ceramic earrings are often found in conjunction with images of the Mother Goddess like the one shown here.[8]

TEMPLE JEWELRY

With clothes, sacred thread, jewels, garlands and fragrant paste my devotee should decorate my form suitably and with love.[9]

Hindus who embrace image worship believe that deities enter into icons to make themselves present to worshipers. When a deity becomes manifest in the physical world by means of an icon, it acquires physical needs and wants. An icon must be fed, bathed, dressed, put to sleep, and entertained—all on a magnificent scale fit for the divine. In a temple, an icon resides in a small inner shrine called the womb-chamber (*garbha-griha*). Here, the devotee leaves the finely wrought forms of the temple behind to confront a small, dark, virtually unadorned room. Its doors are closed much of the time, and physical access is limited to priests. Devotees experience the divine across a threshold. However, that experience is highly sensual. It can include music played for the image, dancing, incense, sandal paste, flowers, fire light, the taste of *prashad* (food for the gods), and the sound of bells rung by worshipers to attract the deity's attention. Ornament is an essential part of this experience. The image (*murti*) is lavishly dressed, and, depending on the wealth of its temple, dressed head to toe in gold and precious gems. Gold and silver utensils, play things, exquisite gifts, and thrones add to the display of wealth. These catch the light, so that the deity literally shines forth from its shrine (see figure at left).

Worshipers may never see at close hand the jewels that adorn a deity. Temple jewelry is kept in a treasury and taken out to celebrate special occasions—the annual celebration of a *murti's* wedding, for instance, or its birthday. On these occasions, large crowds throng a temple, and many see little more than the glitter of the icon over a sea of heads.

Like attributes or extra limbs, jewelry is intrinsic to a deity. The devotee imagines Siva with his garland of skulls or Lakshmi exquisitely ornamented: jewelry is part of the sacred vision. A hymn to Devi describes her "[c]lad in garments of blue hue with tinkling pearl anklets . . . adorned with white armlets, wearing priceless gems and heavenly pearls . . . pearls glittering upon her nose . . . shining with variegated gems . . . with girdle binding beautiful hips, pearls wound around her braid."[10] In a passage like this, jewelry is an expression of the deities' glory, almost a bodily refulgence. At a temple, it is also an expression of a deity's popularity (and concomitantly, its greatness). The wealthiest temples were those that attracted the most wealth from donors, and every piece an icon wears is a gift from a devotee. Material wealth is translated into power. When an icon is more richly dressed, it is considered more potent, and wealthy devotees pay to have private viewings (*darshans*) of deities garbed in their finest.[11]

Gifts to the gods reap merit, and devotees often give jewelry to their chosen deities. Women desiring assistance in marriage or conception may give bangles or *talis*, while wealthy donors may have pieces made for a deity: gold sandals, for instance, or a large armband designed for a giant stone bicep (see cat. nos. 19 and 23). Kings often donated crowns, which sometimes became famous and generated special festivals around their wearing and viewing.

Family shrines were also richly adorned. A well-to-do family would provide its *murti* with precious thrones, utensils for worship, entire suits of clothes (changed according to the season), and special jewelry wrought small for the diminutive icons generally preferred at home. (see cat. nos. 17 and 18).

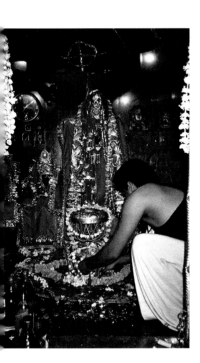

Kalka Devi shrine, Himachal Pradesh, 1999. Photograph courtesy of Anne Murphy.

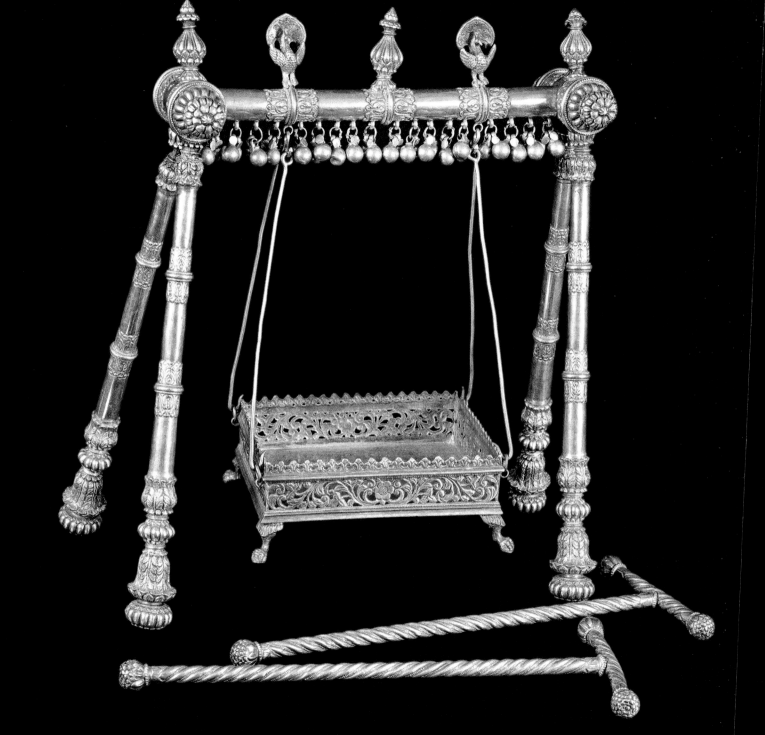

People also carried the divine with them in the form of devotional jewelry: pendants designed as tiny shrines, sacred symbols worn as amulets, the image of a deity on a pair of earrings, or an ornament for a braid. Traces of red paste (*kumkum*) show such ornaments were often treated as objects of reverence.

The Susan L. Beningson collection is particularly important for its temple gold and jewelry and its magnificent devotional pieces. Presented here, temple gold denotes items that were given to or used in temples and family shrines; devotional jewelry includes pieces used in personal devotion that bear images associated with deities.

12

Silver gilded swing for the image of a deity

India; 18th century
35.4 x 40 x 14 cm

This gilded swing is designed to entertain a deity and perhaps his consort. Hindus believe that gods and goddesses make themselves present in their icons. To honor the divine, worshipers treat them like honored guests or royalty, feeding them, entertaining them with dance and music, bathing them, putting them to sleep and waking them up, even celebrating their marriages and birthdays. Swings like this one were mostly used for Krishna, a playful and amorous god. The peacocks perched at the top of the swing are a further link to Krishna, who wears peacock feathers in his crown. Peacocks also symbolize monsoons and romance: the rainy season is a time of love, punctuated by the birds' cries.

This swing was probably used in a home shrine, though similar swings were also used in temples. The devotee would gently push the swing with the two rods pictured here. The small gilt balls on the upper arm would jingle lightly in the movement of the swing or when caught in a breeze, further delighting the deity. The seat of the swing, with its lion feet, is shaped like a throne (see cat. no. 13), honoring Krishna as king.

Published: Dehejia, *The Sensuous and the Sacred: Chola Bronzes from South India* (hereafter cited in text as SS), cat. no. 95.

13

Throne of gold with pendant glass beads for the image of a deity

Gujarat or Maharasthra; 1880s
10 x 11 x 8 cm

Indian thrones were low platforms, often resting on lion feet like this one (such thrones were called *sinhasana*, or lion seats). This miniature throne is edged with lotus petals and surrounded with a railing. The back of the throne is carved into flowers more Victorian than Indian in style. The suspended umbrella is a symbol of royalty and divinity. Such a throne would have been part of a household shrine and would most likely have contained a small figure of Krishna.

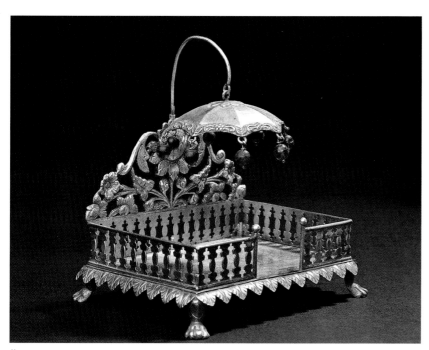

13

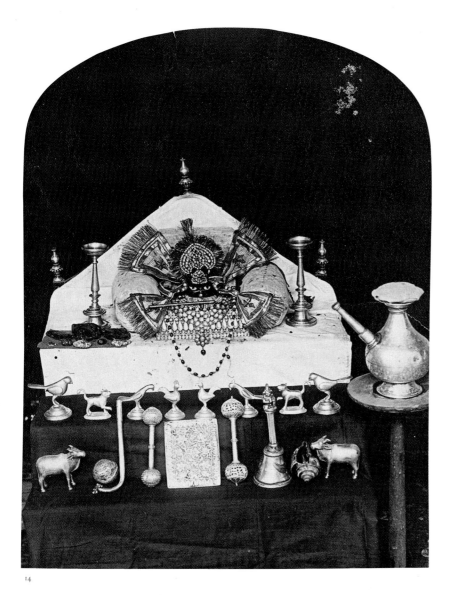

14

14

Photograph of a shrine

India; 19th century
Border: 24.3 x 19.7 cm; image: 22 x 17.1 cm

15

Gold accoutrements for a Krishna shrine

Western India; Umbrella and rattles: 18th century, two birds: late 18th to early 19th century
Umbrella: 11 x 9 cm; rattles: 13 cm length, each; parrot: 12.5 x 5.25 cm; peacock: 7 x 9 cm

These pieces ornamented a temple shrine. The umbrella, a symbol of royalty and divinity, would have hung over the deity. It is topped with a lotus and suspended from—as if carried by—a gold bird. The bird dangles a pearl from its beak. The tassels around the umbrella are modeled on various berries and nuts. The rattles, designed for the baby Krishna's play, unscrew to allow seeds to be placed inside. The round ends of the rattles are made of intricate floral open work (*jali*). The two birds are intended as play things or to set the scene for Krishna, reminding him of his village home. A nineteenth-century photograph of a shrine (cat. no. 14) pictures very similar objects before a Krishna shrine and shows how these objects would have been used.

16

Gold crown for the image of a deity, enameled and set with rubies, emeralds, and diamonds

Central India; late 18th or early 19th century
Base: 14 x 26 cm

Crowns are for rulers and deities in the south, for deities only in the north. Rulers often donated crowns to temples, a recognition both that crowns were theirs to give and that they ruled under higher authorities. In

15 (detail)

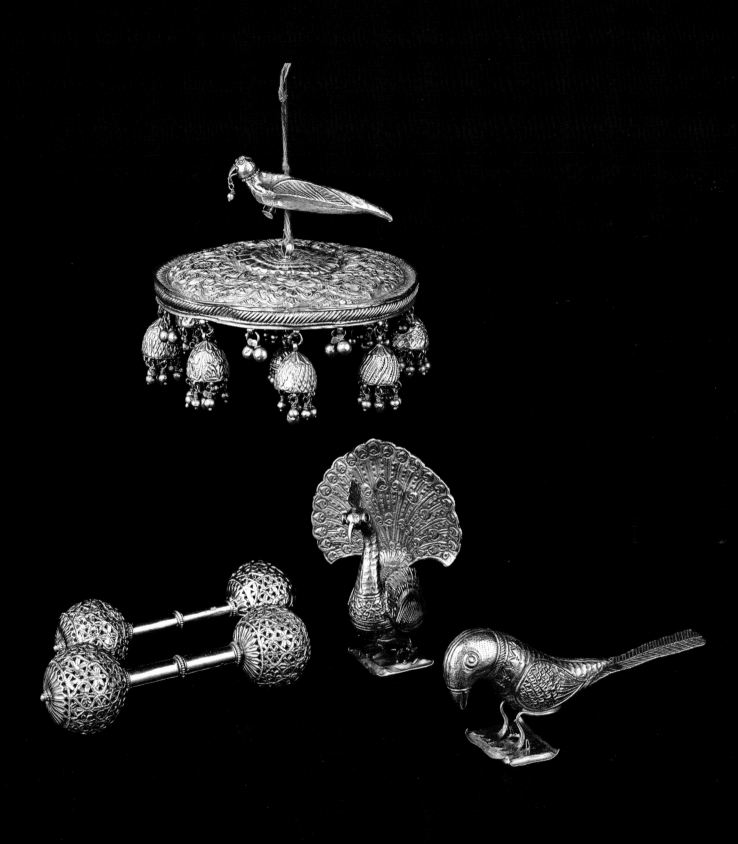

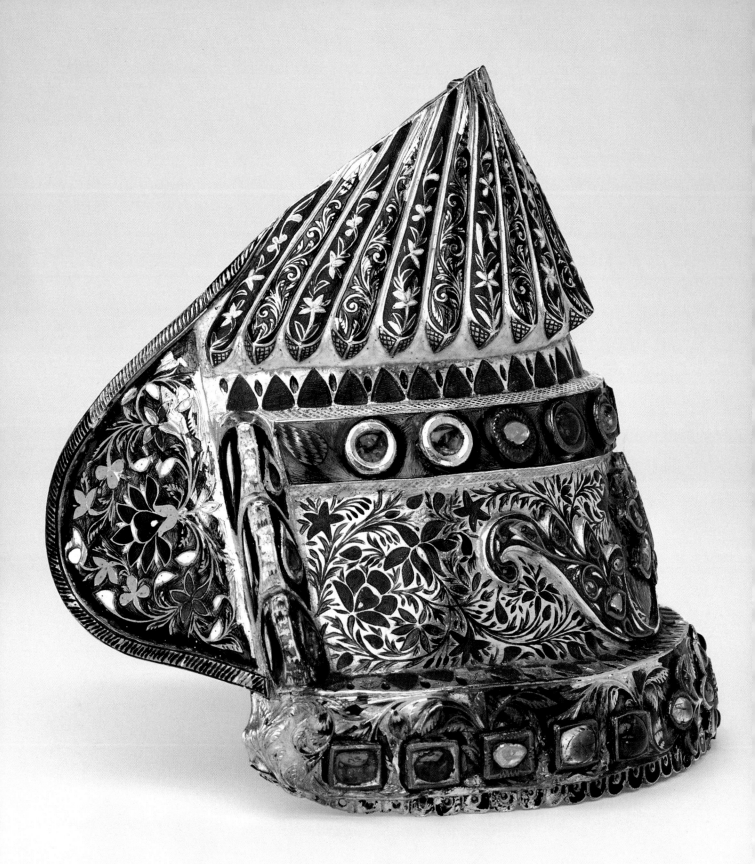

the south, famous temple crowns bore the names of the kings who had donated them and were often the focus of temple festivals.[12] This crown was probably made for a Krishna icon. It is likely that a feather plume (or a jeweled rendering of a plume) was attached through the hole at the top where the enamel is considerably worn. Ties laced through holes in the back would have bound the crown to the icon's head.

The crown is magnificently enameled. Enameled flowers and leafy foliage intermingle with *kundun* set jewel flowers. In addition to the usual red, green, blue, and white enamels used throughout, an unusual yellow enamel has been employed on the sides. A peach-colored enamel also appears on the sides and along the upper rim of the crown's base. The crown's decorative idiom and its extensive enamelwork are typical of North Indian ornament.

17

Gold crown in two parts for the image of a deity, set with rubies, emeralds, and pearls

North or Central India; early 19th century
5 x 4 cm

This small crown was probably made for the Krishna icon in a family shrine. The top fans out like the peacock plumes typically depicted on Krishna's crowns. The top and bottom halves of the crown are detachable.

18

Tiny gold crown set with diamonds, enameled on reverse

North India; early 19th century
2 cm diameter, 1.5 cm height

This tiny crown is easily mistaken for a pinky ring. A mere circlet topped with a flower, it may come from a house shrine, though miniature icons were also worshiped in temples. The rims of the circlet are enameled along with the inside. Nothing specifically identifies the crown with Krishna, but it was clearly made in North India, where Krishna worship dominated in the nineteenth century. Certainly, the floral imagery would suit Krishna's bucolic youth far better than it would suit, for instance, Rama's regalness or Vishnu's grandeur.

17

18 (front)

18 (back)

19

Sandals for a deity (*padukas*) of sheet gold over lac, set with rubies, emeralds, and diamonds and hung with pearls

Deccan; 17th–18th century
11.5 x 6.5 cm

These sandals are modeled on the kinds of shoes worn by deities and holy men. They may have been worshiped as Vishnupada, the feet of Vishnu. Alternatively, they may have been presented to a deity as a gift. To give *padukas* to a deity would be to honor the feet of the deity, that is, to place his feet above oneself.

Published: Dehejia, SS, cat. no. 94.

20

Gold pendant for a deity, set with rubies and emeralds, some of them engraved, and diamonds

South India; 18th–early 19th century
10.5 x 11.75 cm

Krishna sits on a lotus throne, flanked by his consorts Rukmini and Satyabhama. He raises his hand in *abhaya mudra* to give blessings and dispel fear, while his consorts wave pearl flywhisks over his head. This type of pendant seems to be found mostly in temple settings.[13] Two eighteenth-century queens in South India, one a queen of Keladi, the other a Rani Chennamma of Kittur, donated similar pieces to temples.[14] This pendant, though of a later date, adheres to a similar form: a tripartite arch framing Krishna and his consorts. Such pendants were sometimes

19

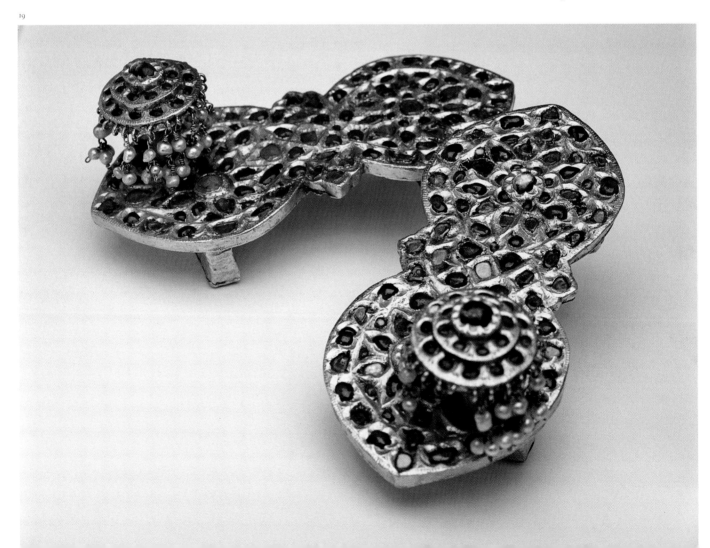

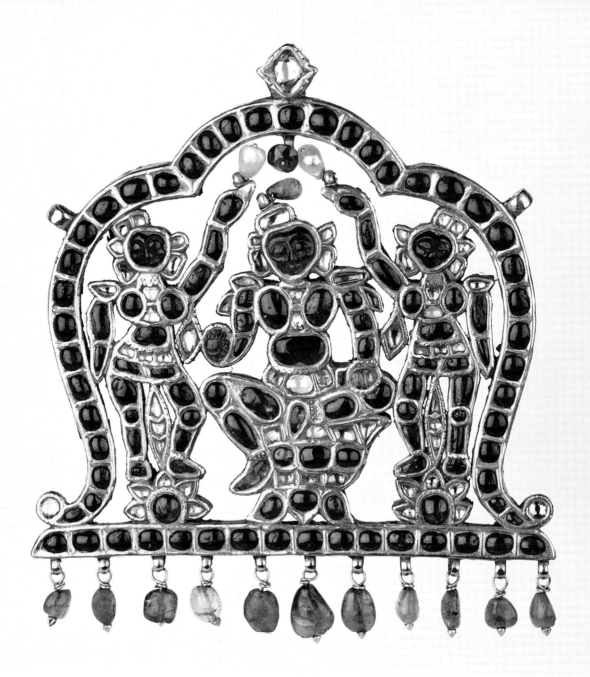

20

given stands so that they could be displayed on a shrine.[15] However, this object seems to have been worn, since the loops from which it would have been suspended betray signs of wear from a chain. The pendant's detailing is very fine. The gems on the figures of Krishna and his consorts have been engraved to depict faces, knuckled hands, and foreshortened toes. The rounded forms of the gems suggest the roundness of flesh and the bulge of bellies and breasts. Krishna wears

anklets of granulated gold.[16] The pendant has gone through several repairs and alterations. The back has been replaced at some point, and the pearls, ruby, and emerald that hang loosely over Krishna's head are later additions.

Published: Dehejia, SS, cat. no. 65.

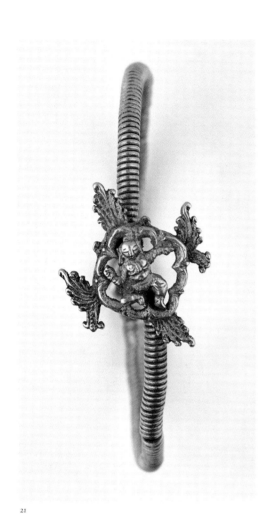

21

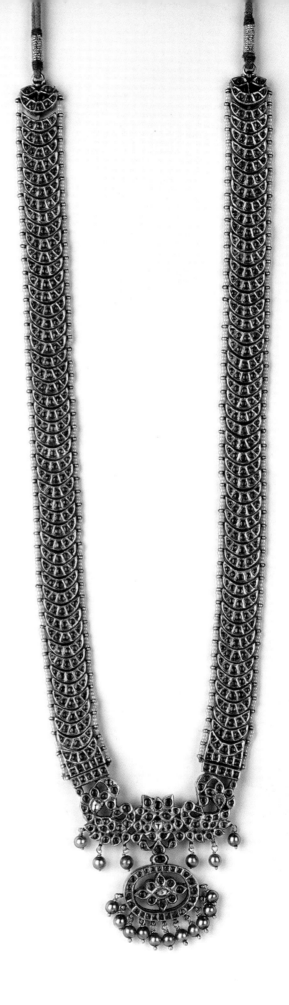

22

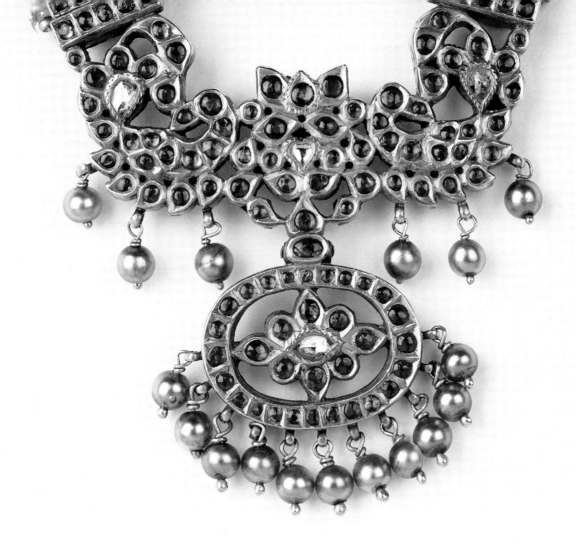

21

Gold bracelet

South India; 18th century or earlier
Image of Krishna: 2 x 1.5 cm

This tiny gold bracelet, probably a gift to a Krishna icon, pictures the baby Krishna dancing in a flaming mandala. The mandala turns the boy's playful dance into a cosmic one; Krishna's playfulness (*lila*) creates the universe.

22

Gold pendant necklace, set with rubies, emeralds, diamonds, and pearls

South India; 19th century
30.75 cm length

This necklace is typical of South Indian designs in which cabochon rubies tend to dominate. The sides of the necklace, forming a continuous band, comprise small crescents, a common motif in Indian jewelry. Small peacocks are almost hidden amid the gems at the base of the necklace, just above the pendant. Necklaces like this one were worn, but they could also be donated to a temple.

Published: Dehejia, SS, cat. no. 74.

23 (left)

23 (right)

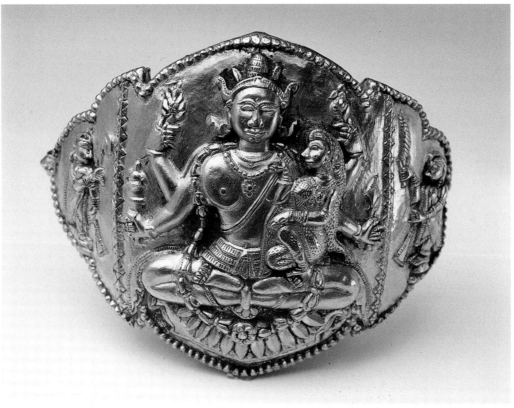

23

66

23

Armband of gold around a lac core, for the image of a deity

Central India; 17th to early 18th century
9 x 16 cm

This large, heavy armband would have been given as a gift to a figure of Vishnu and was probably worn by the icon. The four-armed Vishnu depicted on its face sits on a lotus, wears a large flower garland, and carries emblems of his divinity, including a conch and a *tulsi* plant. His sacred thread falls from his shoulder to his waist, and he wears rich jewelry, including a crown, earrings in the form of *makaras*, a floral pendant, and bracelets. His attendants hold a flywhisk and a fan; his consort sits on his lap.

24

Gold cobra-head braid ornament (*nagar*) with silver back

Tamil Nadu or Karnataka; 18th or 19th century
9 x 8 cm

On festive occasions, women in South India sometimes wear long, linked ornaments (*jadai nagam*) over the lengths of their braids. Such ornaments show cobras to symbolize fertility and sexuality.[17] They also play on a common poetic conceit equating women's braids with snakes, an equation based on Indian associations of snakes with wealth and fertility. The top of the *jadai nagam* (*nagar*) is shaped like a multiheaded cobra. The snake on this *nagar* shelters the deity Shiva and his consort Parvati. The god and goddess are flanked by attendants and sit on a trio of horned, masklike faces (*kirtimukhas*). Unusually, the *kirtimukhas* on the right and left have bird bodies with small wings and frothing tails. Two sacred geese (*hamsas*) perch to either side of the cobra's head, and a fourth *kirtimukha*, at the bottom of the piece, disgorges a crescent of vegetative ornament. The style and refinement of the piece point to a royal Madurai workshop. However, at least one similar piece has been documented in a temple treasury in Mysore, Karnataka.[18]

Published: Dehejia, SS, cat. no. 64.

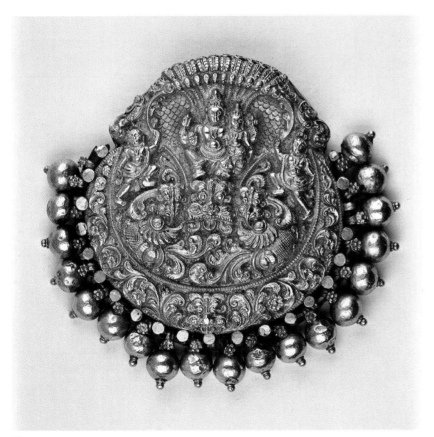

24

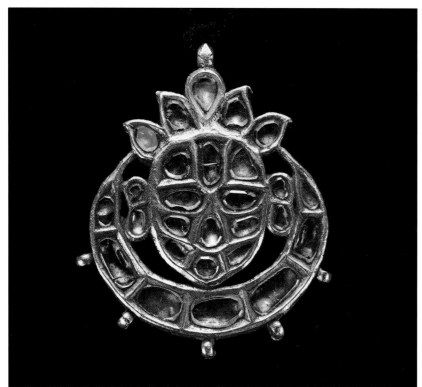

25 (front)

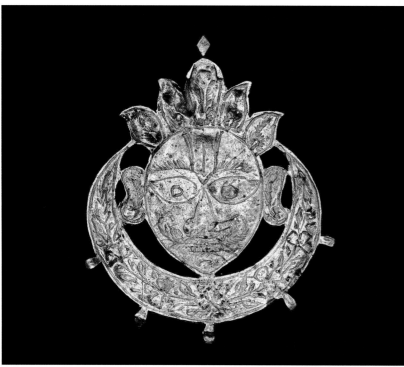

25 (back)

25

Gold pendant with diamonds and engraved back

Rajasthan or Kutch (?); 18th century
4.2 x 3.5 cm

The iconography of this piece is unusual. A crowned head in uncut diamonds rests on a crescent moon. The gold back is engraved with a mustached face, which bears a Vaishnavite marking on its forehead. Such a face would not have been made for decoration; it almost certainly represents a deity. One possibility is Rama, a Vishnu *avatar*, also known as Ramachandra, which means literally "Rama-moon," but which is perhaps best translated as moonlike Rama. However, close examination of the back of the head shows that the crown is engraved with peacock feathers. Only Krishna, another Vishnu *avatar*, wears a peacock feather crown. Krishna was most often represented without facial hair as a boy or young man. The moustache shows this to be the mature Krishna, a king and warrior. The moon must therefore represent his dynastic lineage, the moon lineage (*chandravamsha*). It is not customary to make an iconographic point of Krishna's dynastic lineage. That this piece does so suggests it was a matter of some importance to the wearer/donor, probably a member himself of the moon dynasty. Prominent *chandravamsha* clans include the ruling families of Jaiselmer (the Bhattis) and of Kutch (the Jarejas). The piece may have been made to be worn or as a gift to a temple.

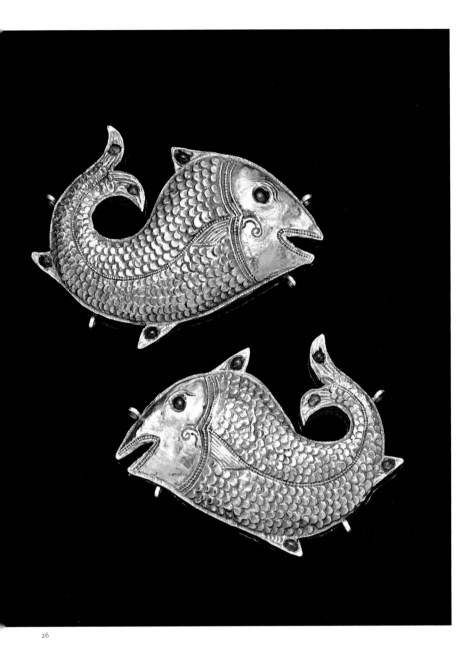

26

26

Pair of gold ear covers (*karnapatras*), set with rubies and emeralds

Orissa; late 17th or early 18th century
7.4 x 5.4 cm

Stylistically, these ear covers seem to be from Orissa. Engraved details delineate the fins, scales, and faces of the fish. Adornments for deities included not just jewelry but gold shaped to the parts of an icon's body: hands, feet, and torsos. Ear covers fall somewhere between jewelry and gilded body part. Called *karnapatras* or *karnakundala*, they were frequently worn in conjunction with crowns. They were wrought in a variety of forms, including ears, flowers, leaves, snakes, and lion faces.[19] *Karnapatras* like this pair would have been presented to a temple by a wealthy donor. Fish imagery is common in Orissa, as the state's major temples, such as the temple at Konark and the Jagannath temple at Puri, face the Bay of Bengal. Small loops around the fish would have held dangling pearls or gems.

27

Gold depiction of a vessel set with rubies and diamonds; an offering to a shrine

India; 19th century
3.2 x 3.5 cm

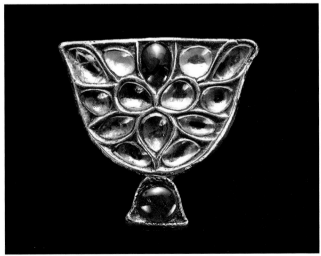

27

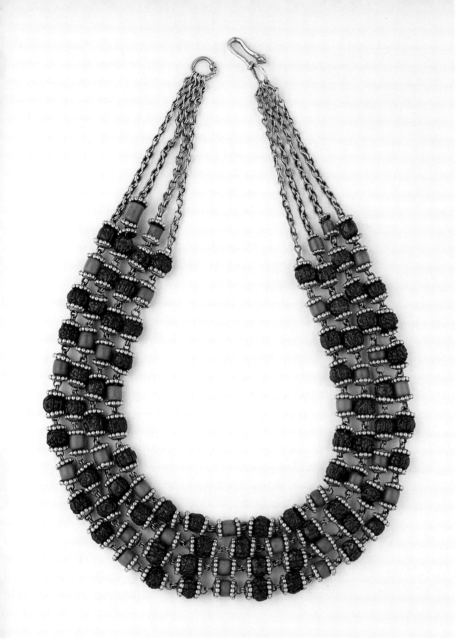

28

28
Rudraksha seeds and coral beads with gold caps on a gold chain

South India; 19th century
15 x 18 cm

According to Shaivite legends, *rudraksha* seeds were formed from the tears of Shiva and are sacred to that god. The name *rudraksha* breaks into two: *rudra*, a name for Shiva, and *aksha*, meaning eyes. Seeds from the fruit of an indigenous tree, *rudrakshas* are strung on necklaces often used as rosaries. The segments of the *rudraksha* bead are thought to represent the faces of Shiva, and the seeds are categorized by the numbers of their segments. These seeds appear to have six segments.[20] They alternate on the necklace with coral beads, which are thought to bring wealth.[21] Both the coral and *rudrakha* beads are held between gold caps.

29 and 30
Pendants of gold on green glass

Pratapgarh, Rajasthan; 19th century
Left: 6.5 x 5.5 cm; right: 1.75 x 2 cm

Jewelers from Pratapgarh invented a new technique in the mid-eighteenth century called *thewa*. *Thewa* involves the fusion of sheet gold with glass. A miniature scene is drawn on a thin sheet of 24-carat gold and then pierced with tiny chisels to create a filigree. The filigree is then placed on glass and heated in a crucible. The heat binds the gold and glass together.[22] *Thewa* pieces became popular in the nineteenth century, particularly among foreign visitors. Seeking mementos of Hindu culture, travelers sometimes purchased scenes of Hindu deities. However, the large Vishnu pendant pictured here was probably bought by a Hindu. Set

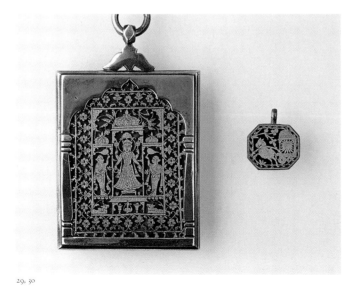

29, 30

in a silver frame cut into the shape of an arch, it looks like a small shrine. Its weight makes it cumbersome to wear, and it was probably used for devotional purposes.

31
Circular gold pendant set with rubies and crystal

Tamil Nadu; 17th century
4 cm diameter

This delicately wrought pendant opens like a box; a latch on the bottom allows the ruby and crystal lid to be raised and gives access to the figures inside. The inside of the box is conceived as a temple interior. An arch resting on pillars frames the figures from behind to create a temple setting. Shiva and Parvati sit on Nandi, Shiva's bull-vehicle. They turn toward the viewer to exchange eye contact (a ritual act called *darshan*) and receive worship. Nandi looks fondly back at his master, fitting his head neatly into the circumference of the scene. Tiny details are engraved onto the figures: the folds of clothing, the fringe of the cloth on which the deities sit, and the lines of Nandi's dewlaps. Worn around the neck, this pendant would have functioned as a private shrine. Personal devotion (*bhakti*) focused on a devotee's intimate relationship with her or his deity, a relationship unmediated by texts, priests, or rules. Here, Shiva and Parvati are kept close to the heart.

Published: Dehejia, SS, cat. no. 66.

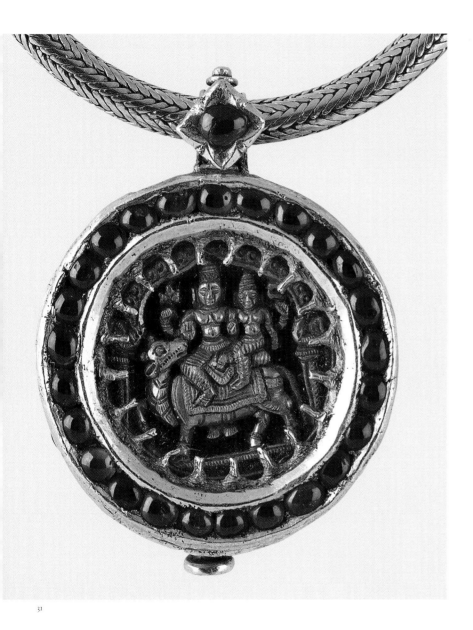

31

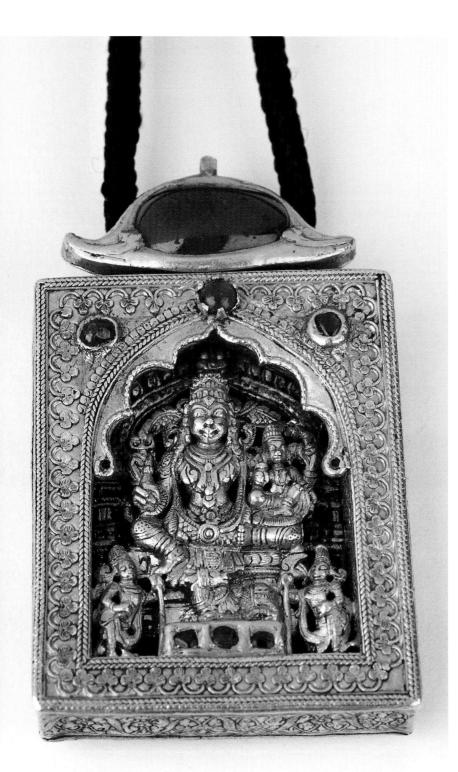

32

Gold pendant set with rubies and emeralds

Tamil Nadu; 17th century
3.5 x 5.75 cm

Shiva sits on a throne with Parvati on his lap. The bull Nandi lies at their feet, turning his head back to gaze at them. Shiva wears a crown, elaborate jewelry, and a flower garland, and he holds a trident and deer in two of his four hands. Two attendants flank the trio. This exquisitely detailed piece, probably made for a royal patron, was conceived as a miniature temple. A columned arch resting on pillars stands behind the deities to define an interior space. It is richly ornamented and bears the face of a *kirtimukha* at its apex, hidden from casual view. A scalloped arch in front of Shiva and Parvati completes the architectural space. The front, sides, and back of the pendant are also meticulously decorated.

A red powder used in worship (*kumkum*) still clings to the pendant, evidence that it was once used at a temple or for personal worship. The owner's astrological chart is engraved on the inside of a small, hinged door. The style suggests an early date of about the seventeenth century. The scalloped arch that frames the figures came into fashion during the seventeenth century, so the pendant must date from that time or later.

Published: Dehejia, SS, cat. no. 67.

32

33, 34, 35

Clockwise from top:

33
Gold conch amulet

India; 17th–18th century
3.7 x 2.7 cm

34
Gold amulet with an impression of Vishnu's feet *(Vishnupada)*

India; 17th–18th century
3 cm diameter

35
Gold Vishnupada

India; 17th–18th century
2 x 1.5 cm

Vishnu was sometimes worshiped in the form of his feet—Vishnupada. Showing reverence to the feet of a deity, an elder, a holy man, or someone of higher status is a common practice in India. Buddha's feet were also objects of worship. Amulets like these would be tied around the neck to keep Vishnu close to the heart and to identify the wearer as a Vaishnavite. A song in praise of Vishnu's feet concludes: "This very sacred Pada [Vishnu's feet] has bestowed on the lives of many great saints a place of sublimity."[23]

The conch would have performed a similar function. A symbol of Vishnu, the conch is often held in one of his hands. Two holes pass through each side of the "bead," suggesting it may once have been attached to another piece of jewelry.

36 (front) 36 (back)

38

36
Gilded silver ring

Mysore; 18th century
Seal: 2 cm diameter

37
Gold ring covered with crystal

Mysore; 18th century
Seal: 2 x 1.5 cm

The coronation of Rama was a popular scene among Mysore artists and jewelers. Both these examples follow what seems to have been a fixed convention. Rama sits on a platform with Sita in his lap. He is approached below by the monkey king Sugriva and the superhuman Hanuman, a deity in his own right, who is cherished for his devotion to Rama. Catalogue number 37 has been carved[24] and catalogue number 36 stamped. Catalogue number 37 is far more detailed and skillfully made than catalogue number 36, which is considerably worn. Both rings picture the same number of figures arranged in almost the same disposition. However, catalogue number 36 does not have the umbrellas found in catalogue number 37, and its figures are barely legible: it takes some foreknowledge to find Sugriva's tail or trace Sita perched over the thigh of her husband.

38
Gold seal ring bearing the inscription "Shri Ram Ram Ram Ram . . ."

South India; 10th century
Seal: 2 x 1.5 cm

The engraved inscription seen here has been written backward, so that it could be used as a seal. Called "winged signet rings," *muhr* rings of this kind were made in Maharashtra, Karnataka, and Bangelore.[25]

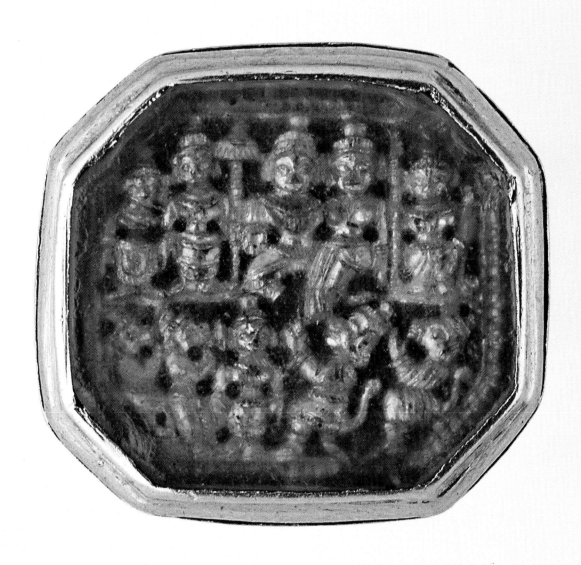

39

Gold Vaishnavite forehead pendant (*tikka*) set in rubies and diamonds

India; 19th century
3 x 2 cm

Devotees express their allegiance to a particular deity by painting a sectarian *tikka* on their foreheads. This gold *tikka* in a U-shape worn by devotees of Vishnu would supplement such a mark. It is not clear how it was attached to the forehead. It was probably worn by a priest.

40

Gold medallion bracelet set with rubies

Tamil Nadu; Medallion: possibly 17th century, bracelet: 19th century
7 cm diameter, 3.5 cm height

The figure represented in the center of this medallion, with a flower garland around his shoulders and a crown on his head, is

39

40

probably Vitthala.[26] Vitthala was initially a cult hero from Maharasthra, but he was later identified with Krishna. He is most often worshiped by low-caste devotees, but this piece was clearly made for someone of refinement and wealth. Vitthala's body sways in a graceful S-shape called the three-bend pose (*tribhanga*). His strong, rounded body and stout proportions suggest an early date, possibly earlier than the seventeenth century. The circle of cabochon rubies that frames him may be a later addition. Certainly, the bracelet into which the medallion has been set is much later. It is Victorian in style, though its engraving is executed in an Indian manner, punched with a small chisel rather than carved.

41
Gold pendant

Mewar, Rajasthan; 17th–18th century
9 x 5.5 cm

The sun and moon to either side of the horse's head are emblems of the Mewar royal house (Udaipur, Rajasthan). The umbrella is a symbol of royalty and divinity. The umbrella was not used much by the Maharanas (the kings of Mewar) but had ancient associations. Here, the umbrella stands over the horse rather than the king. He may be Vishnu's tenth *avatar*, Kalki, who is expected to arrive at the end of the present dark age riding a horse and bearing a flaming sword. The Maharanas of Mewar would have worn the pendant in a religious ceremony. However, the absence of a sword in this image (associated with Kalki) is puzzling, as is the bowl from which the horse seems to eat, for it emphasizes his horse character over his heroic dimensions. The eighteenth century saw a revival of the ancient horse sacrifice performed by kings to assert their control over land. Perhaps this is not Kalki but a horse from an Ashvamedha sacrifice. (At Jaipur, an association was made between Kalki and the Ashvamedha at a Kalki temple built to commemorate the sacrifice). The presence of the Mewar emblems would make sense in this context, as would the umbrella, which shows the horse to be, in a sense, a representation of the king conveying his rule across the land. Horses in the Ashvamedha are said to have been adorned with special pendants, though these have not been described. The size and shape of this piece would suit it for a horse, and gold would be appropriate for the sanctity of the ritual.

41

42

Gold forehead pendant (*tikka*) set with rubies, emeralds and a diamond and hung with pearls and rubies

North India; 19th century
5 x 3 cm

A *tikka* is a dot on the forehead, marking the site of what Hindus believe is the third eye. Women traditionally place a cosmetic *tikka* or *bindi* on their foreheads after marriage. They may also wear a piece of jewelry on the forehead that is called a *tikka*. This usually dangles from a chain or string of pearls that lies along the central part and is discreetly attached to the hair. In some communities, the *tikka* is considered one of the

signs of a married woman. This *tikka* features a flower blossoming above a red crescent moon. Though associated with Islam, the crescent moon is a motif found in both Hindu and Muslim jewelry. A number of similar *tikkas* have been published;[27] the design seems to have been widespread. The triangular diamond at the top of this piece is a late translation of a flower bud featured in earlier *tikkas* of this design.

43

Gold cobra-head braid ornament (*nagar*) set with rubies, emeralds, diamonds, and pearls

South India; 18th century
5 x 5 cm

Krishna plays his flute and dances on the snake Kaliya. The image of a deity sheltered by a snake is an ancient one in India and originates in snake worship. Co-opting early snake-god (Nagaraj) imagery, Buddhists and Hindus developed stories that placed images of their gods under cobra hoods. Needless to say, an ornament like this one would belong to a Vaishnavite woman, while catalogue number 24 would have graced the hair of a Shaivite. Such ornaments were often worn by young women trained in dance who were married to a god (*devidasis*).[28]

The most astonishing detail on this piece would probably have eluded most people who saw the ornament in its wearer's hair: the emerald head of Krishna is beautifully carved into a soft youth's face. The back of this *nagar* also rewards examination, for it has been engraved with the ribs and scales of a snake's skin (see fig. 22, p. 38). As in catalogue number 24, small birds, probably *hamsas*, flank the cobra, all but invisible to a casual glance. There is a nearly identical piece in the National Museum, New Delhi.[29]

Published: Dehejia, SS, cat. no. 62.

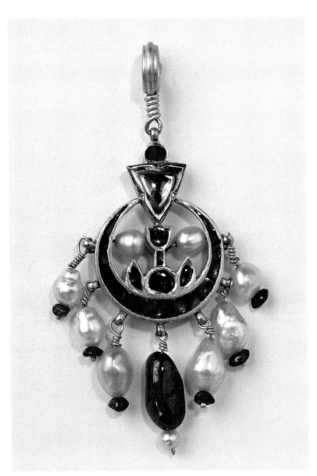

42

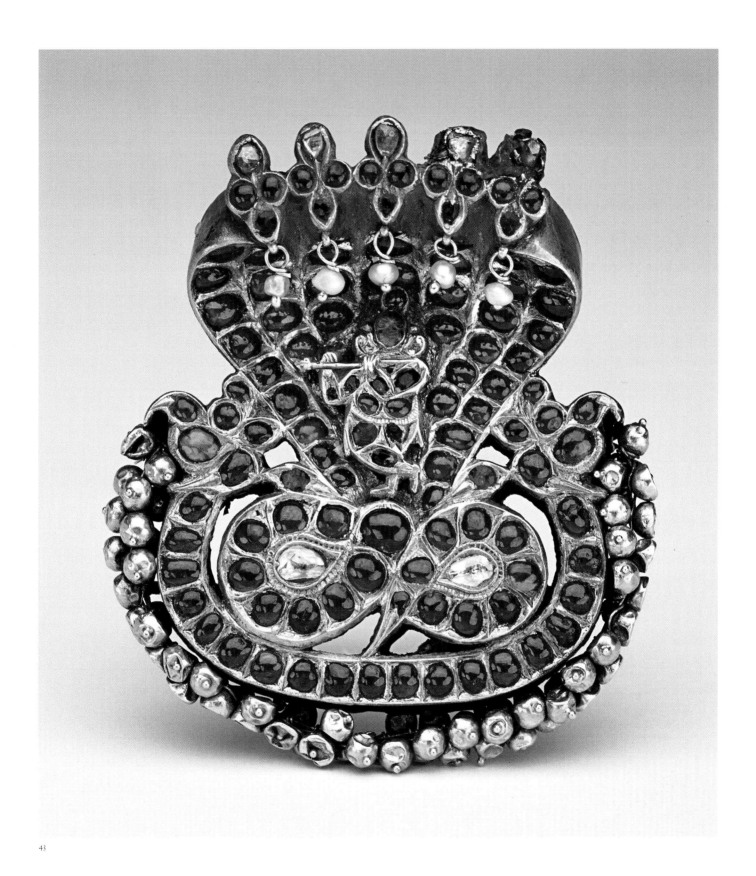

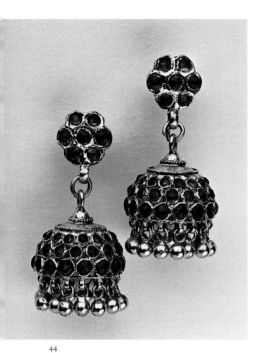

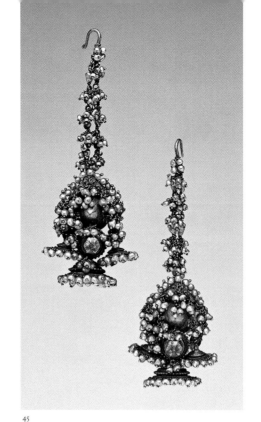

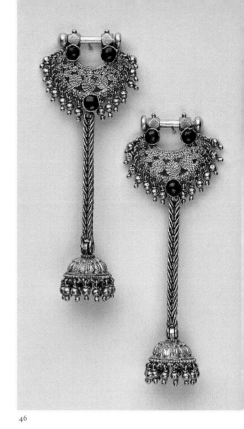

44

45

46

44
Gold swaying earrings (*jimki*) with rubies

South India; 19th century
2.5 x 2 x 2 cm, each

45
Gold swaying earrings (*jimki*) with pearl and coral

Tamil Nadu or Karnataka; 18th century
6.5 cm long, each

Published: Dehejia, SS, cat. no. 90.

46
Gold swaying earrings (*jimki*) with red stones

Tamil Nadu or Karnataka; 18th century
9.4 x 3.5 x 3.5 cm, each

Published: Dehejia, SS, cat. no. 89.

Indian jewelry is designed to enhance the movements of the body as well as its forms. Anklets and bangles ring; necklaces and earrings sway. Earrings like catalogue numbers 44, 45 and 46 augment the movements of the head. Such earrings in Indian poetry are often said to graze a woman's cheek during love play, indicating that she has taken a position above her mate. The tassle (*jhumka*) of catalogue number 46 is hinged to a braided gold chain. Tiny gold beads supplement the sway of the chain with a jangling motion. Catalogue number 45 is constructed of several individual pieces bound together. Seed pearls give the impression of a quivering, intricate whole. At the center of each earring, gold cones almost buried in pearls are backed with pegs that fit into ear holes; pearl-strung chains pull over the ears, fasten behind them, and take the weight of the earrings off the lobes.

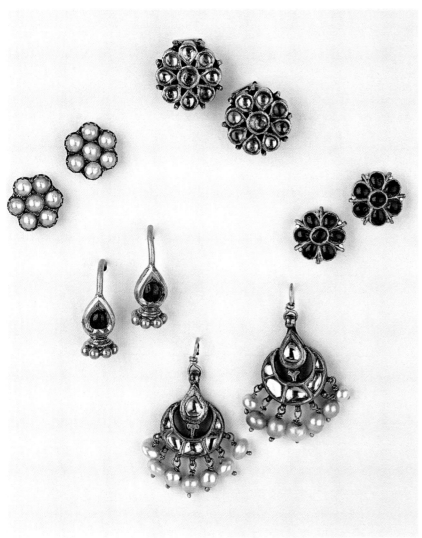

47, 48, 49, 50, 51

Clockwise from top:

47
Gold earrings *(thodus)* set with white sapphires

South India; 19th century
2 cm diameter and 1.5 cm depth, each

48
Gold earrings set with rubies

South India; 19th century
1.5 cm diameter and 1.8 cm depth, each

49
Gold earrings set with diamonds

North India; 19th century
3.6 x 3 x 0.5 cm, each

50
Gold earrings set with rubies

South India; 19th century
3 cm long, each

51
Gold earrings *(thodus)* set with pearls

South India; 19th century
1.5 cm diameter and 1.1 cm depth, each

Published: Dehejia, SS, cat. no. 82.

Simple round earrings like catalogue numbers 47, 48, and 51 are called *thodus* (meaning seven-stone ear stud) in South India. They are worn on the lobe, together with other earrings placed higher on the ear. Their design alludes to the Indian custom of wearing flowers in the ear instead of earrings. Catalogue number 49 draws on another common design from nature, the crescent moon. Originally, this last pair may have formed part of a necklace or other ornament.

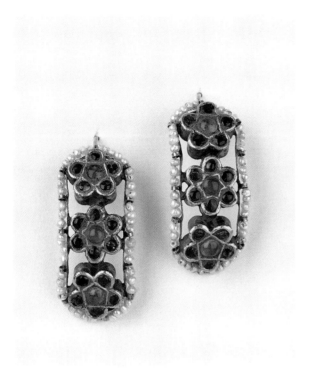

52

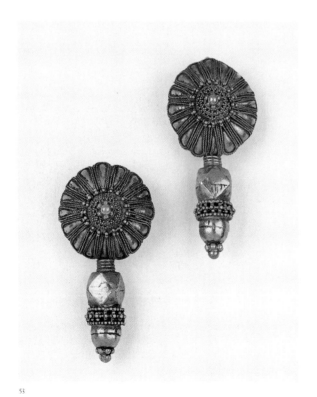

53

52

Gold earrings set with rubies, emeralds, and seed pearls

South India; 19th century
3 cm long, each

53

Gold earrings

Saurashtra-Kutch; 19th century
5.7 x 2.9 x 2.5 cm, each

54

Double-sided gold earrings with pearls

Travancore; possibly 16th century
4.6 x 3 x 1.3 cm, each

Both sides of these exquisite earrings bear images of the goddess Lakshmi lustrated by elephants. Yet their fronts are subtly identified by three tiny pearls that dangle at the top of each roundel. Lakshmi, the goddess of wealth and good fortune, is strongly associated with gold. Her icon on these earrings expresses the essence of wifehood: that a beautifully adorned wife, who models herself on Lakshmi, will bring prosperity to her home. The earrings derive from a very old design, dating back at least as far as the eleventh century.[30]

Published: Dehejia, SS, cat. no. 85.

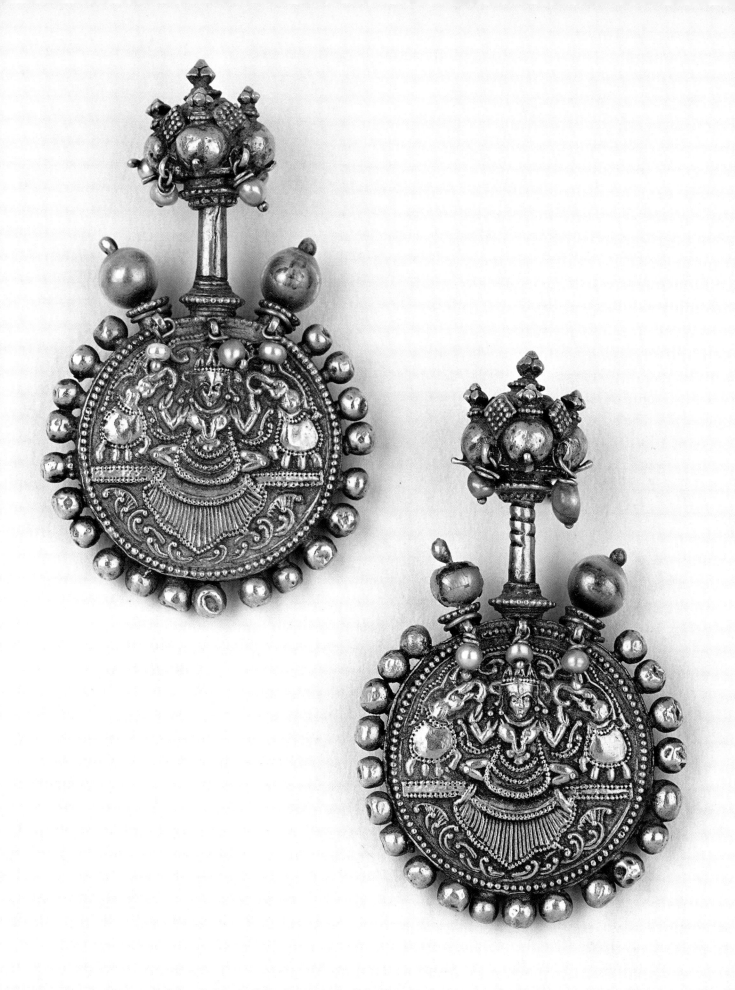

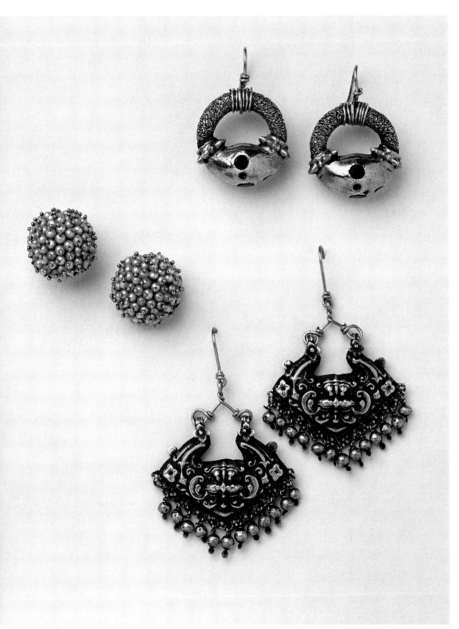

Clockwise from top:

55

Gold rope earrings with red stones

Western India; 18th century
2.2 x 2.2 x 1.2 cm, each

Published: Dehejia, SS, cat. no. 84.

56

Gold earrings with *kirtimukhas*

South India; 19th–early 20th century
3 cm width, each

These repoussé earrings bear horned, mask-like faces (*kirtimukhas*). *Kirtimukhas* are usually found on places associated with beginnings and endings, such as thresholds and apexes. They are a common motif in temple architecture, often crowning doorways and entrances to shrines. Typically, a stream of ornament pours from their mouths. They are understood both to emit and consume, symbolizing the divine powers of creation and destruction. *Kirtimukhas* feature more on South than on North Indian jewelry (see cat. nos. 24 and 83). They offer the wearer protection against evil influences.

57

Earrings made from buttons of pearls linked with gold wire

India; 19th century
1.7 cm diameter and 1.6 cm depth, each

55, 56, 57

58, 59, 60

Clockwise from top:

58
Gold earrings with gold mesh balls

South India; 18th–19th century
2.9 x 2.8 x 0.8 cm, each

59
Gold wire earrings

North India; 19th or early 20th century
5 cm length, each

A single gold wire turns sinuously into a snakelike form. The wire thickens and thins with the elegance of a painted line, and the decorative end flattens as it rolls into a spiral. The design may be intended to evoke a snake or perhaps the outline of a mango (a paisley form). However, other examples of this type of earring betray no obvious model from nature and sometimes end in a simple spiral.

60
Gold earrings called "knot" (*mudicchu*)

Tamil Nadu; 16th–17th century
1.5 cm diameter and 0.5 cm width, each

These earrings are not as simple as they look. They appear to be made from a single coiled wire but are hinged and fastened with a screw.

Published: Dehejia, SS, cat. no. 81.

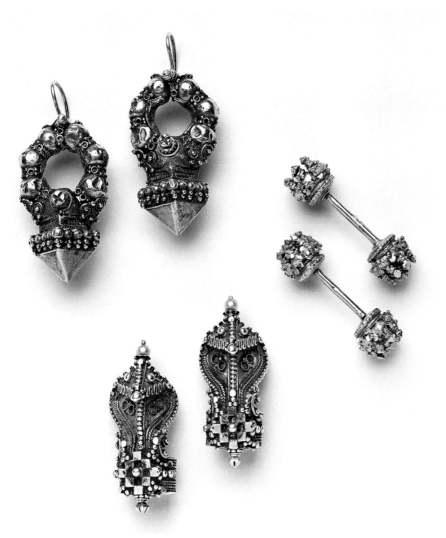

61, 62, 63

koppu refers to the earrings' clovelike shape. Such studs are worn together with other earrings on the helix and lobe of the ear.

Published: Dehejia, SS, cat. no. 87.

63

Gold earrings with pearls in the form of rearing cobras *(nagavadura)*

Tamil Nadu; 18th–19th century
3.2 cm length, each

A nineteenth-century British source described Sudra women wearing earrings like these along with five other ear ornaments.[31] Like much South Indian jewelry, these pieces combine natural forms with architectural geometry. The bottoms end in a small gold finial, and the base of the snake's curling body is decorated with concentrically arranged squares resembling the concentric geometries found on temple walls and spires; it is a motif that is common on South Indian jewelry. Yet the snake has life, with gold bead eyes and markings on its breast made of applied gold wire. Gold zigzags along its mouth, though purely decorative, give an impression of toothiness. The ornamentation has been applied to the surface in the form of wires, stamped motifs, and granulation. Pearls are set on the top of the snakes' heads. The earrings are hinged with latches, a puzzling and seemingly awkward mechanism for an earring.

Published: Dehejia, SS, cat. no. 86.

61

Gold earrings called "molten beads" *(urukkumani)*

Tamil Nadu; 18th–19th century
3 cm length, each

Published: Dehejia, SS, cat. no. 79.

62

Gold ear studs *(koppu)*

Tamil Nadu; 18th–19th century
2.75 cm length, each

These ear studs, however small, are complex, almost architectural constructions. Made of sheet gold, they terminate in spheres, surrounded with tiny petals of gold and buried under a cluster of pyramidal tips. The term

64

Gold ear studs in the form of lotuses, set with rubies

Assam; 19th century
3. 75 x 2.5 cm, each

The lotus is associated with purity because it rises clean from muddy waters. Long a sacred symbol, the lotus is among the most

64

ancient motifs in India. Here slender gold lines etched beneath the petals re-create the gently striated surface of petals; they are hidden to anyone but the wearer. Petals also wrap the earring stems, as if the stems too were blooming.

Published: Dehejia, SS, cat. no. 78.

65

Geometric earrings (*thandatti*) of gold over a lac core

Tamil Nadu; 19th century
4 cm length, each

These earrings look solid and heavy, but, filled with lac, they are surprisingly light. Typically they hang in groups of similar earrings on hugely stretched ear lobes. Women in Tamil Nadu begin stretching the holes in their ears from a young age. Though large ear lobes suggest a lifetime wearing heavy jewelry, the stretching is done artificially with posts made of wood.

Thandatti are made in both gold and silver. Some take the form of monkeys or bats, while others, like these, are purely abstract. One author has compared them to a sacred design (*yantra*),[32] but the original inspiration for these striking and unusual arrangements is now lost.

Published: Dehejia, SS, cat. no. 80.

66

Gold tubular earrings (*puchikudu*)

Tamil Nadu; 18th–19th century
3.75 cm width, each

The term *puchikudu* means insect nest, suggesting a model for the zigzag pattern and tubular shape of these earrings. The gold finials at the base are a common South Indian motif. Earrings like these were worn over a stretched ear lobe.

Published: Dehejia, SS, cat. no. 83.

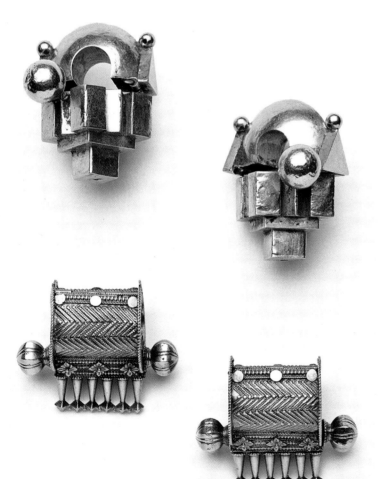

65, 66

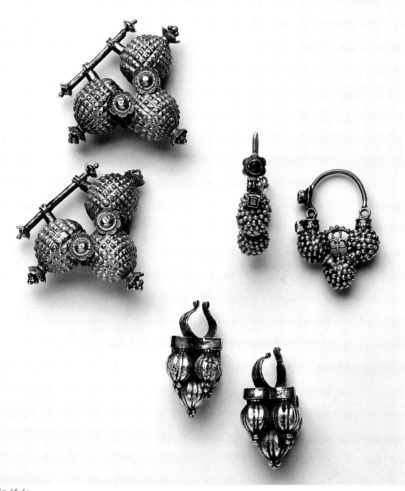

67
Gold earrings

North India; 18th century
4 cm width, each

Published: Dehejia, SS, cat. no. 88.

68
Gold men's earrings set with glass

Barmer and Jaislemer, Rajasthan; 19th–early
20th century
3.25 cm length, each

69
Gold earrings

North India; possibly 18th century
3 cm length, each

All three pairs of earrings, comprising hol-
low beadlike pieces, imitate seeds and berries.
Seeds and berries are associated with fertility

and are among the earliest motifs in Indian
jewelry. Forms such as these long predate
the Mughal designs that came to dominate
Indian jewelry—particularly North Indian
jewelry—after the seventeenth century.

Clockwise from top:

70, 71, 72, 73
Nose rings of gold, pearls, semi-precious stones, and glass

Maharashtra or Gujarat; 19th century
Clockwise from top: 6 x 4.2 cm; 5 x 4.5 cm;
15 x 6 cm; 5 x 4 cm

The nose ring was introduced to India by
Muslims entering the Subcontinent between
the eighth and twelfth centuries. Though
young girls wear them, nose rings are con-
sidered an essential ornament for married
women in many parts of India. Nose rings
like these would be worn only on special
occasions. An often-cited passage by a nine-
teenth-century missionary notes: "When the
wearers are at meals, they are obliged to hold
up this pendant with one hand, while feed-
ing themselves with the other."[33] The basic
term for nose ring in India is "*nath*," also the
term in Sanskrit for "lord" or "husband"
and in Hindi for a rope passed through
a draft animal's nose. These overlapping
meanings frame the *nath* as an emblem of a
woman's slavery in marriage. Popular notions
of the nose ring appear to draw on these
associations: for instance, a pandit, cited on
an on-line forum, believes nose rings control
a woman's anger.[34] Nose rings are generally
worn in the left nostril, though women from
some communities wear them in both nos-
trils or through the septum. According to
popular belief, the left nostril was linked to
a woman's reproductive organs, and the nose
ring aided a woman's fertility and childbirth.
Some of the most elaborate *naths*, like those
shown here, are made in Maharashtra. An

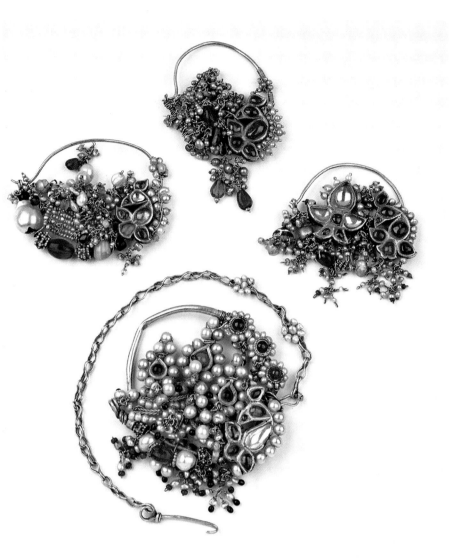

70, 71, 72, 73

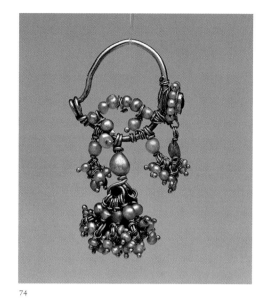

74

74

Nose ring of gold, pearls, and glass beads

Maharashtra or Gujarat; 19th century
5 x 5 cm

following page, clockwise from top:

75

Nose ring of gold

Gujarat; 19th century
6.2 cm length

76

Nose ring called *laung* of gold and glass

South India; 19th century
3 cm length

77

Nose ring of gold, set with diamonds and emeralds

Central India; 19th century
5.5 cm length

78

Nose ring of gold, set with pearls and glass

Central India; 19th century
5.5 cm length

underlying armature defines the basic shapes: the circlet of the nose ring itself, a peacock set with gems and often a flower or paisley. On and around this armature, an elaborate rigging of slender gold wires binds tiny seed pearls and beads to the ring. The backs of these rings reveal a complex winding and binding of tiny parts to the whole. They are etched with the outlines of a peacock, demonstrating the typically Indian sensitivity to hidden surfaces. In the case of the largest *nath* (cat. no. 72), gold chains augment the wires binding the tiny parts together, and a larger chain has been added to attach the ring to the ear. This last chain is intended to take some of the weight of the ornament off the wearer's nose.

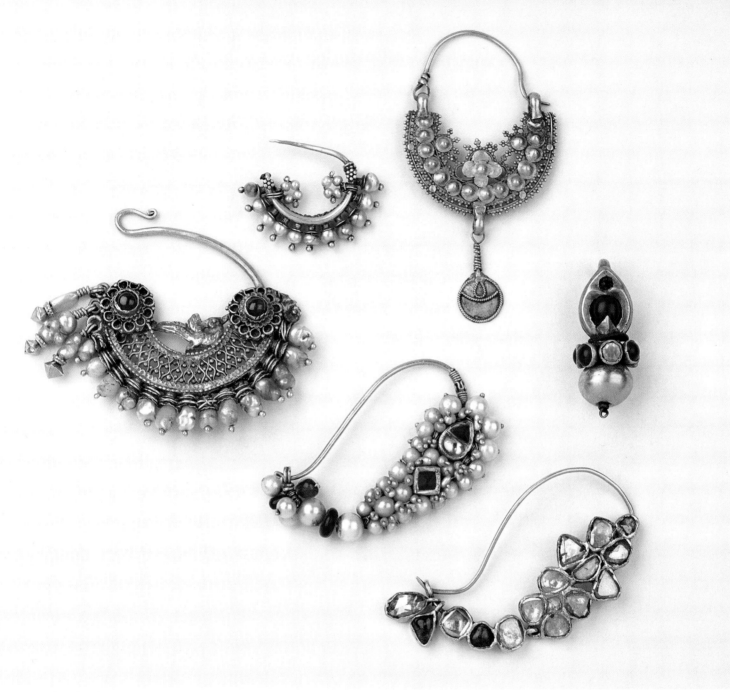

79
Nose ring of gold, set with pearls and garnets

North India or Pakistan; 19th century
6.2 cm length

80
Nose ring of gold, set with pearls

South India; 19th century
3.25 cm length

Catalogue numbers 75, 79, and 80 are crescents, a common form for nose rings as it fits neatly under the nose. The contours of catalogue numbers 77 and 78 are based on the mango, a form that is commonly found as paisley on Indian textiles. The type represented by catalogue number 76 is sometimes called a *laung*, meaning clove. The most precious of the nose rings pictured here is catalogue number 77. The jeweler has

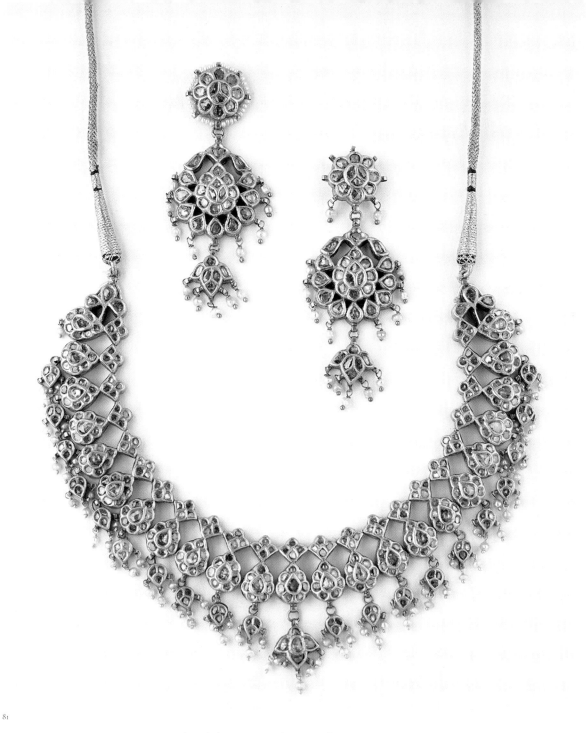

81

accommodated the piece to the irregular
shapes of its gems rather than cut the gems
into conformity with one another. In Indian
jewelry, a precious stone is rarely cut down
and faceted to perfection. Faceting was
known and practiced on semiprecious gems,
but with precious stones, size was valued
over glitter and symmetry.

81
Gold necklace and earrings set with diamonds

North India; 19th century
Necklace: 29 cm length; earrings: 6 cm length, each

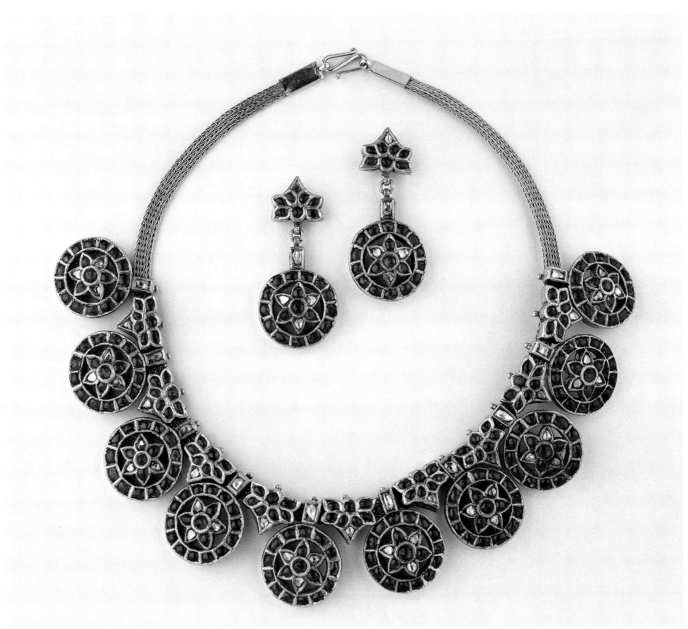

83 (pendant)

83 (earrings)

82

Gold necklace and earrings set with diamonds, rubies, and emeralds

South India; 19th century
Necklace: 50 cm length; earrings: 5 x 2.4 x 0.6 cm, each

Though most of the ornaments exhibited here were purchased singly or in pairs, Indian women often buy jewelry in sets. Generally necklaces are purchased with matching earrings as in these two sets, which exemplify northern and southern tastes. The northern set (cat. no. 81) is all cool shimmer with small, dangling flowers, leaves, and seed pearls. The southern set (cat. no. 82) has more structure, less dangle, and is warm with its characteristically southern profusion of cabochon rubies. The units and sub-units of the northern set barely touch one another, joining at their tips to create a loose, open effect. The larger units of the southern set fit more snuggly together.

83

Gold pendant and earrings

South India; 19th century
Pendant: 5.8 x 7.5 cm; earrings: 2 x 2.3 cm, each

This set was not originally designed as such. The two smaller pieces, recently turned into earrings, may have formed part of a necklace. However, they and the larger pendant do not seem to have been made at the same time. The centerpiece bears a repoussé relief of Vishnu dancing on a snake. The earrings picture Krishna playing his flute and dancing on Kaliya (see cat. nos. 43 and 150). Birdwood has published a similar piece from Sawantwari, near Bombay. According to Birdwood, Sawantwari produced the best repoussé gold jewelry in western India.[35]

Published: Dehejia, SS, cat. no. 63.

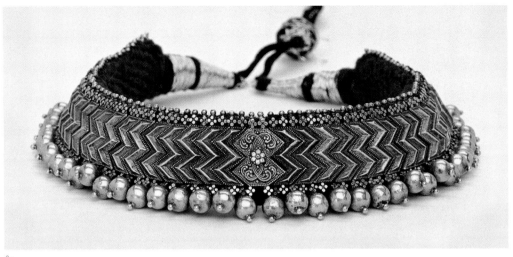

84

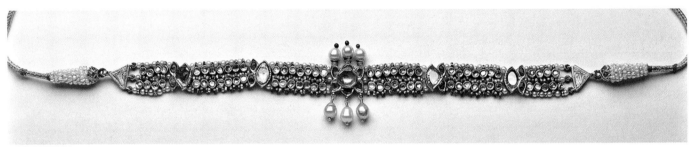

85 (front)

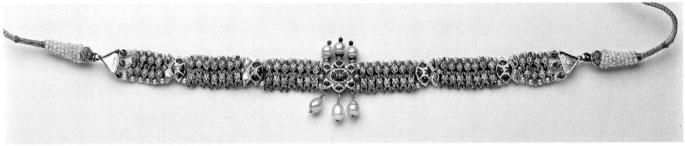

85 (back)

84
Gold choker on fabric

South India; 19th century
13.5 x 11 cm

The wave (*laheria*) pattern is popular in
northern and southern design.[36] Chokers
were made on this pattern in both gold and
silver. Each wave is, in essence, a separate
bead through which fabric ties have been
strung. The necklace has been reinforced
with a fabric back. It is quite similar to a
bracelet in this collection (cat. no. 120), but
subtle differences in design and scale indi-
cate that the two do not comprise a set.

85
Gold necklace set with diamonds, emeralds, and pearls, with enameled back

Probably Benares; 18th–19th century
27 cm length

On the back of this necklace, each small
diamond becomes a tiny pink rose bud. In
enamel, pink, like red, is a highly fugitive
color and is tackled only by the best enamel-
ers. Pink enamel originated in Persia and
was brought from Kabul to the Oudh court
in the eighteenth century.[37] The enamelers

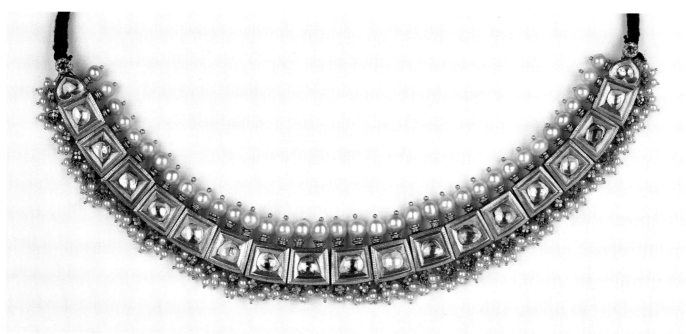

86 (front)

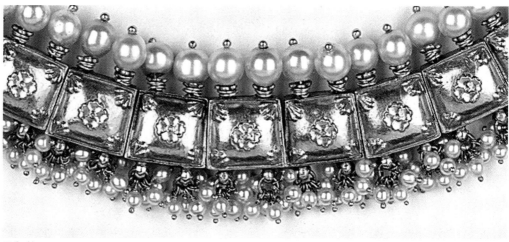

86 (back)

for the Oudh rulers worked in Benares
and soon made pink enamel a specialty.
Though pink enamel was practiced else-
where, popular sayings of the early twentieth
century still associated it with Benares. The
red poppies are typical of Mughal-style
enamel work.

86
Gold necklace set with diamonds and edged with pearls

Tamil Nadu; 19th century
15.5 x 9.5 cm

The *kundun* on this necklace is particularly
fine. The diamonds have been cut to maxi-
mize weight and surface rather than glitter.
Nevertheless, they glow brightly. Tiny
rosettes ornament the rounded backs of
each diamond unit.

Published: Dehejia, SS, cat. no. 69.

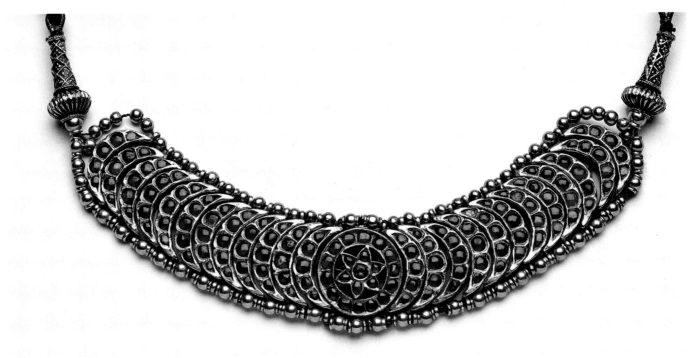

87

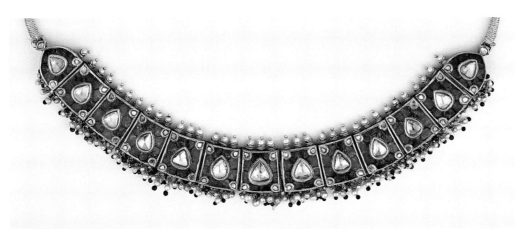

88 (front)

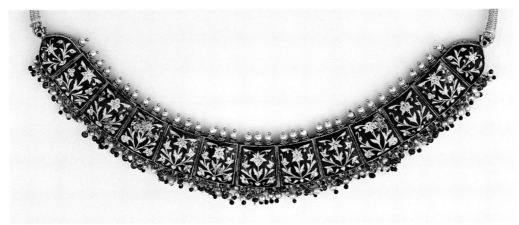

88 (back)

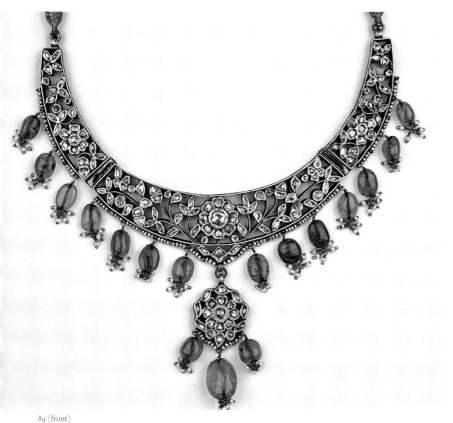

87

Gold necklace set with rubies and emerald

South India; early 19th century
16 x 2.5 cm

This necklace may come from Tamil Nadu,[38] but similar published necklaces are also ascribed to Kerala, Malabar, and Travancore.[39] The design, with its crescent motif (cat. no. 22), seems to have been widespread in South India. One example was incorporated into a temple crown.[40] The back of the center roundel is brass, not gold.

Published: Dehejia, SS, cat. no. 73.

88

Gold necklace set with emeralds and diamonds, edged with seed pearls, rubies, and emeralds, and enameled on the reverse

Jaipur; 1920s or 1930s
28 cm length

This necklace employs an unusual cut of emerald called a pavée setting. Typically, green enamel served as background on a necklace like this, but here planes of emerald create a more lavish effect. Such a necklace was probably made for a woman's dowry. The enamel on the back is simpler and more stylized than the Jaipur enamel work of the nineteenth century.

89 (front)

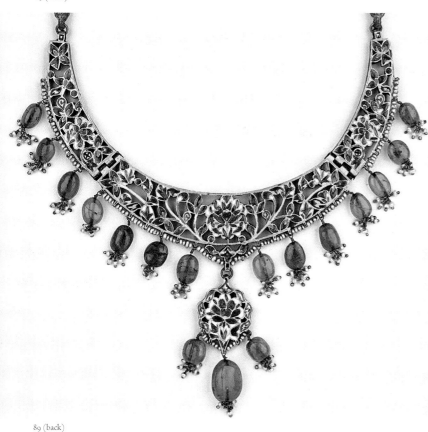

89 (back)

89

Gold necklace set with diamonds, edged with a border of seed pearls, and hung with emeralds and seed pearls

North India; 19th century
14 x 15 cm

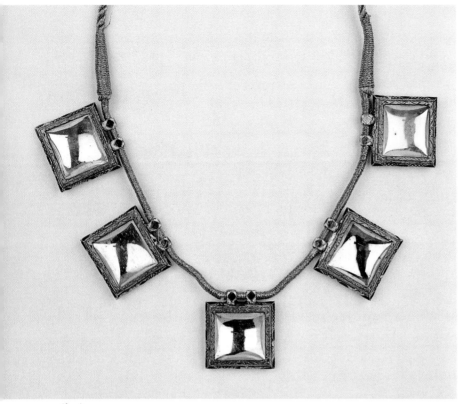

90 (front)

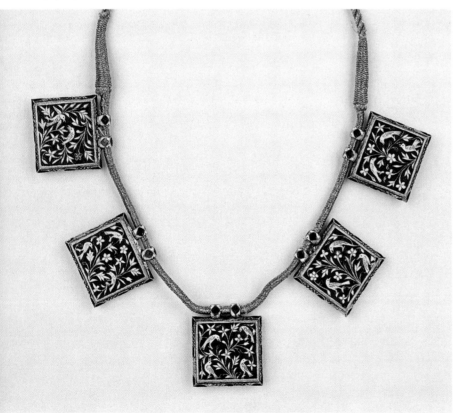

90 (back)

European jewelry in India inspired increasingly lacey open work. This piece is still essentially on the Mughal model, but the slenderness of the foliage stems suggests a response to European design. The stems are not carved away according to more refined practice but are constructed in an additive manner that takes some of the fluidity away from their curves. The reverse is beautifully enameled in green, white, and red. On the terminal pieces, right and left, appears an odd detail easy to miss: two dark blue circles with a cross in the center. These may be a subtle workshop marking. Unfortunately, no sustained study has been done on jewelry workshops, and few such signature-like marks were made.

90
Square gold pendants set with crystal, enameled, and strung on fabric

North India; 19th century
2.7 x 2.4 cm, each pendant

Crystal was often used as an alternative to diamonds, even by the wealthy. It is the enamel work on this seemingly simple piece that surprises and delights. Each vignette of birds perched on a spray of flowers is slightly different. Groups of two, three, and four birds chatter to one another. On one pendant, two birds look at each other, with their beaks open in intense conversation. One spreads its wings, poised to fly away. Here alone a single turquoise flower makes an appearance.

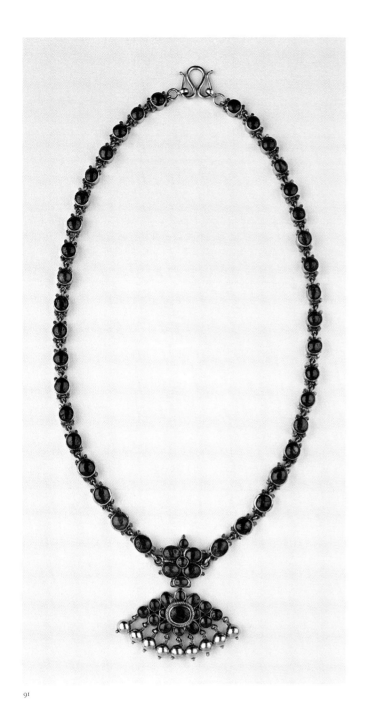

91

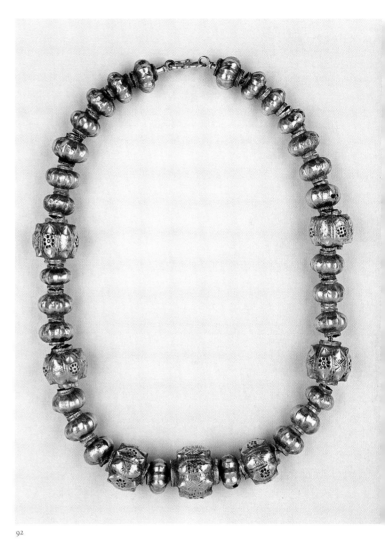

92

91

Gold necklace set with rubies

Tamil Nadu; 19th century
Necklace: 50 cm length; pendant: 5 cm length

92

Gold bead necklace

South India; 19th century
42.5 cm length

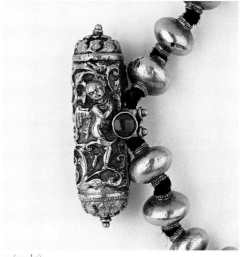

93 (amulet)

93
Gold necklace with beads, a pendant set with a piece of lacquer, and amulets set with garnets, strung on a knotted string

India; Amulets: as early as the late 16th century;
bead and pendants: 19th century
60 cm length

Virtually identical matching amulets in the
Al-Sabah collection have been dated to the
late sixteenth or early seventeenth century.[41]
The small cherubic winged figures on these
amulets closely resemble the cherubs that
sixteenth- and seventeenth-century Mughal
artists and artisans adapted from European
imagery. However, winged figures were also
a motif on nineteenth-century jewelry from
Tamil Nadu, where they tended to appear
on wedding jewelry, flanking the upper ends
of *talis*.[42] In general, the winged figures on
talis are mature women with long, slender
limbs, modeled on celestial beauties (*apsaras*),
while the winged figures on these amulets
are somewhat infantile. Opposite these
cherubic figures, small birds perch in the
decorative foliage. Further study will be
needed to date such amulets precisely. The
rest of the necklace appears to be nineteenth
century in origin.

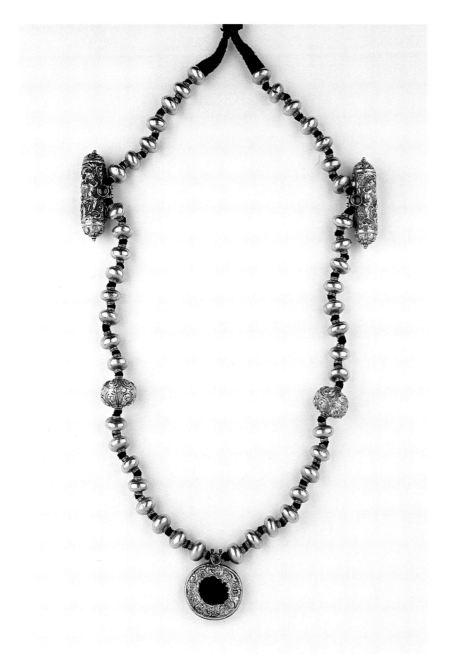

93

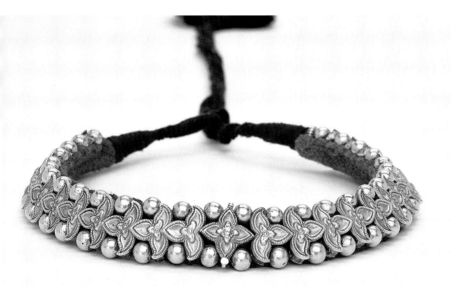

94

94

Gold beads, round and trefoil, strung onto a fabric backing

Possibly Karnataka; 19th century
12 x 12 cm

This necklace consists of several small beads designed to fit together. The trefoils line up in opposite directions around a single four-leaf centerpiece. With round beads nestling between trefoil leaves, the individual units join into a tight, symmetric whole. These beads were not uncommon in South India. An identical necklace has been published elsewhere, [43] and the Beningson collection includes another set as well.

95

Gold chain necklace

India; 18th century
Necklace: 46 cm length; clasp: 4 cm length

Several gold chains are gathered together into clasps shaped like *makaras*. In Indian design, the *makara*, a crocodile-like beast, emits and consumes ornamentation, symbolizing infinity. Its role is similar to the *kirtimukha* with which it often appears. Loose, graduated gold chains that fit into animal terminals are an ancient and widespread design.[44]

95 (detail of clasp, side view)

95

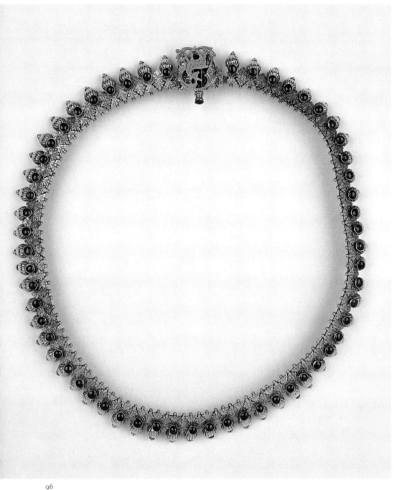

96

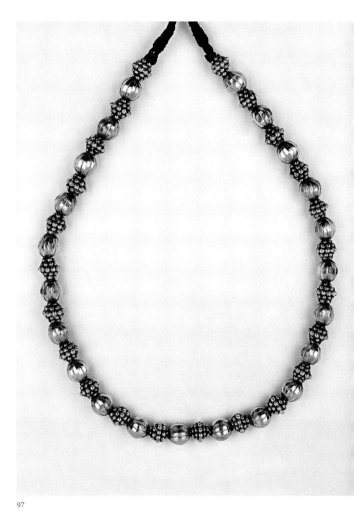

97

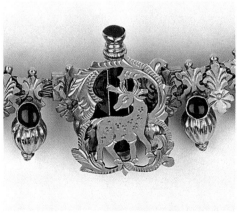

96 (clasp)

96
Gold necklace set with rubies with deer clasp

Tamil Nadu; early 19th century
17.5 x 17.5 cm

Published: Dehejia, SS, cat. no. 70.

97
Gold bead necklace

Tamil Nadu; 19th century
54 cm length

Published: Dehejia, SS, cat. no. 71.

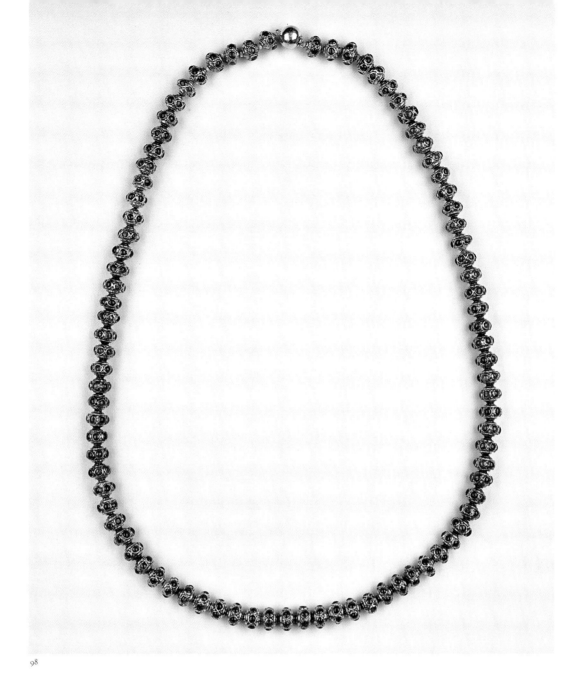

98

98
Gold bead necklace studded with rubies

Tamil Nadu; 19th century
58 cm length

Published: Dehejia, SS, cat. no. 72.

The beads on these three necklaces imitate the forms of seeds, berries, and flower buds. Such natural forms are among the oldest in Indian jewelry and are considered highly auspicious. Whether on buildings, textiles, or jewelry, seeds, nuts, fruits, and flowers are thought to promote growth and prosperity. On women, in particular, such beads bear potent associations with fertility. The small gold buds on catalogue number 96 are suspended from and alternate with gold foliage rendered in two dimensions. These flat, engraved pieces fit neatly together to create a continuous, flexible band. A small gold deer is rendered in the same manner on the clasp. It is a popular motif in Tamil Nadu jewelry and brings another element of the wild into this exquisitely crafted flower garland.

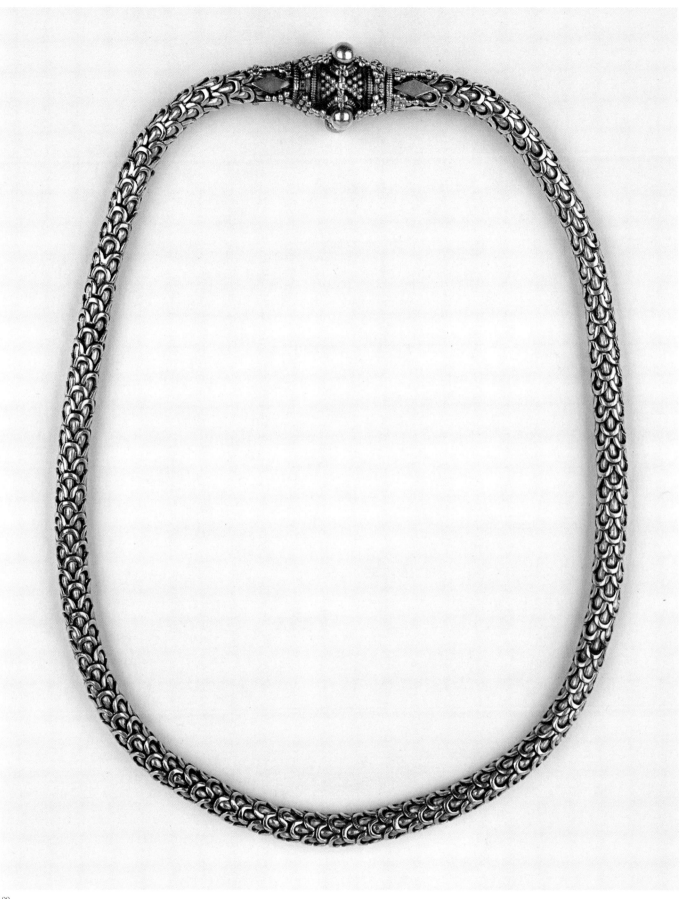

99
Gold chain necklace

Tamil Nadu; 19th century
41 cm length

The rope on this chain resembles a garland
of flower petals or, perhaps, a fish's scales or
a snake's skin. Gold wires running length-
wise swell at each loop like a tongue. These
wires and the looping cross pieces with
which they intersect are not visibly connect-
ed, so that the whole seems to hang together
organically. The clasp is beautifully granu-
lated and tucked within an outer structure
to suggest half-hidden intricacy.

Published: Dehejia, SS, cat. no. 68.

100
Gold pendant (possibly *tikka*), set with rubies, emeralds, and diamonds with a pendant pearl, with enameled back

North India; 19th century
4 x 3 cm

101
Gold pendant set with rubies

Mysore; 17th–18th century
4.5 x 3.5 cm

This pendant appears to be considerably
older than the others shown here, though
its design is similar. Gold repoussé leaves
frame the piece. The heads of two extremely
abstract birds branch from a common body,
a simple ruby circle; they are the double-
headed bird of Mysore, Gandabherunda.
The piece would have been made for a
member of the Mysore royal family, possibly
as a gift to a temple.

102
Gold pendant set with rubies, emeralds, and diamonds

South India; 18th–19th century
7 x 5 cm

The design of this pendant draws on the
motifs favored by the other pendants shown
here: a frame of petals, a central flower,
and two birds. The birds have become fairly
abstract. Close examination shows them to
be peacocks, with long necks, ruby plumage

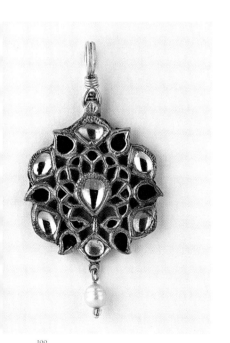

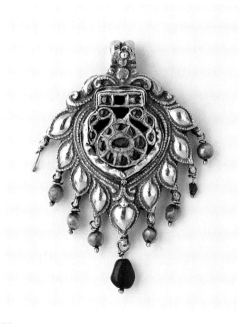

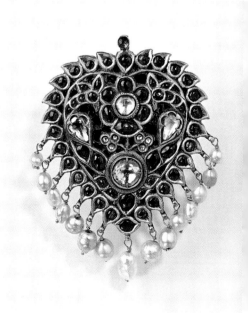

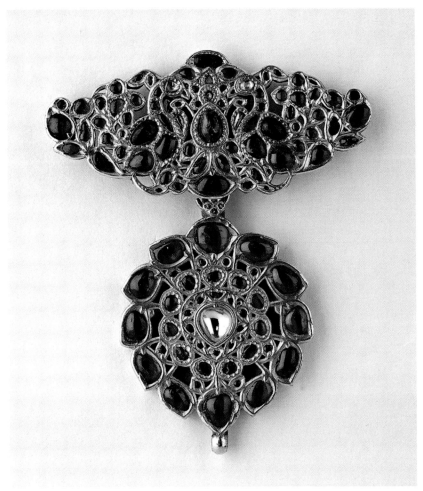

103

on their heads, and sweeping tails extending beyond their diamond wings. The peacocks turn their backs on an exquisite round diamond, then turn their faces toward a ruby flower with a diamond center and tiny diamond petals sprouting from its stem. The pendant employs two different kinds of setting: claws for its larger diamonds and *kundun* for its other gems.

103
Gold pendant set with rubies, emeralds, and diamonds

South India; 18th century
7.25 x 6 cm

The workmanship and design of this pendant are extremely refined. Both parts have been carved into an intricate openwork, and the gold around each gem has been expertly notched and grooved. In fact, the upper and lower portions of the pendant originally belonged to different ornaments. Though they are similar in style, the lines in the upper half of the pendant are more sinuous and the design more involved than in the lower half. On both portions, though, design elements playfully denote more than one image at once. The suspended pendant is a flower comprised, on closer examination, of smaller interlocking flowers and petals. The plumage of two facing birds blossoms into flower on the ornament above, and small ruby flowers on the far left and right terminate in tiny emeralds that suggest the heads of birds pecking at fruits.

104
Gold pendant set with rubies, emeralds, and diamonds

South India; 19th century
7 x 4.5 cm

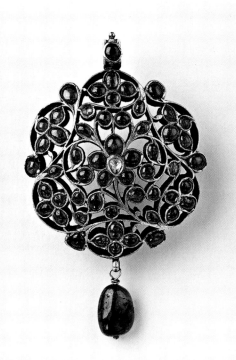

104

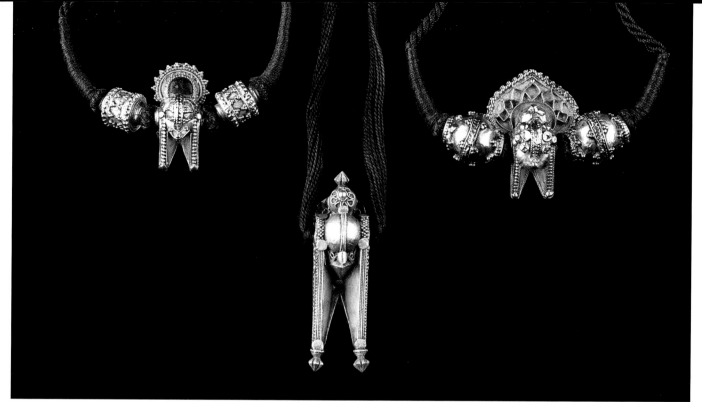

105, 106, 107 (front)

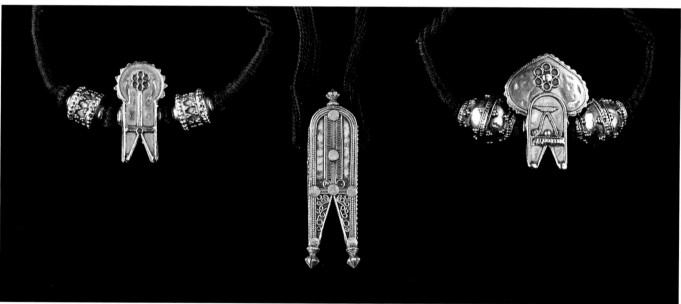

105, 106, 107 (back)

left to right:

105

Gold *tali* set with brown stone,
flanked by gold beads

Tamil Nadu; 19th century
3.5 x 1.7 cm

106

Gold *tali*

Tamil Nadu; 18th century
6 x 1.7 x 1.8 cm

107

Gold *tali* flanked by gold beads

Kerala; 19th century
4 x 2.8 cm

Published: Dehejia, SS, cat. no. 61.

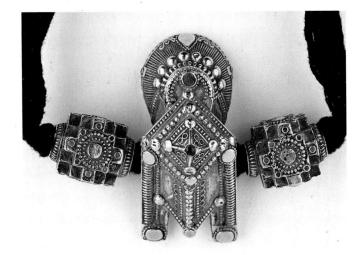

108 (front)

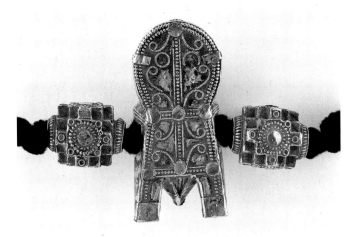

108 (back)

109

108
Gold *tali* set with ruby, flanked by gold beads

Tamil Nadu; 19th century

6.5 x 7 cm

Published: Dehejia, SS, cat. no. 59.

109
Gold *tali*

Tamil Nadu; 19th century

3 x 4 cm

The high point of most South Indian weddings is the tying of the marriage pendant, or *tali*. The *talis* worn during weddings are elaborate and often uncomfortably heavy. A woman typically replaces her wedding *tali* with one like these to wear every day. The *tali* is a symbol of a woman's identity. It shows her to be married with a living husband; its style indicates where a woman is from; and it often bears sectarian marks, denoting her devotion to Shiva, Vishnu, the Great Goddess, or Jesus. The *talis* pictured here are wrought in an M-shape favored in Tamil Nadu. Catalogue number 105 features a flowering stalk on its back (possibly the *tulsi* plant revered by Vaishnavites); and catalogue numbers 106 and 107 are both embossed with Vaishnavite emblems (a "V" and two vertical lines). The sectarian marks on catalogue number 108 are less clear; they subtly trace a cross, possibly to denote a Christian wearer. Catalogue number 109, a small, flat, filigreed pendant reiterates the M-shape of the Tamil *tali* and is decorated with tiny geese (*hamsas*). A simpler *tali*, it probably belonged to a less wealthy woman.

110
Gold Chettiar *tali*

Tamil Nadu; 19th century

74 cm length

The Nattukottai Chettiars are a wealthy merchant community in Tamil Nadu with a

distinctive tradition of ornament. Chettiar grooms tie grand wedding necklaces such as this one on their brides, though it is the bride's family who supplies most of the gold for the *tali*. Only the central piece, the *tiru-mangalyam*, is contributed by the groom. This piece alone will remain his property, while the rest of the necklace can be passed from the bride to her daughters.[45] The four hand-like pendants are considered abstractions of the newlyweds' hands.[46] Lore has it that they derive from stylized crabs, a holdover from the Chettiars' earlier incarnation as fisher people.[47] The spires on the backs of these hands end in faceted finials thought to represent the cardinal directions.[48] Centerpieces differ from one *tali* to the next. Many represent Lakshmi or Shiva and Parvati, but this example is a simple shaft, considered talismanic.[49] Though necklaces like this one seem massive compared with other *talis*, earlier examples were even grander. Most women own several small *talis*, simpler ones for everyday use and fancier ones for festive wear. A necklace like this one would only be worn at a woman's wedding and on her husband's sixtieth birthday (see cat. no. 111).

111 (front)

111 (back)

III

Gold *tali* around a lac core, set with rubies

Tamil Nadu; 19th century
13.25 x 6 cm

Women had ruby-studded *talis* like this one made for their husbands' sixtieth birthdays. Hindus consider sixty the half-way point of a man's life.[50] When a man turns sixty, if his wife is alive, a large celebration is held and his marriage is reenacted. His wife becomes highly auspicious, a consummate married woman (*sumangali*), for wives are held responsible for their husbands' longevity. Younger women seek the blessings of such women.[51]

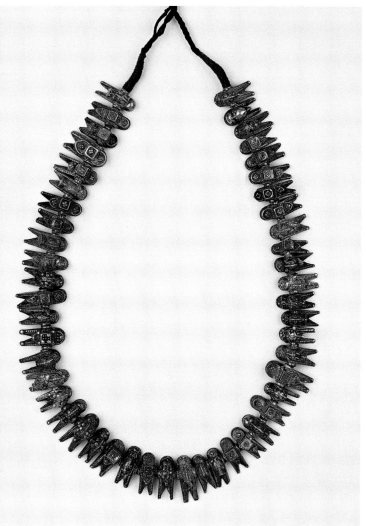

112 (front)

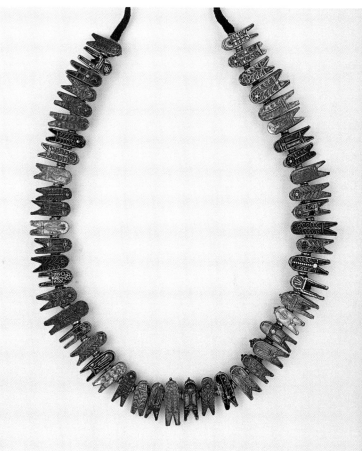

112 (back)

Talis like this one, which were made for the occasion, bear an emblem of motherhood on the front, a dome-shape that represents the female breast.[52]

Published: Dehejia, SS, cat. no. 60.

112

String of silver *talis*

Tamil Nadu; 19th century

30 x 18 cm

These silver *talis* have been gathered from a variety of sources and strung together. They demonstrate a wide range of Vaishnavite markings on the back, including the *tulsi* plant and the U- or V-shape said to derive from the form of Vishnu's feet.[53] Remnants of a red paste often used in worship (*kumkum*) remain on some of the *talis* indicating the reverence with which women treated these ornaments.

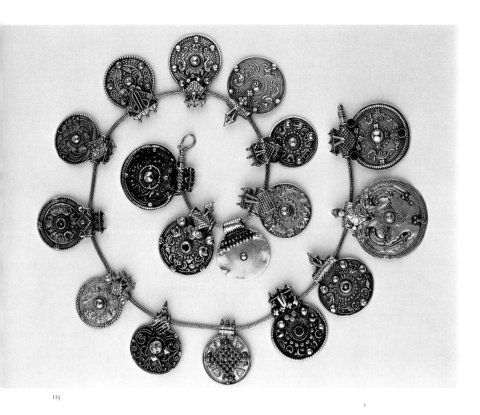

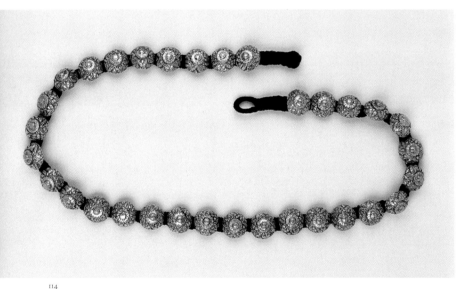

pair of facing peacocks adorns all but two of the pendants. In several cases, the peacocks have become completely abstract, mere lines sketching the curve of a peacock's back and the flounce of his tail. The tops of these *talis* end in the faceted finials characteristic of South Indian jewelry. Note the reddish color on some of the pieces. An offering used in worship, red powder would have been applied in a gesture of reverence by the *talis*' owners (see cat. no. 112).

114

Gilt silver belt strung on black fabric

South India; 19th century
81 x 2 cm

115

Gold armband set with diamonds, spinels, with enameled back

North India; 18th century
4.5 x 10 cm

Armbands were worn by both men and women. The size of this armband (*bazuband*) suggests a woman's arm. With its delicate balance of abstract order and natural fluidity, its design is typical of the Mughal idiom that prevailed in North India into the nineteenth century. Eleven spinels define the center and peripheries of the armband, while diamond petals and leaves fill the interstices like foliage growing around the stones in a garden. As on so much Mughal-style jewelry, the reverse brings the garden to life with the rich reds, greens, and turquoise blues of its enamel work. The settings are *kundun*. As was customary, fabric ties bind the piece to the arm.

113

Seventeen gold *talis* strung on a gold chain

South India; 19th century
Largest *tali*: 4.7 x 3.9 cm; smallest *tali*: 3.5 x 2.5 cm

These round *talis* exemplify a different type of South Indian marriage pendant. They were probably assembled from a variety of sources and strung together to be sold. A

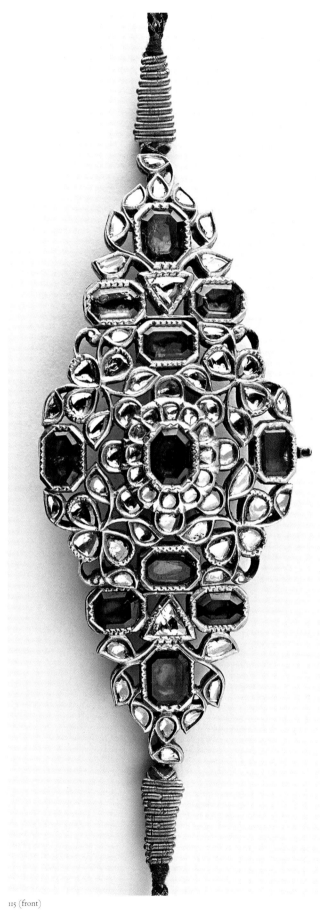

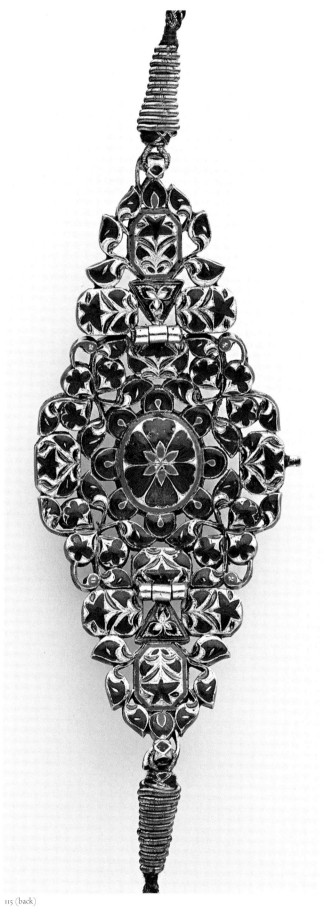

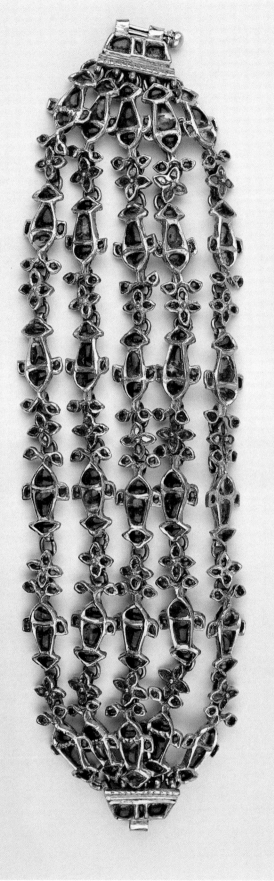

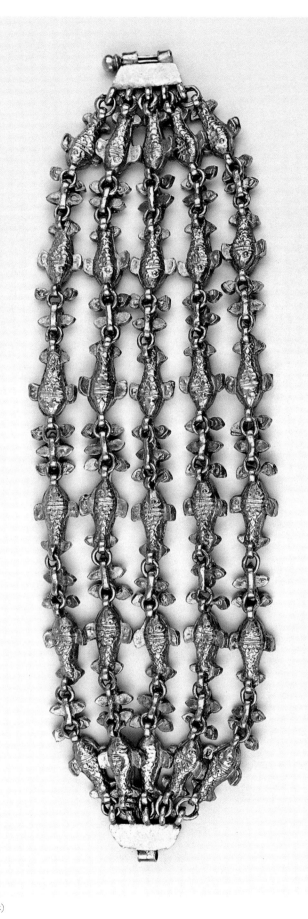

116 (front)

116 (back)

116

Bracelet of jeweled fish, set with emeralds and rubies

North India; 18th century
16.5 x 4 cm

The fish is among the oldest motifs in Indian jewelry, dating as early as the first century C.E. It remains a pan-Indian design. A symbol of fertility, the fish appears on wedding implements,[54] but is not necessarily associated with marriage. Fish are often hung as pendants or, as here, strung loosely so that they quiver with motion and seem to swim. A subtle symmetry in this bracelet turns the fish on each side toward a center row of small flowers. Tiny details on the back of each fish denote eyes, scales, and fins.

117

Gold bracelet with rattle inside

Tamil Nadu; 19th century
8 cm diameter

Tiny balls inside this hollow bracelet make it ring when it moves. For this reason, it has been suggested that the piece was worn by a child. However, its size would better suit a grown woman. In India, the sounds of jewelry were part of its beauty. Bracelets like this one would have broadcast a woman's movements, insuring that she did not stray, on the one hand, while, on the other, giving a lovely voice to her gestures. In poetry, the music of jewelry was understood to heighten yearning for those who were out of sight or reach.

117

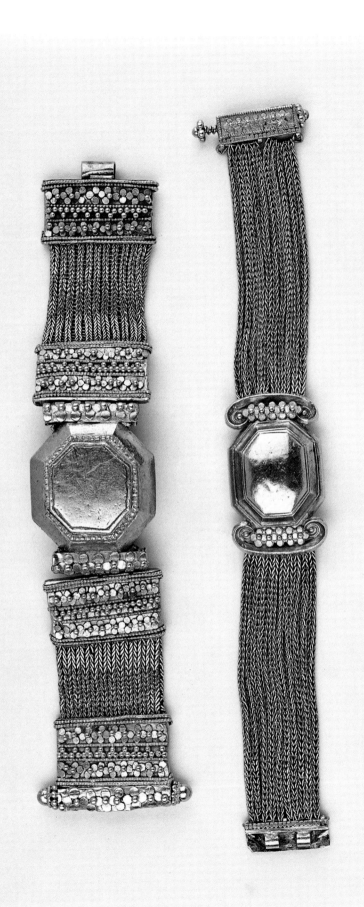

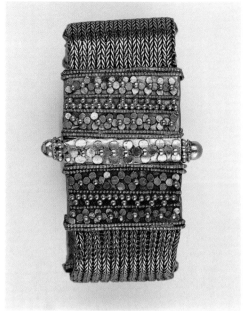

118 (clasp, detail)

118 (far left and above)

Gold bracelet with woven chains and lac-core centerpiece

Rajasthan; 18th century

16.5 x 3.25 cm

119

Gold bracelet with loose chains and lac-core centerpiece

Rajasthan; early 19th century

19 x 2.5 cm

Catalogue number 118 is considerably older than catalogue number 119 and resembles bracelets worn in Rajasthan. Its gold chains have been woven together like a fabric. The chains of the other bracelet hang loosely around the wrist and may be a later evolution from the earlier style.

118, 119

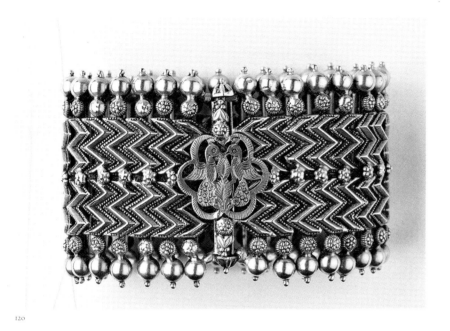

120

120

Gold bracelet

Tamil Nadu; 19th century
19 x 5 cm.

The wave (*laheria*) pattern is a common one (see cat. no. 84). This one was probably worn with a matching bracelet as a pair. The flat, etched gold clasp, bearing the image of two facing peacocks, is typical of gold jewelry from Tamil Nadu. (See, for instance, cat. nos. 96 and 110.)

121

Gold bracelet

North India; 19th century
7 cm diameter

This piece typifies older traditions kept alive outside urban centers. The individual units of this bracelet are faceted, highly abstracted depictions of garlic clove, a popular North Indian motif. The pieces fit together snugly, giving the impression of a chainlike weave.

121

122

Pair of gold chain bracelets

Tamil Nadu; 18th–19th century
7 cm diameter

Published: Dehejia, SS, cat. no. 76.

122

123

Pair of gold bracelets, set with diamonds

Hyderabad; early 19th century
6 cm diameter, each

Published: Dehejia, SS, cat. no. 77.

124

Pair of gold bracelets with clusters of pearls, set with rubies, emeralds, and diamonds, sewn onto fabric backing

Rajasthan; early 19th century
9 cm diameter, each

Each cluster of pearls wraps around a gold core terminating in florets: florets of rubies and diamonds alternate with florets of diamonds and emeralds. Such bracelets are called *gajredar bangri*.[55] Silver imitations were made for less affluent women.[56]

Published: Dehejia, SS, cat. no. 75.

125

Gold bracelet with enamel work, set with rubies, diamonds, and pearls

South India; late 18th century
7 cm diameter

Though enamel seems to have predated Mughal rule in India, it was the Mughals who made it a fine art and created the taste for richly enameled jewelry that thrives in India even today. In many respects, the design of this piece is typically Mughal. However, it may have been made for the great Mysore ruler Tipu Sultan (1750–99). Tiger-head bracelets are not uncommon, and at least one very similar piece has been ascribed to the Mughal court.[57] However, the heads of these tigers also resemble those found at Tipu's court, where the tiger was a royal emblem. A good piece for comparison is the tiger finial from Tipu's throne at Powis Castle.[58] A switch behind one of the tiger's necks causes its head to swivel, so that the bracelet can be opened and closed.

123

124

125 (detail of clasp)

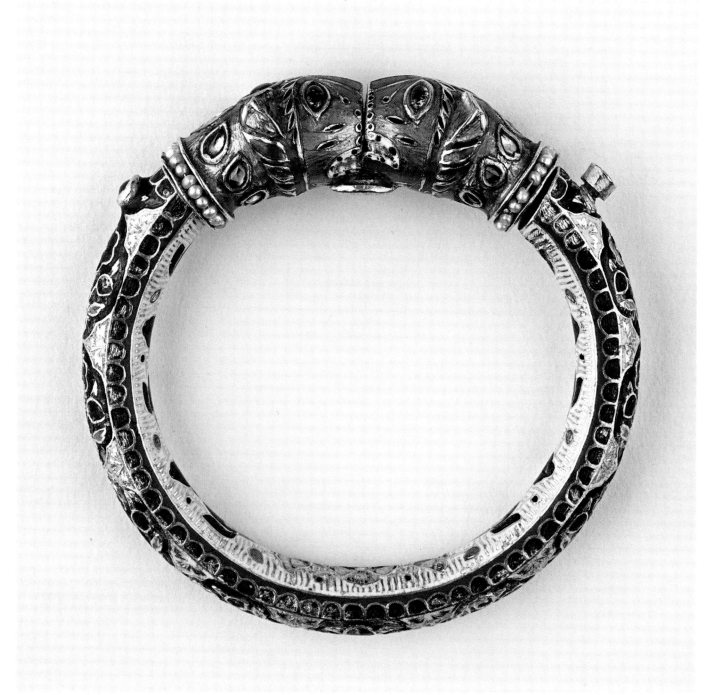

125

126

126

Pair of enameled gold bracelets, set with diamonds

Jaipur; 18th–19th century
6 cm diameter

127

Silver bracelet with rubies set in gold

North India; 19th century
8.5 cm diameter

A bit of family history has made its mark on this ornament. A silver bracelet, it would have been worn by a woman without considerable means. At some point, however, her family must have come up in the world, allowing her to adorn the circumference of the piece with gems set in gold and to add a gold and jeweled floret latch. It is interesting that the owner did not exchange the bracelet for something more expensive. One guesses that she treasured it for sentimental reasons.

127

128

Gold hand ornament called "hand flower" (hath phul), set with rubies, diamonds, emeralds, and pearls

North India; 19th century
13.5 x 6 cm

It is unusual to find pieces like this one intact. Two rings fit on the index and ring finger; the roundel or flower rests on the back of the hand and the chain below fastens around the wrist. Hand flowers (hath phuls) may incorporate four or five rings. They are worn in pairs, mostly by brides, though nineteenth-century paintings and photographs show women wearing them as if they were routine accoutrements for the well-dressed woman.[59]

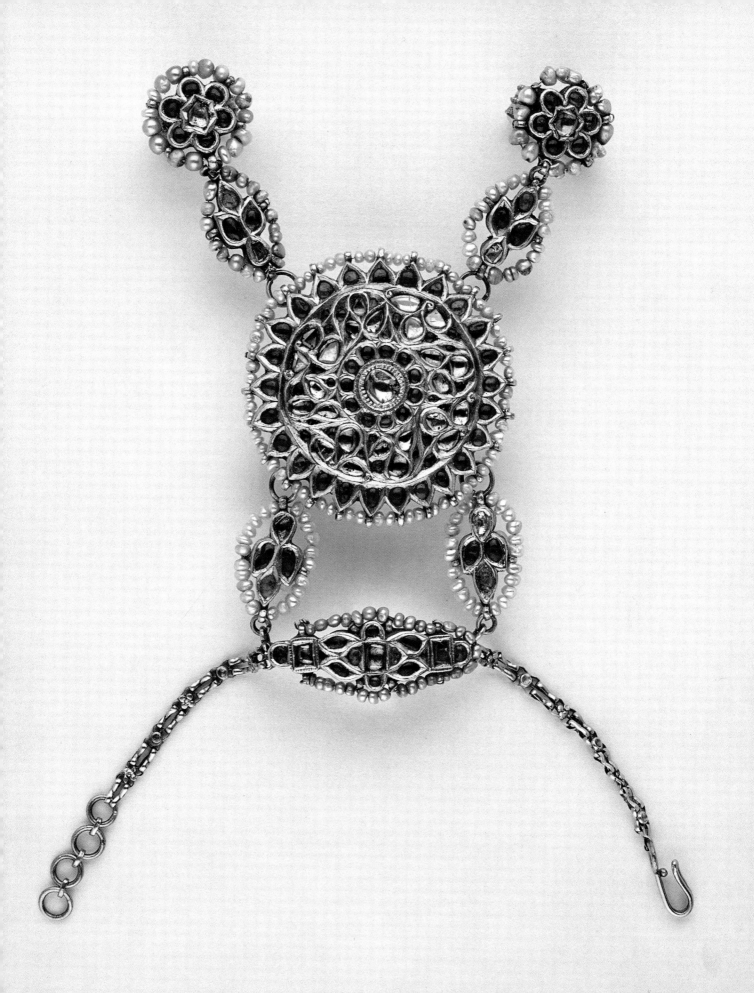

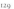

129

130 (front)

130 (back)

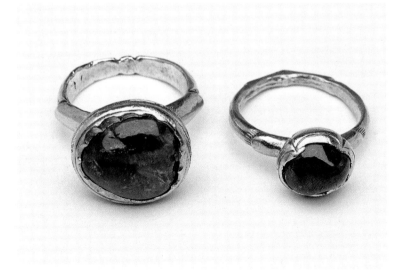

131, 132

129

Gold ring set with diamonds

India; 18th century
Jewel setting: 1.5 cm height

130

Gold ring set with diamonds and enameled on reverse

North India, possibly Jaipur; 19th century
2 cm diameter

131

Gold ring set with sapphire

South India; 18th century
Jewel setting: 1.75 cm diameter

132

Gold ring set with ruby

South India; 19th century
Jewel setting: 2 cm diameter

In keeping with the Indian practice of preserving as much of the stone as possible, only the imperfections have been removed from these gems, leaving polished but slightly uneven surfaces, more pebble than cabochon. Though catalogue number 131 was made in the south, its setting is true *kundun*. Close examination reveals that the gold around the gem is a different color from the rest of the setting. The *kundun* has been pushed down into shallow concavities, leaving tips of gold, like claws, to hold the sapphire in place.

Slight clawlike tips have also been left in the gold setting of catalogue number 132 to hold the gem in place. True claws were sometimes used in Indian jewelry, in imitation of European models, but they are fairly rare (see cat. no. 102). The base of the ring has been delicately shaped into quadrants to suggest petals opening and to liken the ruby to a blossoming flower.

133 (front) 133 (back)

134, 135

133
Silver and gold ring

Possibly Eastern India; 19th century
Setting: 2 cm diameter

Gold and silver coins are often turned into jewelry in India. The gold medallion on this ring was not a coin but intentionally resembles one. It is stamped like a coin and pictures a rider galloping on an armored horse. The medallion has been set into a complex silver ring. Its base is shaped like a lotus, and two delicate silver arms attach the rim of the ring to its circlet.

134
Silver hair ornament

India; 18th–19th century
7 cm diameter with knob

Complete adornment includes jewelry for the hair: along the braid, to either side of the part, at the front of the part, or over a bun. This ornament, decorated with interwoven irises, may have held a bun or gathering of hair in place. Such ornaments are found all over India.

135
Silver ear covers in the shape of *makara*

India; 18th century
7.25 x 5 cm

A small hole allows these to be strung over the ear. *Makara* are a motif found throughout Indian design (see cat. no. 95), particularly in architecture, where they appear to emit the building from their mouths, symbolizing the forces of creation and destruction. These are a particularly lively and curvaceous pair. Silver jewelry tends to be larger, less finely crafted, and also brasher and more imaginative in its designs than gold.

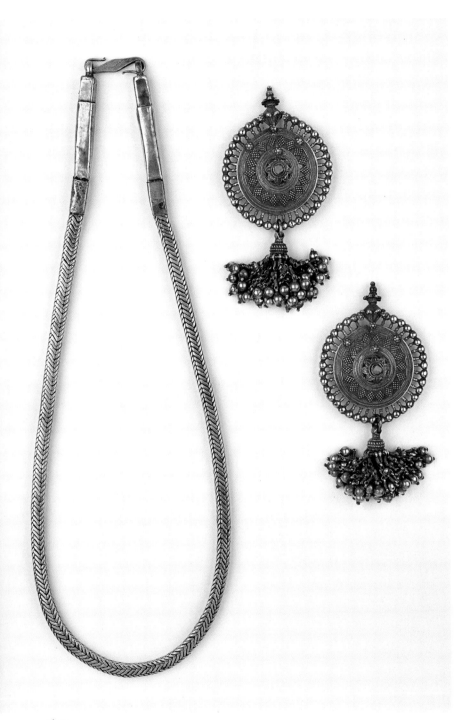

136
Silver chain, hammered into a squared form

India; 19th century
70 cm length

137
Silver earrings called *karanphul jhumka* set with turquoise

Himachal Pradesh; 19th–early 20th century
12 cm length; diameter of disk: 6.25 cm

The basic design seen here is a widespread and longstanding one: a bell-shaped pendant suspended from a round flower (*karanphul*). Hendley has published a similar pair of earrings from Barmaur in Chamba State.[60] The design, with its granulated diamond pattern set in a ring, and its central turquoise, owes a great deal to Arabic jewelry patterns, presumably by way of Central Asia. One finds similar designs in Rajasthan and Gujurat as well.

136, 137

138

138
Silver amulet

Mysore, Karnataka; 19th century
6.5 x 15 cm

This amulet opens to contain objects or verses imbued with sacred power. The upper row of small pyramidal finials is typical of South Indian jewelry design and is reminiscent of the spires atop temple gateways. The pointed cones on each end are based on highly stylized renditions of buds, with petals opening around them. The two-headed bird on the front represents Gandabherunda, the mythical bird who served as the insignia of the Mysore royal family.[61] Similar amulets have been published in a number of places.[62]

139
Silver anklet

Rajasthan or Gujarat; 19th or early 20th century
9 cm diameter, 3 cm width

139

140, 141

140
Silver anklet

Maharashtra or Southern Gujarat; 19th–early
20th century
14 cm diameter, 7 cm width

141
Silver anklet

Baroda, Gujarat; 19th or early 20th century
14 cm diameter, 9 cm width

142
Silver anklet

Kutch, Gujarat; 19th–early 20th century
12 cm at widest point, 6 cm height

142

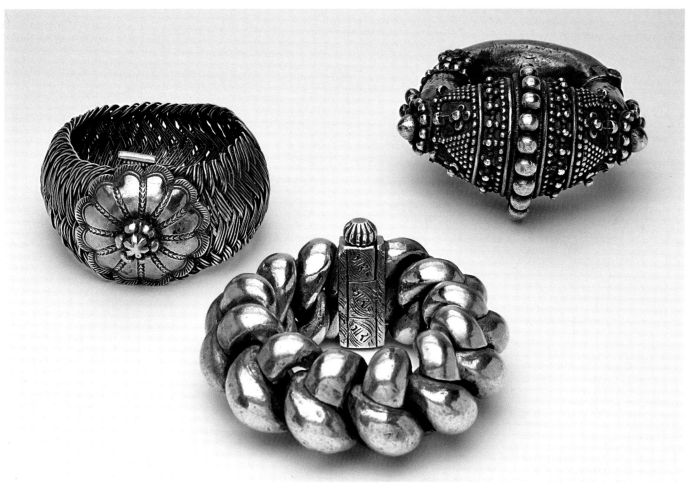

143, 144, 145 (left to right)

143
Silver anklet

Gujarat or Madhya Pradesh; 19th or early
20th century
10 cm diameter, 6 cm width

144
Silver anklet

Kutch, Gujarat; 19th–early 20th century
11.5 cm diameter, 4 cm width

145
Child's silver anklet

India; 19th or early 20th century
12 cm diameter, 7 cm width

One of the pleasures afforded by pieces like
these is the ingenuity of their chain work.
Catalogue number 143, for example, is made

of a complex, somewhat flexible weave of
silver wires, and catalogue number 139 is
composed of seemingly independent coils,
found on the reverse to be tightly braided
together. In general, silver was worn by
women who could not afford gold. This rule
breaks down in the case of anklets, however.
The feet are potent symbols in India. It is
important never to touch one's feet to a
revered thing or person, and, in turn, it is
customary to touch a revered person's feet.
Because gold was considered a sacred sub-
stance, only royalty could wear gold on their
feet. Many women otherwise adorned in
gold could wear only silver anklets and toe
rings. Today, very heavy anklets such as
those illustrated here are worn by rural and
low-caste women for whom they constitute a
kind of bank account to be cashed in during
desperate circumstances. The designs for

these anklets are specific to particular communities and regions. Catalogue number 142, for example, is worn by Harijan and Koli women in Gujarat,[63] catalogue number 143 by Mahratta and Gujurati women of the Raval community,[64] and catalogue number 141, with its rich repousé work, tiny birds, and elaborate *makara* faces, by women from merchant families.[65] The unyielding weight of such pieces can chafe the skin and hinder movement. Some women wear cloth around their ankles to protect themselves.[66] Amazingly, the prodigious weight of catalogue number 145 was made for a child's foot. Child marriage is not uncommon in India, though a child bride typically remains with her family until she has reached adolescence.

THE TOILETTE

146
Silver collyrium (*kajal*) container called *surmadani*, with gilding

Rajasthan; 18th century
9 x 3.5 cm

This *surmadani* is shaped like a mango.[67] Its stem unscrews and a long tip emerges, covered with the black cosmetic collyrium (*kajal*), which is used to outline the eyes. The vessel is etched and gilded with floral motifs on one side and a woman on the other. The woman is looking in a mirror, applying *kajal* to her eyes. She wears necklaces, a nose ring, a *tikka*, armbands, and bangles all indicated by lines and rows of dots.

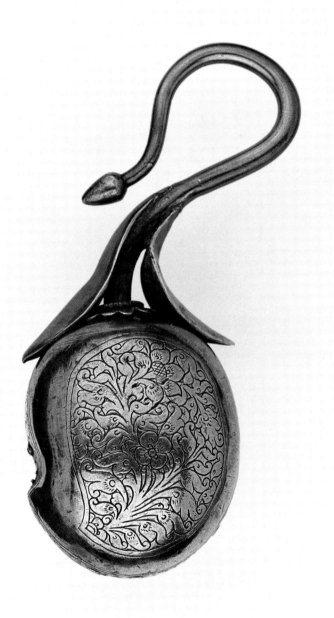

146 (back)

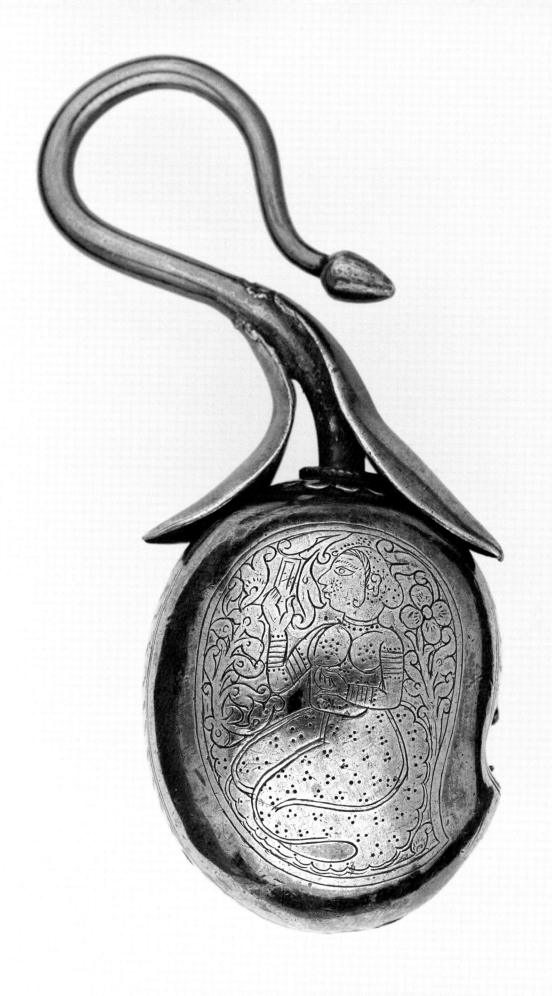

147
Enameled collyrium container (*surmadani*)

Jaipur; late 18th or early 19th century
2.5 x 1.5 x 1.3 cm

147

148
Gold pomander

India; 18th century
4 x 2 cm

This pomander holds perfume. Its top unscrews and small holes on the bottom release scent. Leaves surround the neck of the pomander and a flower circles its base, so that the vessel itself becomes a flower, opening to give out its sweet scent.

149
Silver comb with some gilding

Mysore, Karnataka; 19th century
8.25 x 5 cm

Note the similarity between the decoration on this piece and on the silver amulet pictured in catalogue number 138. In both cases, the birds at the center are joined in one body to form a centerpiece—the double-headed bird that was the crest of the Mysore royal house. The comb was probably made for a member of the royal family. Two parrots with gilded wings perch on long leaves above.[68] They peck at a knob that opens onto a reservoir for scent. Scented hair was valued in India. While deities are thought to have naturally scented hair (one South Indian goddess is called "the mother with the sweet-smelling locks"),[69] mortals must apply oils and perfumes.

150
Silver comb

Possibly Orissa; 18th century
9.75 x 4 cm

Ivory combs like this one were made in Orissa.[70] With flanking pillars and an arch of frothing foliage, its frame resembles a shrine door or niche on a temple wall. As

149, 150

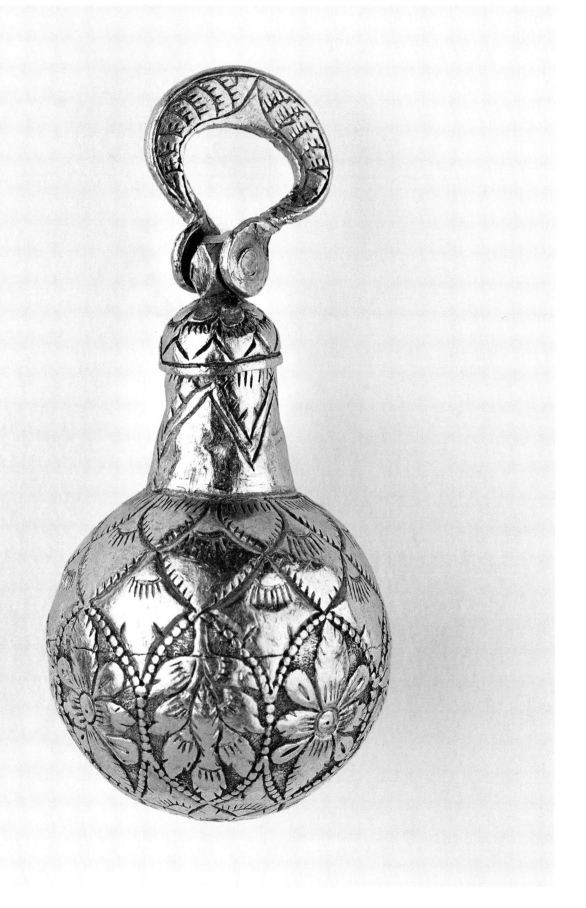

a baby, Krishna battled demons, wayward deities, and forces of nature. Here he dances on the head of the snake Kaliya. This was one of the most popular icons of Krishna in sculpture and jewelry. By defeating the snake, Krishna subdues the waters and restores order to the universe.[71] Kaliya's defeat is staged not as a battle but as a dance, expressing Krishna's playfulness (*lila*)—the spirit in which he creates and maintains the cosmos. An allusion to the snakelike qualities of a woman's braid may be intended here, as it is on braid ornaments (cat. nos. 24 and 43). Or perhaps another metaphor is intended: as Shiva tames the river Ganga in his hair, so Krishna subdues the waters in the hair through which this comb is drawn.

151

Ivory and gold comb with ruby knob

Karnataka; late 18th century
10.5 x 7 cm

Amorous scenes carved in ivory were popular under the Nayaka rulers of Vijayanagara and their successor states. The erotic lives of the ruler and his nobles were an important part of their public images. The ivory-carved vignette on this comb is typical, with an aristocrat and his mistress seated in a loving embrace on a low bed, and vessels below holding the accoutrements of love. A crystal chandelier hangs from the ceiling and a curtain has been drawn to one side, motifs that characterized European-style portraits. These details date the comb to the last decades of Nayaka rule in the late eighteenth century. Though the scene appears secular, the man may be identified with Krishna. (The Nayaka rulers made a point of associating themselves with Krishna and identified their amorous exploits with the god's many affairs). The combination of gold and ivory and the extremely fine work may indicate that the piece was made as an offering to a temple, where it would have been used in rituals of adornment. Note the back of the comb, which bears a delicate, etched vignette of birds perched on flowering foliage.

Published: Dehejia, SS, cat. no. 93.

151 (back)

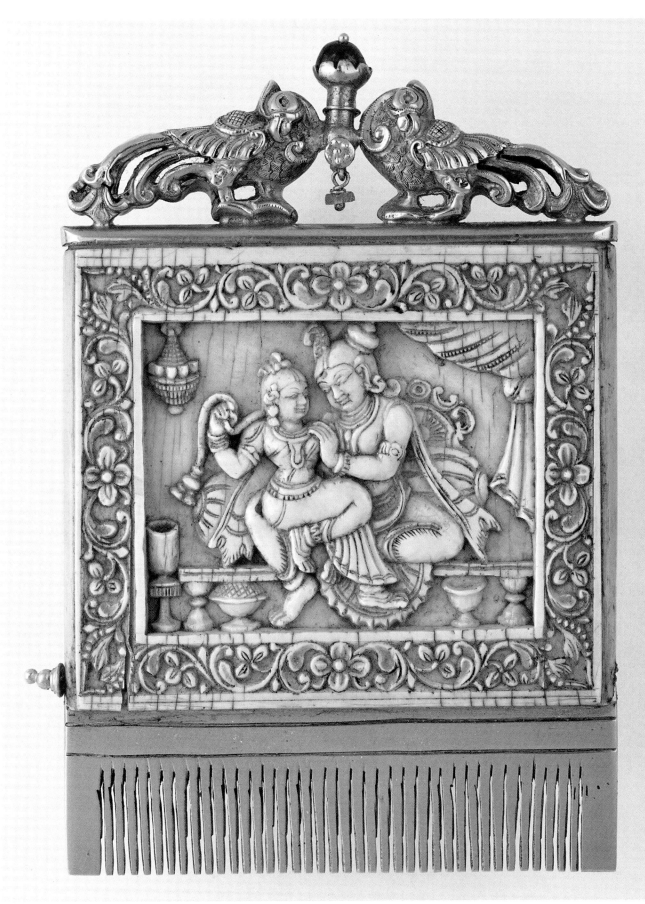

pearls and earrings, to breasts and bellies, and the round body of the woman's sitar. To steal a term from Sanskrit aesthetics, the scene re-creates the *rasa*, or flavor of pleasure, not just its component parts. Unlike catalogue number 151, this comb is one-sided. Traces of color show it was once painted.

153
Ivory and gold comb

Tamil Nadu; 18th century
8.5 x 8.5 cm

Ivory combs were common in the nineteenth century: Birdwood mentions them "in every Indian bazaar."[73] However, the artistry on this piece is extraordinary and almost certainly derives from the Madurai royal workshops. The dancer's earrings sway in opposite directions, and his elaborate robes billow and swirl. The artisan has created several layers of depth here: the figure's knee comes forward, his head turns, his slender, muscular torso is sculpted in a full round to his back, where a second, identical figure appears. The dancer's pose is typical of the dancing Krishna, and the round object in one of his hands may be Krishna's butterball. Also identifying him with Krishna is the scalloped frame around him, commonly found on Krishna mandalas and very like that on the tiny Krishna bracelet in this collection (cat. no. 21).

Published: Dehejia, SS, cat. no. 92.

152
Ivory comb

South India; 18th century
11 x 13 cm

Like catalogue number 151, this comb is also carved in the style of the Nayaka rulers.[72] Though it depicts a nobleman in Nayaka headdress, it lacks the refinement of a court piece and probably comes from a nonroyal workshop. What it lacks in technical perfection, it makes up for in vivacity. The women who surround and entertain the recumbent nobleman turn their heads in opposite directions, circulating attention across the scene. Bodies turn in sinuous S-curves, echoed by the snaking lines of their clothes. Augmenting these curves are circles everywhere, from

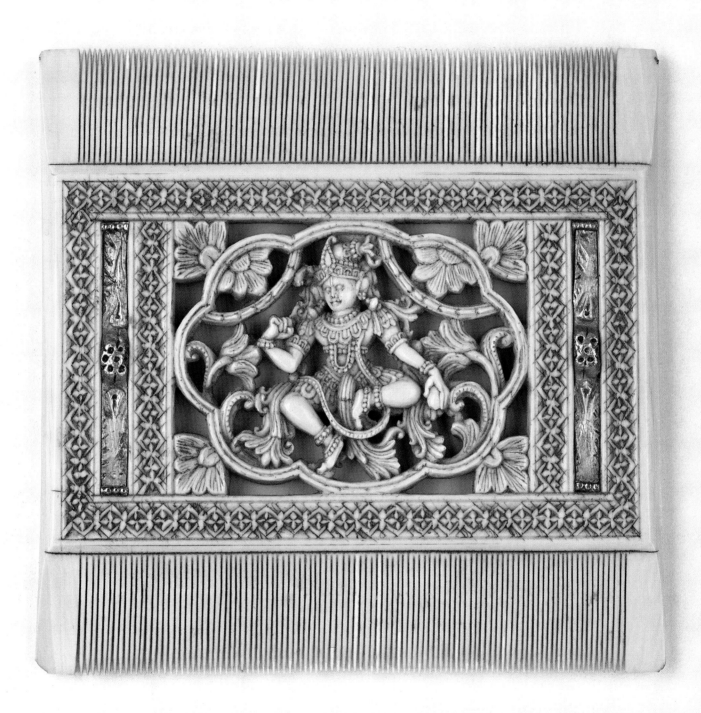

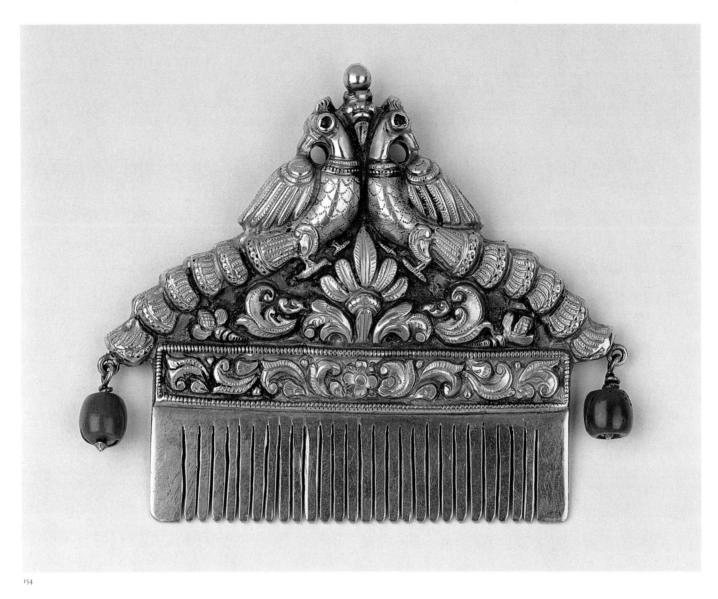

154
Gold comb with rubies and coral

Tamil Nadu; 19th century
9 x 7.75 cm

This regal gold comb depicts two peacocks
perched on a blossoming lotus. The pea-
cocks are symbols of beauty and love, the
lotus of purity. The repoussé work is intri-
cate. The peacocks have ruby eyes, delicately
etched breast feathers, and cascading tail
feathers. The pendant corals would have
contributed a poetic shiver of motion when
the comb was used.

Published: Dehejia, SS, cat. no. 91.

1. Birdwood writes: "Gem engraving is an immemorial Eastern art, as the cylinders of Nineveh and Babylon and Persepolis testify, and Delhi has always been famous for its practice; as was Lucknow also before the abolition of the native court of Oudh." G. C. M. Birdwood, *The Industrial Arts of India* (London: the Reprint Press, 1971) 198.

2. Jonathan M. Kenoyer, *Ancient Cities of the Indus Valley* (Karachi: Oxford University Press; Islamabad: Americna Institute of Pakistan Studies, 1998).

3. Cited in Michael Willis, *Buddhist Reliquaries from Ancient India* (London: British Museum Press, 2000) 14.

4. Published in Stronge, *A Golden Treasury*, cat. 26, and Stanislas J. Czuma, *Kushan Sculpture: Images from Early India*, exhibition catalogue (Cleveland, New York, Seattle, 1985–6) 75–76. Susan Stronge also mentions, in connection with the V&A piece, two similar repousse busts of Athena and Artemis at the Art Museum, Princeton Museum.

5. Personal communication. 1/8/04. See John Miksic, *Old Javanese Gold* (Singapore: Ideations, 1991).

6. Michel Postel, *Ear Ornaments of Ancient India* (Bombay: Project for Indian Cultural Studies, 1989) 9–28.

7. Postel, 25

8. Ibid.

9. Klaus K. Kllostermaier, *A Survey of Hinduism* (Albany, New York: State University of New York Press, 1994) 316.

10. Vidya Dehejia, *Devi, The Great Goddess: Female Divinity in South Asian Art* (Washington DC: Arthur M. Sackler Gallery, 1999) 258.

11. Untracht, *Traditional Jewelry*, 195.

12. Choodamani Nanda Gopal, "Jewellery in the Temples of Karnataka," *Marg*, Vol. XLVII, No. 1.

13. Filliozat and Pattabiramin, *Parures Divines*, pl. LXXXI, fig. 1 and pl. LXXXII, fig. 2.

14. Nanda Gopal and Iyengar, *Temple Treasures*, 169.

15. Ibid. One of the pieces illustrated has an attached stand.

16. A very similar, but slightly less intricate pendant, dated to the 20th century, has been published in Bala Krishnan et al., *Dance of the Peacock*, fig. 104.

17. Jyotindra Jain and Aarti Aggarwala, *National Handicrafts and Handlooms Museum, New Delhi* (Ahmedabad: Mapin, 1989) 63.

18. Nanda Gopal and Iyengar, *Temple Treasures*, cat. 87.

19. For a variety of examples, see Ibid., 114–117.

20. According to Untracht, *Traditional Jewelry*, 71, six-segment *rudrakshas* are associated with Shiva's son Kartikkeya.

21. Ibid.

22. For an extensive description of this process, taken from interviews with craftspeople, see Untracht, *Traditional Jewelry*, 302.

23. Cited in Nanda Gopal and Iyengar, *Temple Treasures*, 211. The song was written by the 16th-century Telugu poet Sri Annamacharya.

24. For a very similar scene of Rama's coronation, also set behind crystal, see Nanda Gopal and Iyengar, *Temple Treasures*, cat. 152.

25. Untracht, *Traditional Jewelry*, figs. 607 and 608, has reproduced a very similar ring.

26. A similar but much later representation of Vitthala appears on a repoussee pendant published in Nanda Gopal and Iyengar, *Temple Treasures*, 155.

27. One from Surat, is dated 1740–49; another, in the V&A is dated to the 18th century and described as North Indian and a third from the Punjab, also in the V&A, is dated to the 19th century. Susan Stronge notes a similar piece in a 1774 album of jewelry painted for Colonel J. B. Gentil at Faizabad. Like the Beningson piece, these other examples feature rubies filling a crescent in an unbroken row.

28. Jain and Aggarwala, 63.

29. National Museum, New Delhi, 87.1156 and 89.992.

30. M. L. Nigam, *Indian Jewellery* (New Delhi: Lustre Press/Roli Books, 1999) 25–26.

31. Stronge, *Golden Treasury*, cat. 58.

32. Bala Krishnan et al., *Dance of the Peacock*, 172.

33. Ibid, 175.

34. This notion was culled from an on-line discussion on www.beliefnet.com.

35. Birdwood, *Industrial Arts*, pl. 50.

36. Similar necklaces have been published in a number of places. For a North Indian version, see Gerd Hopfner and Gesine Haase, *Metallschmuck aus Indien* (Berlin: Museum fur Volkerkunde, 1978) 90.

37. Krishnadasa, Rai, "The Pink Enamelling of Banares," *Chhavi: Golden Jubilee Volume*, Banaras, 1971, pp. 327–31.

38. The necklace was ascribed to Tamil Nadu in a previous publication. Vidya Dehejia, *The Sensuous and the Sacred: Chola Bronzes from South India* (New York: American Federation of Arts, 2003) cat. 73.

39. See, for instance, Jamila Brij Bhushan, *Indian Jewellery, Ornaments and Decorative Designs* (Taraporevala Sons, 1964), pl. LVII.

40. J. Filliozat and P. Z. Pattabiramin, *Parures Divines Du Sud do L'Inde* (Pondicherry: Institut Francais D'Indologie, 1966), pl. XXII.

41. Manuel Keene and Salam Kaoukji, *Treasury of the World: Jewelled Arts of India in the Age of the Mughals; the Al-Sabah Collection, Kuwait National Museum* (New York/London: Thames and Hudson, 2001) cat. 3.4.

42. See, for instance, Untracht, *Traditional Jewelry*, figs. 306 and 307 and Bala Krishnan et al., *Dance of the Peacock*, fig. 212.

43. An identical piece, strung in the same fashion, has been published in Borel, *Splendors*, 142.

44. See, for instance, Carolyn Woodford Schmidt, *Sacred and Secular*, for a 1st century C.E. version from Uzbekistan.

45. Carol Radcliffe Bolon and Amita Vohra Sarin, "Metaphors in Gold: the jewelry of India," *Asian Art* (Fall 1993) 19.

46. Untracht, *Traditional Jewelry*, 158.

47. Bala Krishnan et al., *Dance of the Peacock*, 156.

48. Untracht, *Traditional Jewelry*, 158; Bolon and Sarin, "Metaphors," 21

49. Bolon and Sarin, "Metaphors," 21.

50. Untracht, *Traditional Jewelry*, 158.

51. Bolon and Sarin, "Metaphors," 21.

52. Bala Krishnan et al., *Dance of the Peacock*, 152.

53. For a useful chart of sectarian marks, see Birdwood, *Industrial Arts*, pl. M.

54. Pria Devi and Richard Kurin, Aditi: *The Living Arts of India* (Washington D.C.: Smithsonian Institute Press, 1985) 89.

55. Bala Krishnan et al., *Dance of the Peacock*, 146.

56. Untracht, *Traditional Jewelry*, cat. 588.

57. See, for instance, Keene and Kaoukji, cat. 6.20.

58. Mark Zebrowski, *Gold, Silver and Bronze from Mughal India* (London: Alexandria Press in association with Laurence Kind, 1997) cat 59.

59. Bala Krishnan et al., *Dance of the Peacock*, 297.

60. Thomas Holbein Hendley, "Indian Jewellery," *The Journal of Indian Art and Industry*, Vol. XII, no. 95 (July 1906): pl. 38, fig. 259.

61. Choodamani Nandagopal and Vatsala Iyengar, *Temple Treasures Vol. II* (Bangalore: Crafts Council of Karnataka, 1997) 55–56.

62. e.g. Havel, "Madras Presidency," cat. 646; Borel, *Splendors*, 144; Untracht, *Traditional Jewelry*, cat. 218.

63. Untracht, *Traditional Jewelry*, 272.

64. Ibid., cat. 550.

65. Anklets similar to cat. 141 have been published elsewhere, including Ibid., cat 648; Anne van Cutsem, and Mauro Magliani, *A World of Bracelets: Africa, Asia, Oceania, America* (New York: Skira, 2002) 190; Stronge, *A Golden Treasury*, cat. 107. Stronge's examples from the Victoria and Albert Museum lack the tiny birds that perch on the rims of these pieces. These anklets are generally said to have been worn by wealthy women, but Untracht understands them to have been worn by Maldhari women.

66. Untracht, *Traditional Jewelry*, 273.

67. A similar *surmadani* is published in *Alamkara: 5000 years of Indian Art* (Singapore: National Heritage Board, 1994) cat. 68.

68. Similar birds appear on a comb with a perfume reservoir in Borel, *Splendor*, 141.

69. C. Shivaramamurti, "The Charm of Feminine Coiffure," *Chhavi: Golden Jubilee Volume*, (Banaras: Bharat Jala Bhavan Banaras, 1971).

70. For comparison, see Sharma, *Alamkara*, cat. 70.

71. John Stratton Hawley, "Krishna's Cosmic Victories," *Journal of the American Academy of Religion*, XLVII/2, 201–221.

72. For comparison, see B. N. Goswamy, *Essence of Indian Art* (San Francisco: Asian Art Museum of San Francisco, 1987) cat. 7.

73. Birdwood, *Industrial Arts*, 218

Glossary

apsara. Celestial being, often appears female.

bazuband. Indian armband.

bhakti. Religious devotion; form of worship associated with intimate and sometimes unconventional devotion to a deity.

Bharhut. Ancient Buddhist reliquary monument (*stupa*) built ca. 150 B.C.E. Located between Allahabad and Jabalpur in the present-day state of Madhya, North India. One of India's earliest and most important monuments.

bindi. Indian term derived from the Sanskrit word *bindu*, meaning "dot" or "droplet." Auspicious mark placed on the forehead (between the eyebrows). In North Indian communities, a *bindi* denotes a woman's married status, while in South India, both unmarried and married women wear a *bindi*.

gandabherunda. Mythical two-headed bird. Used as an insignia by the Mysore royal family.

granulation. Surface tension causes small drops of gold to form perfect balls; these are bonded, through a chemical process, to the surface of an ornament.

hamsa. Sacred bird, often described as a goose. Popular motif on Indian art.

Hariti. Female Buddhist deity. Ogre-turned-goddess who, according to legend, gave birth to 500 children and turned to devouring children. After being converted to Buddhism, she vowed to protect children and is usually shown with them. Her name means "one who steals."

hathphul. Hand ornament consisting of two or more finger rings, a chain, and a bracelet. Worn in pairs, mainly by brides.

jadai nagam. South Indian linked ornament, placed over a hair braid. The top of this ornament, shaped like a cobra, is called *nagar*.

Jain. Religious sect founded by Mahavira in North India in the late seventh century B.C.E. Main beliefs center around the concept of karma, the sum of good and bad actions that accumulates over many lives and affects future rebirths.

jali. Floral open work; literally, "net," "lattice," or "screen."

jhumar. Marriage ornament worn to one side of the hair part by Muslim brides.

jhumka. Indian earring with a bell-shaped pendant, generally suspended from a flower motif. Commonly worn in North India.

jimki. South Indian term for earring with a bell-shaped pendant, usually suspended from a flower motif.

kajal. Collyrium, also known as kohl; black cosmetic for the eyes.

karanphul. Indian earring; literally, "ear flower." Often worn with a bell-shaped pendant suspended from a round flower (called *karanphul jhumka*).

kinnara. Half-bird, half-human celestial creature.

kirtimukha. Masklike horned face intended to defend from evil; literally, "face of glory." Often seen crowning door-ways or thresholds to shrines and temples in India; it symbolizes the divine, dualistic powers of creation and destruction.

koppu. Indian earring worn on the helix of the ear.

Krishna. Male Hindu deity and incarnation in human form (avatar) of Vishnu.

kunkum. Red pigment derived from turmeric, used during worship ceremonies in India.

kundun. Gem-setting technique developed at the Mughal court. First, a gem is placed on a piece of natural resin (or lac). Then, several thin layers of 24-karat gold are built up around the gem to hold it in place.

lac. Natural resin obtained from the secretion of an indigenous Indian insect.

laheria. Wave pattern; a motif in Indian art.

Lakshmi (or Sri-Laksmi). Hindu goddess of wealth and good fortune; wife of Vishnu.

laung. A kind of nose ring; literally, "clove."

makara. Ancient, mythical aquatic beast (part fish, part crocodile, often depicted with an elephant's head); associated with water and fertility.

mangaliyam. A marriage necklace. It can refer to a string of gold wedding pendants worn by the groom.

mangalsutra. Indian necklace, often made of black beads and a gold pendant, worn by married women in North India.

mehndi. Hindi term for henna. A red-staining paste, made from the leaves of the henna plant, used to decorate the body in India (especially the hands and feet of new brides). *Mendhi* decorations are believed to protect the wearer from evil. Usually listed as one of the "sixteen adornments" (*solah shringar*).

minakari. Indian enamelwork. Jewelry technique whereby the surface of a metal object is decorated with vitreous polychrome oxide glazes that, when fired, fuse onto the surface of the metal. Most enamelwork in India is of the *champlevé* type, in which enamel is applied to an engraved surface.

mold techniques. Indian jewelers use molds in several ways. A wax form may be cast in a mold, then placed in sand, and finally melted away, leaving an impression in the sand into which gold is poured. Alternatively, sheet gold may be placed over a mold and wax used to press the gold into the mold.

mudicchu. Type of Indian earring; literally, "knot."

Mughal (or Moghul, Mogul). The Muslim dynasty that ruled an empire in India (based in Delhi) from the sixteenth to nineteenth century.

muhr. Signet ring.

Mysore. City in South India (in the present-day state of Karnataka). Capital of the Wodeyars dynasty (1578–1947).

nagar. Top part of a braid ornament (called *jadai nagam*) decorated with a many-headed cobra. The Hindi term *nagar* is derived from *naga*, a mythical serpent and guardian to the deities.

nath. Nose ornament.

paduka. Style of sandal, typically worn by deities and ascetics.

Parvati. Hindu goddess and benevolent form of the Great Goddess; wife of Shiva.

puchikudu. Tubular-shaped earring; literally, "insect nest."

Rajputs. Warrior clan that ruled northwest India (present-day Rajasthan) from the seventh century until independence (1947). Ruled under Mughal and then British authority from the sixteenth to twentieth century.

Ramayana. Ancient Indian epic relating the story of Prince Rama, his exile, his wife Sita's abduction, and the great battle he fought with her captor, Ravana. *Ramayana* was an oral epic for many centuries, before it was written down around the fourth century.

repoussé. Jewelry technique used to create a relief surface. A sheet of metal (silver or gold, for example) is placed over a soft substance (lac, for example), and the surface design is hammered out from the back.

Rgveda. One of four ancient Hindu texts (the *Vedas*) believed to be of divine origin. Composed ca. 1300 B.C.E.

rikri. Silver head ornament.

rudraksha. Seeds from an indigenous Indian tree that are used as beads. Indian term derived from *rudra* (another name for Shiva) and *aksha* (literally, "eyes"). They are believed to be formed from the tears of Shiva and are often worn in the form of jewelry for their religious significance.

Sanchi. Ancient Buddhist reliquary monument (*stupa*) built by the Mauryan Emperor Ashoka in the third century C.E. on the site of an earlier Buddhist monastery. Located in the present-day state of Andhra, North India. Today designated as a World Heritage Site.

Shaivite. Sect of Hinduism that worships Shiva as the supreme deity.

shakti (or sakti). The active power, generally associated with the feminine powers, of various deities.

Shiva (or Siva, Mahesh). One of India's three most important deities (along with Vishnu and the Great Goddess in all her forms). Shiva is often shown with a trident and in association with his bull-vehicle, Nandi. Although an ascetic (with matted hair and ash-smeared skin), he has a wife (Parvati) and two children (Ganesha and Skanda). Worship of Shiva is especially dominant in South India.

sinhsana. Lion-seat throne.

solah shringar. "Sixteen adornments" worn by women in India; believed to correspond to the sixteen phases of the moon, associated with female physiognomy.

spinel. Mineral made up of the oxides of magnesium and aluminum ($MgAl_2O_4$). Used as a gemstone in Indian jewelry-making. Looks similar to a ruby.

surmadani. Container for collyrium.

Surya. Hindu Sun God.

tali. South Indian term for matrimonial pendant. The most common style among the Tamils is the M-shaped tali.

thandatti. Type of Indian earring.

thewa. Indian jewelry technique, in which sheet gold and glass are fused together. The technique was developed in Pratapgarh, Rajasthan, in the mid-eighteenth century.

thodus. Indian ear stud with a simple, round shape; worn on the lobe; literally, "seven stones."

tikka. Ornament worn by women in India on the head over the parting of the hair (believed to be the *ajna* chakra).

tirumangalyam. Central ornament on the Chettiar *tali*. It is given to the bride during the wedding ceremony but is said to belong to the groom.

tribhanga. An S-shaped pose used in Indian sculpture; literally, "three-bend pose."

tulsi. Basil plant considered sacred in India; especially revered among the Vaishnavites.

Vaishnavite. Sect of Hinduism that worships Vishnu as the supreme deity.

Vishnu. One of India's three most important deities (along with Shiva and the Great Goddess in all her forms). Vishnu generally takes the role of savior (or preserver), for which he adopts human and animal incarnations (called *avatars*). His attributes include a conch and a discus.

Vishnupada. Symbol of the Hindu deity, Vishnu; literally, "feet of Vishnu."

Selected Bibliography

I list here those sources upon which I have formed my ideas for the essay in this publication. It is by no means a complete record of all the works I have consulted, and is meant to serve as a guide for those wishing to pursue the study of Indian jewelry.—M.E.A.

Allen, Charles and Sharada Dwivedi. *Lives of the Indian Princes*. London: Century Pub, 1984.

Apfell-Marglin, Frédérique. *Wives of the God-King: The Rituals of the Devidasis of Puri*. New Delhi: Oxford University Press, 1985.

Bala Krishnan, Usha R., Meera Sushil Kumar, and Bharath Ramamrutham. *Indian Jewellery: Dance of the Peacock*. Bombay: India Book House, 2000.

Bihari. *The Satasai*. Translated by Krishna P. Bahadur. New Delhi: Penguin Books / UNESCO, 1990.

Bolon, Carol Radcliffe. *Forms of the Goddess Lajja Gauri in Indian Art*. University Park, PA: Pennsylvania State University Press / New York: College Art Association, 1992.

Bolon, Carol Radcliffe and Amita Vohra Sarin. "Metaphors in Gold: The Jewelry of India." *Asian Art* (Fall 1993): 10–33.

Borel, Frances. *The Splendour of Ethnic Jewelry; The Colette and Jean-Pierre Ghysels Collections*. Translated by I. Mark Paris. New York: Harry N. Abrams, 1994.

Brij Bhushan, Jamila. *Masterpieces of Indian Jewellery* Bombay: Taraporevala, 1979.

Chaturvedi, B. K. *Jewelry of India*. New Delhi: Diamond Pocket Books, 1991.

Cohn, Bernard. "Clothes, Cloths, and Colonialism: India in the Nineteenth Century." In *Cloth and Human Experience*, edited by Jane Schneider and Annette B. Weiner. Washington, DC: Smithsonian Institution Press, 1988.

Dehejia, Vidya. *Indian Art*. London: Phaidon, 1997.

Dehejia, Vidya. *The Sensuous and the Sacred: Chola Bronzes from South India*. With essays by Richard H. Davis, R. Nagaswamy, and Karen Pechilis Prentiss. New York: American Federation of Arts / Seattle: University of Washington Press, 2002.

Desai, Vishakha N., and Darielle Mason, eds. *Gods, Guardians, and Lovers: Temple Sculptures from North India A.D. 700–1200*. New York: The Asia Society Galleries / Ahmedabad: Mapin Publishing, 1993.

Dhamija, Jasleen. "Jewellery." *Marg: A Magazine of the Arts* 23, no. 2 (1970): 42–46.

Dongerkery, Kamala S. *Jewelry and Personal Adornment in India*. New Delhi: Indian Council for Cultural Relations, 1970.

Doshi, Saryu. "Traditional Ornaments: Fluctuations in Taste." In *Symbols and Manifestations of Indian Art*, edited by Saryu Doshi. Bombay: Marg Publications, 1984.

Filliozat, Jean, and P. Z. Pattabiramin. *Parures Divines Du Sud de l'Inde*. Pondicherry: Institut française d'indologie, 1966.

Ganguly, K. K. "Jewellery in Ancient India." *Journal of the Indian Society of Oriental Art* 10 (1942): 342–343.

Gode, P. L. "The Antiquity of the Hindoo Nose-Ornament called 'Nath.'" *Studies in Cultural History* 2 (1960): 313–322.

Good, Anthony. "The Structure and Meaning of Daily Worship in a South Indian Temple." *Anthropos* 96 (2001): 491–507.

Gough, Kathleen. "The Nayars and the Definition of Marriage." In *Marriage, Family and Residence*, edited by Paul Bohannan and John Middleton. Garden City, NY: The Natural History Press, 1968.

Guy, John, and Deborah Swallow, eds. *Arts of India: 1550–1900*. Contributions by Rosemary Crill, *et al*. Exhib. cat. London: Victoria and Albert Museum, 1990.

Haque, Zulekha. "Early Jewellery of Bengal: The Sunga Period." In *The Jewels of India*, edited by Susan Stronge. Bombay / Mumbai: Marg Publications, 1995.

Havel, E. B. "The Art Industries of the Madras Presidency: Jewellery." *Journal of Indian Art and Industry* 4, no. 34 (April 1891): 29–34.

Hendley, Thomas Holbein. "Indian Jewellery." *Journal of Indian Art and Industry* 12, no. 95 (July 1906): 20.

Hendley, Thomas Holbein, and Swinton S. Jacob. *Jeypore Enamels*. London: William Griggs and Sons, 1886.

Höpfner, Gerd, and Gesine Haase. *Metallschmuck aus Indien*. Berlin: Museum für Völkerkunde, 1978.

Hupre, Jean-Francois. "The Royal Jewels of Tirumala Nayaka of Madurai (1623–1659)." In *The Jewels of India*, edited by Susan Stronge. Bombay / Mumbai: Marg Publications, 1995.

Jacobson, Doranne. "Women and Jewelry in Rural India." In *Main Currents in Indian Society 2, Family and Social Change in Modern India*, edited by Giri Raj Gupta. Durham, NC: Carolina Academic Press, 1976.

Jagannathan, Shakunthala. "Jewellery." In *Arts and Crafts of Tamilnadu*, edited by Nanditha Krishna. Middletown, NJ: Grantha Corporation / Ahmedabad: Mapin Publishing, 1992.

Jain, Jyotindra, and Aarti Aggarwala. *National Handicrafts and Handlooms Museum, New Delhi*, edited by Ayesha Kagal. Ahmedabad: Mapin Publishing, 1989.

Kalidasa. "Rtusamharam" [The Gathering of the Seasons]. In *The Loom of Time: A Selection of His Plays and Poems, Kalidasa*. Translated by Chandra Rajan. New Delhi: Penguin Books, 1989.

Keene, Manuel, and Salam Kaoukji. *Treasury of the World: Jewelled Arts of India in the Age of the Mughals; The Al-Sabah Collection, Kuwait National Museum*, Exhib. cat. New York/London: Thames and Hudson, 2001.

Keshavadasa. *The Rasikapriya of Keshavadasa*. Translated by K. P. Bahadur. Delhi: Motilal Banarsidass/UNESCO, 1972.

Krishnadasa, Rai. "The Pink Enamelling of Banaras." In *Chhavi: Golden Jubilee Volume. Bharat Kala Bhavan, 1920–1970*. Edited by Karl Khandalavala, Anand Krishna, and Chandramani Singh Banares. Banaras: Banaras Hindu University, 1971.

Leslie, Julia. "The Significance of Dress for the Orthodox Hindu Woman." In *Dress and Gender: Making and Meaning in Cultural Contexts*. Edited by Ruth Barnes and Joanne B. Eicher. New York / Oxford: Berg, 1992.

Maheshwari, Uma. *Dress and Jewellery of Women, Satavahana to Kakatiya*. Madras: New Era Publications, 1995.

Nanda Gopal, Choodamani. "Jewellery in the Temples of Karnataka." In *The Jewels of India*. Edited by Susan Stronge. Bombay / Mumbai: Marg Publications, 1995.

Nanda Gopal, Choodamani, and Vatsala Iyengar. *Temple Treasures Vol. II*. Bangalore: Crafts Council of Karnataka, 1997.

Nigam, Mohan Lal. *Indian Jewellery*. New Delhi: Lustre Press/Roli Books, 1999.

Pal, Mrinal Kanti, and B. K. Roy Burman. *Jewellery and Ornaments in India—A Historical Outline*. Census of India 1971, Series 1, no. 1. New Delhi: Manager of Publications, 1973.

Paulus, Caleb R., et al. *A Kaleidoscope of Colours: Indian Mughal Jewels from the 18th and 19th Centuries*. Antwerp: Provinciaal Diamantmuseum, 1997.

Postel, Michel. *Ear Ornaments of Ancient India*. Project for Indian Cultural Studies Series, Vol. II. Bombay: Franco-Indian Pharmaceuticals, 1989.

Pressmar, Emma. *Indian Rings*. Ahmedabad: New Order Book, 1982.

Prior, Katherine, and John Adamson. *Maharajas' Jewels*. Ahmedabad: Mapin Publishing, 2000.

Sen, Jyoti, and Pranar Kumar Das Gupta. *Ornaments in India. A Study in Culture Trait Distribution*. Anthropological Survey of India, no. 22. New Delhi: Government of India/Calcutta: Indian Museum, 1973.

Sharma, Ramesh C., et al. *Alamkara: 5000 Years of Indian Art*. Singapore: National Heritage Board/New Delhi: Mapin Publishing, 1994.

Spink and Son. *Islamic and Hindu Jewellery*. London: Spink and Son, 1988.

Stronge, Susan. "Jewels for the Mughal Court." *Victoria and Albert Museum Album* 5 (1985): 309–317.

————. Mughal Jewellery." *Jewellery Studies* 1 (1983–84): 49–53.

Stronge, Susan, James C. Harle, and Nima Poovaya-Smith. *A Golden Treasury: Jewellery from the Indian Subcontinent*. Exhib. cat. New York: Rizzoli/London: Victoria and Albert Museum, 1988.

Tarlo, Emma. *Clothing Matters: Dress and Identity in India*. Chicago: University of Chicago/London: Hurst, 1996.

Tewari, S. P. *Nupura, The Anklet in Indian Literature and Art*. New Delhi: Agam Kala Prakashan, 1982.

Tharu, Susie, and K. Lalita, eds. *Women Writing in India: 600 B.C. to the Present*. New York: Feminist Press at the City University of New York, 1991.

Untracht, Oppi. *Jewelry Concepts and Technology*. Garden City, NY: Doubleday/London: Hale, 1982.

————. "Swami Jewelry: Cross-Cultural Ornaments." *Marg: A Magazine of the Arts* 47, no. 1 (1995): 117–132.

————. *Traditional Jewelry of India*. New York: Harry N. Abrams/London: Thames and Hudson, 1997.

Vatsyayana. *The Complete Kama Sutra*. Translated by Alain Daniélou. Rochester, VT: Park Street Press, 1964.

Weihreter, Hans. *Blumen des Paradieses : der Fürstenschmuck Nordindiens*. Graz: Akademische Druck, 1997.

————. *Ur Stormogulernas Skatt*. Augsburg: Välkommen till medelhavsmuseet, 1997.

Welch, Stuart Cary. *India: Art and Culture, 1300–1900*. New York: The Metropolitan Museum of Art/Holt, Rinehart, and Winston, 1985.

Zebrowski, Mark. *Gold, Silver and Bronze from Mughal India*. London: Alexandria Press/Laurence King, 1997.